THIRSTY?

CHICAGO

THE LOWDOWN ON

WHERE THE

REAL PEOPLE

DRINK!

Edited by Michelle Burton

Printed in the United States of America

First Printing: September, 2006

10 9 8 7 6 5 4 3 2 1

Library of Congress Cataloging-in-Publication Data
Thirsty? Chicago: The Lowdown on
Where the Real People Drink!
Edited by Michelle Burton
224p. 8.89 x 22.86 cm.
ISBN-10: 1-893329-22-4
ISBN-13: 978-1-893329-22-5
I. Title II. Travel III. Chicago

Production by Nancy Ruzow

Visit our Web sites at www.GloveBoxGuides.com
and www.HungryCity.com

To order Thirsty? or our other Glove Box Guides,
or for information on using them as corporate gifts,
e-mail us at Sales@HungryCity.com. or write to:

Glove Box Guides
P.O. Box 86121
Los Angeles, CA 90086

Glove Box Guides are available to the trade through:
SCB Distributors
(800) 729-6423
www.SCBDistributors.com

THANKS TO

...all of the contributors: Nicole Allen, J. Asala, Melanie Briggs, Sarah Brown, Michelle Burton, Jennifer Carsen, Keidra Chaney, Grant Christman, Josh Cox, Gina M. DeBartolo, Catherine De Orio, Danielle Deutsch, Brian Diebold, Mike Fertig, Brent J. Fuscaldo, Nicole Galbreath, Mindy Golub, Jeffrey Goodman, Michelle Hempel, Brent Kado, Billy Kenefick, Brad Knutson, Amy Lillard, Katie Murray, Courtney Nealis, Sy Nguyen, Piper Parker, Spiro Polomarkakis, Chaz Reetz-Laiolo, Janet E. Sawyer, Alana Sitek, Kristy Stachelski, Mark Vickery, Kellee Warren, Ian Weiss, and Marcy Wrzesinski.

..and special thanks to the folks that put it all together:
Linda Branover, Jennifer Chang, Mari Florence, our designer Nancy Ruzow, David Wegbreit, and all the folks at the Glove Box Guides and the great people at Worzalla.

Thank you!

—*Michelle Burton*

CONTENTS

NORTHWEST SIDE

WEST SIDE

SOUTH SIDE

KEY TO THE BOOK

ICONS

Most Popular Drinks

 Coffee

 Beer

 Tea

 Cocktails

 Smoothies

 Desserts

 Wine

Ambience

 It's late and you're thirsty

 Live Music

 Nice places to drink solo

 Patio or sidewalk dining

 Get cozy with a date

 In business since 1969 or before

 Sports Bar

 Editor's Pick

Cost

THIRSTY?

Cost of the average tab:

$	$5 and under
$$	$8 and under
$$$	$12 and under
$$$$	$13 and over

Payment

Note that most places that take *all* the plastic we've listed also take Diner's Club, Carte Blanche and the like. And if it says cash only, be prepared.

 Visa

MasterCard

 American Express

 Discover

PLEASE READ

Disclaimer #1
The only sure thing in life is change. We've tried to be as up-to-date as possible, but places change owners, hours and menus as often as they open up a new location or go out of business. Call ahead if you've got your heart set on the place or if you don't want to drain your tank crossing town only to get there after last call.

Disclaimer #2
Every place in *Thirsty?* is recommended, for something. Each reviewer has tried to be honest about his/her experience of the place, and sometimes a jab or two makes its way into the mix. If your favorite spot is slammed for something you think is unfair, it's just one person's opinion! And remember, under the Fair Use Doctrine, some statements about the establishments in this book are intended to be humorous as parodies.

And wait, there's more!
We believe in diversity. We're not anti-chain (hell, we drink our share of corporate coffee), but you don't need a book to find them. So, for the most part, Thirsty? is a roadmap to the independently owned world of drinking in Chicago. While we encourage you to check out our recommended drinkeries, and even seek out a few on your own, keep in mind that your patronage of local mom-and-pop shops keeps the city from becoming a sea of chain after chain (and you're helping Chicago's economy, too).

Don't Drink and Drive.
We shouldn't even have to tell you this: Drink responsibly. Don't drive after you've been drinking alcohol. If a designated driver is hard to come by and you don't live walking or bus or El distance from your favorite bar, call a cab to take you home. Split the cost with some friends and it's not even that expensive (and it's a lot less expensive than a lawyer). If you're not cab-savvy, ask your waiter or barkeep to call for you. They'll be delighted to and you'll be glad you did.

Tip, Tip, Tip.
If you can't afford to tip you can't afford to drink. In the United States, most baristas, bartenders and juice blenders make minimum wage or less, and depend on tips to pay the rent. Tip fairly, and not only will you get better service when you come back for the next round, but you'll start believing in karma (if you don't already).

Share your secrets.
Know about a place we missed? Willing to divulge your secrets? Send your ideas for the next edition to "Thirsty? Update", P.O. Box 86121, Los Angeles, CA 90086 or e-mail updates@hungrycity.com. There's no guarantee we'll use your idea, but if it sounds right for us we'll let you know.

MAP O' THE TOWN

① DOWNTOWN
- Magnificent Mile
- The Loop
- South Loop
- Gold Coast
- River North
- River West/West Loop/West Town
- Streeterville

② NORTH SIDE
- Lincoln Park
- Edgewater
- Roger's Park
- Old Town
- Lakeview
- Boystown
- Wrigleyville
- Roscoe Village
- Uptown
- Lincoln Square
- Andersonville/Ravenswood

③ NORTHWEST DIDE
- Wicker Park
- Ukranian Village
- Logan Square
- Bucktown
- Irving Park/Portage Park

④ WEST SIDE
- Greektown

⑤ SOUTH SIDE
- Hyde Park/Kenwood

INTRODUCTION

Are you thirsty, Chicago? We bet you know (or think you know) every little watering hole and java shack in town. You know, the kind of place where the bartender remembers your name and the barista has your latte waiting before you even get there. But what about when you wander outside of your own side of town? What are a bunch of Southsiders to do when they're in Lakeview looking for a last call?

That's why we wrote *Thirsty? Chicago.* We've gathered fifty Chicagoans to give the inside scoop on their favorite spots in their neighborhoods. So whether you're looking for a pre-game Wrigleyville brew or a post-shopping pick-me-up on the Magnificent Mile, we've got you covered. We've even got your macchiato fix covered with a section dedicated to the outlying 'burbs.

Go Native: *The* Thirsty? Way

The trick to going native (aside from a wealth of self-confidence)? Ask a native. Our contributors share only their favorite places to go. No one was assigned a place to go for the first time, no massive surveys were sent, and no scores were tabulated and cross-referenced to create an arbitrary rating.

Rather, we asked our contributors to tell it to us just like they'd tell it to a good friend. So in addition to addresses, phone numbers, average cost and everything you might find in another guidebook, you'll find tons of information that only a regular would know—like the best drink in the house (and the best bartender to mix it), the best spot to park (or the nearest public transit), what kind of scene to expect, and maybe even a little history. Our contributors let you feel like you're a regular before you've even set foot in the door.

This isn't a guide to the hot new clubs in town—though our contributors have shared some of their favorite place to shake ya rump—but a guide to some of the best deals in town. So whether it's a hip dive with killer prices on Old Style and a couple of TVs to watch the game, a lounge with funky décor and one-of-a-kind top-shelf cocktails, or even a café where you can get a pot of tea and park your butt while you use the wi-fi to get some work done, you'll know you're getting a great deal.

So who are these guys? Above all, our contributors are real people. Some are working writers, others are teachers, market researchers, jewelry designers, caterers, ad folks, and assorted office drones. These guys (and gals) love their 'hoods almost as much as they love to get a good drink. They've shared some of the best spots that we've never heard of and often tell us all the backroom secrets of the places we already know and love and we love 'em for it.

Keep the Guide on Hand and Your Head on Your Shoulders

Chances are as you're reading this you're standing in the aisle of the bookstore trying to decide whether you should buy our drinking guide or the other drinking guide. (If you've already bought this book, congratulations! Open to another page, call your friends, and buy a round or two to celebrate.) Before you buy another guide take a look inside. You won't find anything like this anywhere else. So go on, buy one. Heck, buy two and give

one to that deadbeat pal of yours that owes you a round of drinks. Keep one of these in your pocket, purse, desk, or glove box, and you'll never have an excuse not to try some place new.

We know you've heard it a million times, but you could stand to hear it once more. If it's going to be a long night at the bar make sure you don't drive. In most every case we've provided information about nearby public transit options and if all else fails, call a cab. We've even taken the time to give you the numbers for the nearby cab companies on our back page.

Oh, and if you think there is something our contributors missed (sorry!) be sure to go to HungryCity.com and let us know so we can include it in the next edition of Thirsty? Chicago.

—*Michelle Burton & the Glove Box Guides Editors*

DOWNTOWN

Miracle Juice Bar at Foodlife

Chicago's juice bar.
$$
835 N. Michigan Avenue, Chicago 60611
(near Chestnut and Pearson)
Phone (312) 335-3663 • Fax (312) 335-3664
www.foodlifechicago.com

CATEGORY	Health food store and juice bar.
HOURS	Sun–Thurs: 7 AM–8 PM
	Fri/Sat: 7 AM–9 PM
GETTING THERE	Parking garages everywhere, but the Miracle Juice Bar will only validate for the Water Tower Place Parking G arage and only after 5 PM
PAYMENT	Cash only at the juice bar.
POPULAR DRINKS	High quality carrot juice.
UNIQUE DRINKS	Try the carrot-apple
FOOD	At Foodlife they have many different "stands" of food. From pizza to Mexican to chicken, to soups, to bakery, to breakfast, to sandwiches.
SEATING	Food Life seating for 600 people. more seating can be found in and around the mall (Water Tower Place). Especially good for large groups.
AMBIENCE/CLIENTELE	Busy. Where anything goes, but you probably need a shirt and shorts or they won't seat you.
EXTRAS/NOTES	As you walk into Foodlife you are greeted and seated by a hostess. You are also given a Foodlife card-looks like a credit card. Your table is reserved for you. You go to each "eatery or whichever you chose and get your food, fast and fresh. There the cashier swipes your Foodlife "credit card" and after eating you turn in your credit card to the cashier and pay with cash or credit. Foodlife also has delivery and catering for customers within a five-mile radius, as well as a food market with pre-made sandwiches, some hot foods, and single servings of fruits and vegetables.

—*Danielle Deutsch*

THE LOOP

Argo Tea

(see page p. 27)
Teahouse
16 W. Randolph St., Chicago 60601
Phone (312) 553-1551

Intelligentsia

(see page p. 71)
Independent coffeehouse stout of heart and mind
53 W. Jackson Blvd., Chicago 60604
Phone (312) 253-0594

Jamba Juice
The Starbucks of the Health-Conscious set.
$$
166 N. State St., Chicago 60602
(at Randolph St.)
Phone (312) 641-1925 • Fax (312) 641-1928
www.jambajuice.com

CATEGORY	Trendy Juice bar
HOURS	Mon/Thurs: 6 AM–7 PM daily
	Fri/Sat: 6 AM–6 PM
GETTING THERE	Street parking is non-existent downtown, but the Red Line Lake Street is less than a block away
PAYMENT	VISA MasterCard AMERICAN EXPRESS
POPULAR DRINKS	"Strawberries Wild", made with strawberry juice, frozen yogurt, strawberries and bananas; the "Coldbuster"—orange juice, orange sherbet, peaches, bananas and enriched with vitamin C, The self explanatory "Chocolate and Peanut Butter Moo'd."
UNIQUE DRINKS	Low- fat/Low-Carb "Enlightened" Smoothies made with a base of Splenda sugar substitute. For those who are adventurous as well as health conscious, wheatgrass juice in 1 and 2 ounce shots.
FOOD	Whole grain muffins, soft pretzels and pizza bread sticks, and an assortment low-fat chips and cookies for $2 and under
SEATING	Not much in the way of seating at this downtown location—three stools facing the front. Each store in this popular chain is different and offers a variety of seating options.
AMBIENCE/CLIENTELE	Bright but bland, this colorful location is made with on-the-go students and work commuters in mind. Jamba Juice cookbooks and merchandise are for sale on the wall. Servers are usually prompt and very friendly and will ask to identify you by first name when your drink is ready.
EXTRAS/NOTES	Vitamin "boosts" can be added to most juices and s moothies for no extra charge. Nutritional information is readily available in all stores.
OTHERS	• Maxwell Street: 1322 South Halsted, Chicago 60607, (312) 738-3660
	• Union Station: 225 S. Canal (in the food court), Chicago 60602, (312) 382-9904
	• Citicorp: 500 W. Madison #C007, Chicago 60661, (312) 474-0350
	• West Jackson: 209 W. Jackson, Chicago 60606, (312) 255-0306
	• Madison and Wells: 190 W. Madison, Chicago 60602, (312) 357-1041
	• Many, many more. Just check the website.

—*Keidra Chaney*

"Never buy a drink for the road,
because the road is already laid out."

—*Flip Wilson*

Java Java

*Go Ahead – You're Already
Spending Money Today!*
$$

2 North State St., Chicago 60602
(at Madison St.)
Phone (312) 759-2233

CATEGORY	Java Java is a relatively upscale coffeehouse – it's more of a break-from-shopping spot that serves salads, sandwiches, and desserts to go with one's coffee order.
HOURS	Mon–Fri: 5:30 AM–8 PM Sat: 9 AM–7 PM Sun: 11 AM–5 PM
GETTING THERE	Parking is downright awful in the Loop, and this place is no exception. Cabs are the preferred mode of transportation, the subway is only a block away, or you can travel by foot as you go from shop to shop.
PAYMENT	VISA MasterCard AMERICAN EXPRESS DISCOVER
POPULAR DRINKS	Coffee, Iced coffee, tea, smoothies. No shocker, but fancier drinks are much more expensive.
UNIQUE DRINKS	There is nothing too unique here, other than it is the only restaurant connected to the downtown Sears department store.
FOOD	A salad containing ham, brie, tomatoes, lettuce and Dijon, along with a large iced coffee set me back almost ten bucks, and it wasn't quite as good as it sounded when I ordered it. This place is better for coffee and something sweet, but even a large chocolate chip cookie costs $2.75.
SEATING	Two loft-styled floors allow for lots of open seating. Upstairs, couches, tables and booths are sparsely set with a picture window displaying downtown office buildings across Madison Street. Floor level has the coffee bar and a small row of two-tops.
AMBIENCE/CLIENTELE	The feel here is pleasant and relaxing – newly tiled floors and well-kept décor go nicely with the mid-volume light jazz pumped through the large speakers. The clientele work or shop downtown, so they tend to be well dressed. Then again, Java Java is adjacent to Sears, not Saks 5th Avenue.
EXTRAS/NOTES	Java Java appears new, or at least newly remodeled. Its effort to create a relaxing environment succeeds admirably and the café provides perfect seclusion. Though its address is 2 N. State, the entrance is on Dearborn, through a tiny door to the right of Sears' large, automate doors.

—*Mark Vickery*

Poag Mahone's

*A bit of Irish mirth for
bankrupt traders*
$$

175 W. Jackson Blvd., Chicago, 60604
(at Wells St.)
Phone (312) 566-9100

CATEGORY	Irish pub
HOURS	Daily 10:30 AM–9 PM
GETTING THERE	Street Parking, meters
PAYMENT	VISA MasterCard AMERICAN EXPRESS DISCOVER

POPULAR DRINKS — Poag's is loaded with workweek specials. On Tuesdays, cans of blue-collar brews—think Schlilz and Old Milwaukee—will set you back a mere buck while on Thursdays, Seagram's drinks run $3.50.

UNIQUE DRINKS — Not unique so much as it is reassuring, Poag Mahone's serves up all the expected Irish brews— Guinness, Caffrey's, Smithwick's.

FOOD — The barbecue buffalo wings are as messy as they are exceptional— leave a big tip if she gives you wet naps.

SEATING — Loads of booths and stools are spread out over an interior large enough to facilitate eighty million leprechauns.

AMBIENCE/CLIENTELE — Office workers after work drain their sorrows alongside newly bankrupt traders from the nearby stock exchange. Neckties abound, though none are required and most are atrocious. The outdoor patio is not recommended at rush hour when it becomes a race lane for Carl Lewis wannabes anxious to pay their exorbitant CTA fees. However, exceptional people watching may be had at the tables that line the Jackson Street window.

EXTRAS/NOTES — Michiganians have the unique ability to point out their stomping grounds simply by using the palms of their hands. For everyone else, a tattoo is necessary in plotting geographical landmarks central to one's upbringing. Comely server Jessica brings a Gangs of New York flavor to Poag Mahone's. Her Italian heritage is represented by a tattoo of the boot on her inner arm, alongside the inscription, La Dolce Vita. With fingertip, she traces the length of the country, stopping in the south, at the village of her elders. Translated from the Gaelic, Poag Mahone means, "kiss my ass," but, regrettably, the wait staff never lives up to that threat. Poag Mahone's is located directly across from legendary 'cheezeborger' shack, the Billy Goat tavern, with easy access to the Library-Van Buren stop. A word on the restrooms: the men's room may be the only one of its kind in existence where the urinals are located at a distance further away from the entrance than the toilets. However, for that arduous journey to the urinals, one is rewarded at the sink, where soap dispensers expel a fluffy disinfectant that feels not unlike a generous wisp of heaven in your hands.

—*Josh Cox*

Snuggery

Gorgeous Nordic blonde assuages train delays with aplomb

$$

222 S. Riverside Plaza, Chicago 60606
(at Adams St.)
Phone (312) 441-9334
www.snuggerychicago.com

CATEGORY — Pub for Metra commuters, Amtrak travelers, and office workers

HOURS — Like the best nightclubs of Central Europe, the Snuggery is spread out over several levels. Well, only three, really, but, pay attention, each of them operate at different hours. They all open at the same time, 8:30 AM, but the mezzanine level is open from 8:30 AM

until 9:30 PM, daily, while the upstairs stays open unt[il] 10:30 PM. Of course, the only level worth visiting is th[e] downstairs nook, which closes earliest of all at 8:30 PM[.]

GETTING THERE	Plentiful parking meters line the perimeter of Union Station. There is also a lot operated by the station on Clinton and Jackson.
PAYMENT	VISA MasterCard AMERICAN EXPRESS DISCOVER
POPULAR DRINKS	Wait for Wednesday's five o'clock rush to subside, and then go downstairs between the hours of six and eight PM for a magnificent pitcher of Miller Lite; a miraculous feat of engineering, this pitcher is constructed so as to accommodate ice cubes.
UNIQUE DRINKS	If your taste buds palpitate for eighteen-dollar appletinis, best head elsewhere. The Snuggery is not that kind of place. Beer rules the roost here.
FOOD	The Snuggery offers a menu of moderately priced pub fare, but show up early. The kitchen closes at 7 PM.
SEATING	With tables that stretch the length of Soldier Field, the Snuggery could serve as the canteen for the entire population of Luxembourg—and that's just the downstairs level.
AMBIENCE/CLIENTELE	A typical baseball crowd, baseball caps and pony-tails—on the men.
EXTRAS/NOTES	Your train has not pulled in to station. Has it been delayed? Have the workers gone on strike? Either way, you need a drink. Searching for sustenance, you step outside onto the corner of Clinton and Jackson but a blizzard is blowing. Even if the weather was perfect, the sandwich boards nearby are advertising menus better suited for a member of the jet set. Four-dollar fruit bowls? In season? You could scarcely afford the train ticket, much less fly first class. So what's the plan? Everything you need is right back there in Union Station. Down the escalator, past the newsstand, when you hear the Chinese man in Kelly's Cajun Grill yell, "yummy, yummy!!" you're there. Right around the corner from Nuts on Clark is the Snuggery. Go downstairs, away from the hectic chaos of the scattered chairs and tables. Nestled on a stool, with Norman Rockwell memorabilia on the walls, the game on the screens and a beautiful barmaid behind the bar, suddenly, that delay doesn't seem so bad after all.

—*Josh Cox*

Wet
Simply one of the flyest spaces in the city.
$$$
209 W. Lake St. Chicago, 60606
(at Wells St.)
Phone (312) 223-9232 • Fax (312) 223-9233
www.wetchicago.com

CATEGORY	Slick club
HOURS	Mon–Fri: 10 PM–4 AM
	Sat: 10 PM–5 AM
	Sun: 10 PM–4 AM
GETTING THERE	Drive to Wet? Not a good idea. Parking is not possible and you will be too drunk to drive home anyway. Take a cab or, if you must, or the El.

PAYMENT	VISA MasterCard AMERICAN EXPRESS DISCOVER
POPULAR DRINKS	Champagne from Veuve to Cristal, martinis and exotic cocktails.
UNIQUE DRINKS	Trendy drinks abound, try something Caribbean if glassy aqua atmosphere is making you long for the beaches of some place warmer.
SEATING	Wet is the perfect size for a tasteful club experience. Trim, but with multi-levels, Wet is designed for smaller groups looking for VIP treatment. The space is set up like a fish bowl and a VIP balcony gazes down on the dance floor. Minimalist furniture, glass bar and tables make the club feel intimate and lavish. No bar stools, but you came to get your dance on anyway - right?
AMBIENCE/CLIENTELE	Silver, blue and water hues flood Wet and set a soothing mood for the eyes. Plasma screens radiate soothing ocean vibes to the entourages. The music matches the design some of the time, but the Djs know what it takes to make people party. The bar lights change colors helping set the mood as the night rolls along. But if lighting, music and atmosphere doesn't set the mood for you, scantly-clad dancers mingle with the crowd and shake their tail feathers on the bar. Occasionally go-go dancers groove to the beats in multi-colored glass booths to the side of the do rigs. Tanned bellies and biceps mingle with skin-tight skirts and faux-hawks on the pulsating dance floor. Wet is a full night of exuberance.

—Brent Kado

SOUTH LOOP

Buddy Guy's Legends
This place definitely won't leave you singing the blues
$
754 S. Wabash Ave., Chicago 60605
(at Lawrence Ave.)
Phone (312) 427-0333 • Fax (312) 427-1192
www.buddyguys.com

CATEGORY	Famous Chicago Blues Club, Live Music seven nights a week
HOURS	Mon–Fri: 11 AM–2 AM
	Sat: 5 PM–3 AM
	Sun: 6 PM–2 AM
GETTING THERE	Pay Lot and Metered Street Parking
PAYMENT	VISA MasterCard AMERICAN EXPRESS DISCOVER
POPULAR DRINKS	The most popular beverage here is…drum roll please…beer!
UNIQUE DRINKS	You won't find anything unusual or out of place here. It's all about the classics…good old-fashioned shots and beer.
FOOD	There are full lunch and dinner menus available, featuring a variety of down-home chow. Prices vary depending on what you order and how you order it. Starters include southern fried okra, blue crab cakes or Buddy's Bucket, which is a sampler of the appetizer menu. Also offered are numerous dishes

7

including monstrous salads, delectable gumbo, a plethora of sandwiches, a sea of seafood, and too many side dishes to mention. Whew! And don't forget to save room for dessert! The coffee is recommended with dessert. It's 100% organic, harvested in Mexico, and roasted in Wisconsin.

SEATING
A word of advice: get there early if you want to sit. It's a large room, but it fills up quickly.

AMBIENCE/CLIENTELE
If you don't know who Buddy Guy is or don't like blues music in general, please, do yourself a favor and do not come near this place. Blues memorabilia adorns the walls. The dimly lighted atmosphere puts you in the mood, even at lunchtime. The come as you are dress code is in full effect, though you might look a tad overdressed in a suit and tie. As far as the service, it's obvious that the staff still knows the true meaning of the term 'customer service.' They are helpful, cordial and down to earth. The live music adds a final touch to the whole experience.

EXTRAS/NOTES
Sorry young bucks, the minimum age to enter is 21. Shows start at 9:30 nightly, and admission is $10 during the week and $15 on the weekends. If you happen to be already inside prior to a show, admission money is collected beginning at 8:30. Souvenirs such as t-shirts, hats, CDs, and books are available for purchase. There are pool tables, but they are sometimes pushed aside during concerts to accommodate the crowd. Bonus: if you're lucky, you may catch a glimpse of an impromptu celebrity performance by artists such as Eric Clapton, Mick Jagger, Stevie Ray Vaughn, or, the legend himself, Buddy Guy.

—Nicole Galbreath

Tantrum

No Fuss Martini Bar Refuses to Have a Tantrum
$$$
1023 S. State Street, Chicago 60615
(at 11th St.)
Phone (312) 939-9160

CATEGORY
Tantrum is where the stylish but unfussy martini bar intersects with the neighborhood bar.

HOURS
Mon–Thurs: 5 PM–2 AM
Fri: 2:30 PM–2 AM
Sat: 5 PM–3 AM

GETTING THERE
Parking can be difficult on weekends. There are pay lots north of Tantrum along State Street. There is metered and street parking along this section of State Street, but if you choose to park south of Roosevelt Road listen to am radio to make sure that there are no special events happening at Soldier Field or you could find an orange welcome card—also known as a parking ticket—affixed to your windshield from Chicago's Finest.

PAYMENT

POPULAR DRINKS
This is a full service bar with endless limitations, but Tantrum has a wide variety of martinis. The Tantrum

	martini menu features three sections: Classic Martinis, Dessert Martinis, and House Specialties.
UNIQUE DRINKS	If you enjoy flavored martinis, there are several interesting combinations.
FOOD	Don't come hungry. As of press time, Tantrum is a "liquid only" establishment. Aside from the olive or other garnish you may receive with your drink, Tantrum does not serve solid libations.
SEATING	There is a main bar with stylish stools. There are intimate tables with chairs for two. There are also roomy and comfortable booths for larger groups or simply for more relaxed lounging.
AMBIENCE/CLIENTELE	Approaching Tantrum you will notice the effervescent bubbles that move across a screen above the front door. The Tantrum sign—with its iconic picture of a martini glass—makes it clear that you are entering a martini bar. The chic, modern decor (complete with amber-toned fabrics and velvet curtains) will confirm that you have entered a swank martini bar, but the kick back attitude of the bartenders and patrons will allow you to see that Tantrum is martini without the shi-shi exclusivity. Wearing anything along the spectrum from suits to shorts, people can come to Tantrum to drink and relax without having to posture and profile.
EXTRAS/NOTES	The regulars at the bar will let you know just how well these guys can mix a martini.

—*Nicole Allen*

GOLD COAST

Argo Tea
(see page p. 27)
Teahouse
819 N. Rush St., Chicago 60611
Phone (312) 951-5302

Leg Room
Mmm.....chocolate martinis.
$$$$
7 W. Division St., Chicago 60610
(at State St.)
(312) 337-2583
www.legroomchicago.com

CATEGORY	Swank lounge and, as the evening progresses, crowded nightclub.
HOURS	Daily: 7 PM–4 AM
GETTING THERE	Parking is a nightmare—take a cab or the Red Line (2 blocks away at Clark and Division). Valet parking Friday and Saturday.
PAYMENT	VISA
POPULAR DRINKS	Chocolate Bliss (Godiva liqueur and vodka)
UNIQUE DRINKS	Toro (Roaring Lion-an energy drink-and Finlandia),

9

	Carmel Apple martini (not on the menu)
FOOD	A partial menu with appetizers and a few sandwiches. Prices average between $5 and $6. You're not really going to go there to eat, are you?
SEATING	About 8 tables line the outer walls and 30 barstools surround the island bar. Two VIP areas take up space in the far back corners, while in the front by the only window, plush couches and deep armchairs imitate a library, books and working fireplace included.
AMBIENCE/CLIENTELE	Trendy after college crowd with a smattering of tourists.
EXTRAS/NOTES	Try the Cosmo. Expect to see a famous face or two, but also expect to wait in line.

—Sarah B. Brown

Melvin B's

The patio will fill, even when there's a chill
$$$$
1114 N. State St., Chicago 60610
(at Division St.)
Phone (312) 751-9897

CATEGORY	Outdoor café and bar
HOURS	Sun–Fri: 11 AM–2 AM
	Sat: 11 AM–3 AM
GETTING THERE	Street parking on State can be a nightmare, go valet or the nearest pay lot.
PAYMENT	VISA AMERICAN EXPRESS
POPULAR DRINKS	A lot of people that rollerblade up to the café drink beer to quench their thirst, but they also make great Long Islands and fruity drinks.
UNIQUE DRINKS	Over the summer, they have two machines that make different flavored daiquiris that are perfect on those hot summer nights.
FOOD	There is a full menu, with specialties ranging from ribs to turtle soup.
SEATING	The patio fits up to 150 people with many tables and bar stools to squeeze your friends in.
AMBIENCE/CLIENTELE	The best thing about Melvin B's is it's laid back style for a Gold Coast bar. You may see beautiful people in black pants sipping their cocktails on the patio, but at the same time there will be people in shorts who skate right up to the patio to cool off. It's definitely a hot spot to people watch and chill on a hot summer night. Even when the leaves begin to fall, the patio is always packed until the snow overtakes the tables.
EXTRAS/NOTES	Melvin B's is a great outdoor spot when you want to chill with friends and meet new people. The picture booth inside lets you take home a few memories from your night and is a great way to meet people (sorry, didn't mean to push you in there with my friend).

—Mindy Golub

"Be wary of strong drink. It can make you
shoot at tax collectors... and miss."

—Robert Heinlein

PJ Clarke's Bar & Grill

"Stuck in a Tourist's Nightmare? You're in Luck!"

$

1204 N. State St., Chicago 60610
(at Division St.)
Phone (312) 664-1650 • Fax (312) 664-9329
www.pjclarkeschicago.com

CATEGORY	Bar and Grill
HOURS	Bar:
	Mon–Fri: 11:30 AM–2 AM
	Sat: 11:30 AM–3 AM
	Sunday: 10 AM–2 AM
	Kitchen Hours:
	Mon–Thurs: 1:30 AM–11 PM
	Fri: 1:30 AM–midnight
	Sun: 10 AM–10 PM
GETTING THERE	In this neighborhood, street parking is only slightly better than the traffic—awful. During the day it is much calmer. Cabs run regularly through here, and the Red Line subway is only 1.5 blocks away.
PAYMENT	VISA MasterCard AMERICAN EXPRESS Discover
POPULAR DRINKS	Excellent selection of beers on tap, bourbons and Irish whiskey. But beer rules here.
UNIQUE DRINKS	The most unique thing about this place is how civilized the atmosphere is. Located just around the corner from one of the rowdiest stretches in the entire city, PJ Clarke's might be just the rescue you need.
FOOD	Very high quality bar food at very reasonable prices. Instead of fries, many sandwiches come with a tasty—but a tad oily—pasta salad.
DRINKS	No fancy yuppie martinis or anything, but specific beer specials lower the already fair prices.
SEATING	There are about ten tables on the balcony upstairs—mostly two- and four-tops (though they can be pushed together), two dozen tables below, plus another 20 barstools.
AMBIENCE/CLIENTELE	PJ Clarke's is nicely worn-in; aside from a few cracked tiles on the floor, it has aged rather gracefully. It contains lots of nuance and charm often missing from newer establishments. A sign in front says: "Please, No Tank Tops, Dogs or Roller Blades." Beyond this, apparently, anything goes. The clientele is definitely older than it is at Butch McGuire's or Mother's, but in this neighborhood that could mean anyone a year over legal drinking age!
EXTRAS/NOTES	After 19 well-trafficked years in the Rush Street area, PJ Clarke's has since opened another location on Navy Pier three years ago, and is about to open its third location in Lincoln Park. For either of those two to match the charm of the original, however, would take an impressive effort.
OTHER ONES	• Streeterville: 302 East Illinois St., Chicago 60611 (312) 670-7500

—Mark Vickery

RIVER NORTH

Funky Buddha Lounge

Uber cool, FBL is considered the best dance club in Chicago.

$$$

728 W. Grand Ave., 60610
(at Halsted St.)
Phone (312) 666-1695 • Fax (312) 666-1985
www.funkybuddha.com

CATEGORY	Dance Club, lounge
HOURS	Mon–Fri: 9 PM–2 AM
	Sat: 9 PM–3 AM
	Sun: 9 PM–3 AM
GETTING THERE	Take a cab or catch the El, parking is nearly impossible.
PAYMENT	[VISA] [MasterCard] [American Express] [Discover]
POPULAR DRINKS	Stoli-mixed drinks, the occasional Veuve Cliquot bottle of champagne.
UNIQUE DRINKS	What's unique here is the breath of fresh air that Funky Buddha blows into an otherwise unexciting area.
SEATING	Colorful, exotic printed sofas dot the VIP sections and main front corridor couches, with side lounge chairs towards the dance floor as well. A private booth is also located towards the front of the club. Most people are here to dance, but the seats offer a nice comfortable place to rest your worn-out dogs from the dance floor.
AMBIENCE/CLIENTELE	The Funky Buddha Lounge is definitely one of Chicago's premier dance clubs. A crowd of serious clubbers flocks here to have a good time and dance to the Latin, hip-hop, house, and electronic fused music that pounds out on the dance floor. At around midnight, a sea of scantily clad girls in colorful and stylish tank tops and tight black pants dance and jive away to guys dressed in black DKNY dress shirts and pants. At any given time, the ambience of the place is that of one of Chicago's last true dance clubs where people go to dance and have a good time—and not just to ogle at the beautiful women that places like Buddha always attracts. Going on "Freestyl Fridays," (hip-hop night), is a treat as the DJs spin hip hop classics and live free style rap. The nice Eastern themed decoration is pleasing to the eyes, and you feel like Buddha is looking down, giving a big smile knowing that his people below are down there, having a great time, release positive karma.
EXTRAS/NOTES	Be sure to dress like you would for a night on the town. It is not uncommon to see suited men and women in nice dresses dining there.

—*Sy Nguyen*

"Wine is sunlight, held together by water."

—*Galileo*

Howl At The Moon

Where it's okay to sing with your mouth full!

$$$

26 W. Hubbard St., Chicago 60610

(at Dearborn St.)

Phone (312) 863-7427

www.howlatthemoon.com

CATEGORY	Piano bar
HOURS	Mon–Thurs: 5 PM–2 AM
	Fri: 4 PM–2 AM
	Sat: 5 PM–3 AM
	Sun: 7 PM–2 AM
GETTING THERE	Street parking for the extremely lucky (not recommended); $9 valet for the rest.
PAYMENT	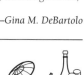
POPULAR DRINKS	Howlin' Hurricanes, Jell-O Injectors (a giant syringe filled with vodka-Jell-O), seven-ounce pony beers and fruit-infused Cosmos- a Howl specialty.
UNIQUE DRINKS	The Bucket of Booze. Your favorite mixed drink, served biggie-stylie in an 86-ounce bucket.
FOOD	Extensive menu with reasonable prices for downtown. The BBQ ribs are a house favorite. Friday evenings feature a free buffet-style "pig roast" after 4 PM, with pulled pork, chicken strips, corn on the cob, fries and a heavenly artichoke dip.
SEATING	Many, many tables situated near the twin baby grand pianos. Additional seating at and near the bar.
ABBIENCE/CLIENTELE	Raucous. The place fills up quickly with the after-work crowd, when the dueling piano players take the stage. Patrons are encouraged to sing along to familiar favorites (think Billy, Elton and Neil) while the piano players swap jokes and take requests.
EXTRAS/NOTES	A healthy dose of kitsch characterizes this offbeat River North bar, which claims to have the "World's Greatest Rock 'N Roll Dueling Piano Show." With a lively and professional bar staff, unique alcoholic concoctions and a highly interactive show, Howl offers a night of singing, dancing and rowdy good fun for everyone. $10 cover.
OTHERS	• 11 locations around the country, including Florida, California, Louisiana and more.

—Gina M. DeBartolo

Japonais

A perfect melding of scene and cuisine.

$$$$

600 W. Chicago Ave., Chicago 60610

(at Larabee St.)

Phone (312) 822-9600 • Fax (312) 822-9623

www.japonaischicago.com

CATEGORY	Beautiful people/trendy scene
HOURS	Mon–Wed: 5 PM–1 AM
	Thurs/Fri: 5 PM–2 AM
	Sat: 5 PM–3 AM
	Sun: 5 PM–midnight
GETTING THERE	Parking is easy if willing to pay. Pay parking lot across street (on Larabee) and valet. Also, some street parking, but pretty difficult to find.
PAYMENT	

13

POPULAR DRINKS	Asian pear martini and an excellent sake list
UNIQUE DRINKS	Floating orchid martini made with Cointreau, pear, lemon and vodka with a floating orchid garnish.
FOOD	The bar offers limited selections from the upstairs restaurant. The tuna salmon roll is heavenly as is the triple unagi roll. Not a sushi fan? Try the kobe beef carpaccio. To satisfy a sweet tooth, have the "dough-nuts and coffee" (green tea semi-freddo with chestnut filled beignets). Pricey.
SEATING	There is a lot of seating, but only a few places for large groups. If in a large group, get there early.
AMBIENCE/CLIENTELE	Miae Lim has succeeded in creating a scene for all seasons for fashionistas and foodies alike. Play the seducer/seductress in the shadows of the sultry, Matrix-like lounge in the winter, and come summer, be transported to Bali as you lounge in the fabric-ensconced rattan love seats while sipping sake infused peach sangria. Need some air after the treatment of the too chic to speak servers…walk onto the patio over-looking the Chicago River and you'll remember why you are staying. If that doesn't work, numb the pain with a few shots of sake from the substantial list. If you aren't into posers, plastic or pretension, this may not be the place for you.
EXTRAS/NOTES	Great place for celebrity sightings.

—*Catherine De Orio*

The Kerryman

This isn't your father's Irish pub.
$$$
661 N. Clark Street, Chicago 60610
(at Erie St.)
Phone (312) 335-8121 • Fax (312) 335-8151
www.thekerryman.com

CATEGORY	Up-scale Irish pub
HOURS	Sun–Fri: 11 AM–2 AM Sat: 11 AM–3 AM
GETTING THERE	Street parking difficult. Some pay lots nearby.
PAYMENT	VISA MasterCard AMERICAN EXPRESS DISCOVER
POPULAR DRINKS	Beer and whiskey
UNIQUE DRINKS	It's a pub—beer and whiskey
FOOD	There is a full menu running the gamut from mac and cheese to filet. The food is well-priced and the portions are generous.
SEATING	Tons of seating spread out over three levels. Down-stairs is the bar plus booths, second floor with another bar and a mix of tables and high boys. Third level has some couches, larger tables and cozy nooks. Weather permitting, there is an outside seating area also.
AMBIENCE/CLIENTELE	The Kerryman reflects the modern sensibility of our generation's Ireland. Gone are the pictures of Yeats and Keats and what's left is beer and a brogued bartender in a contemporary setting. Despite the standard mahogany and glass bar, (actually bars as there is another full one on the second floor), they managed to create an airy, open feel, which makes it a great destination in both the winter and summer. The lofted second and third floor allow the voyeurs

in the group to get a bird's eye view of the front door and any birds hanging at the bar. The drinks are no nonsense with about a dozen beers on tap and of course any whiskeys or other spirits you may desire. The grub is part of the new trend of upscale pub food: think chipotle turkey burger with curried chips or macaroni and cheese made with three varieties of Irish cheese.

—*Catherine De Orio*

Nacional 27

Diversity rules in one of Chicago's finest all-around establishments.

$$$

325 W. Huron St., Chicago 60610
(at Orleans St.)
Phone (312) 664-2727

CATEGORY	Restaurant, dance club
HOURS	Mon–Thurs: 5:30 PM–2 AM
	Fri/Sat: 4:30 PM–2 AM
	Sunday: 4:30 PM–10 PM
GETTING THERE	Take a cab or catch the El.
PAYMENT	VISA MasterCard AMERICAN EXPRESS DISCOVER
POPULAR DRINKS	A lot of Vodka-tonics, martinis, were seen around the place.
FOOD	The Latin food (ranging from $8-$15) at Nacional 27 is diverse, colorful, and definitely something to keep you coming back to try other menu items. Cuban, Brazilian, basically the whole gamut of Latin flavor is expressed in the fare. The menu is both urbane in the number of choices as well as the type of food you can get. From the boniato (a sweet potato) to a red snapper, the menu is sure to have something for even the most indecisive or finicky of eaters.
SEATING	The spacious main dining room makes way for a dance floor after 11 PM on the weekends, but for couples, there are curtained cushy booths towards the front of the place for intimate dining. The huge bar allows for easy access to buy drinks from the tenders as well as accommodate those who just want to chill out with a friend or two and have a place to sit or lean.
AMBIENCE/CLIENTELE	Very rarely in Chicago can you find a place that is more diverse in its crowd. Well dressed people of many different cultures, ages, and backgrounds fill up the dining area and then the dance floor, dancing away to electronic-fused Latin beats. Everything about this place exudes diversity. From the menu, the list of drinks, to the stylishly colorful decorations, and of course the people, Nacional 27 successfully brings pretty crowds together in a place where an experience of dining, dancing, flirting, and conversing can be all achieved under one roof.
EXTRAS/NOTES	When you come, dress like you would for a night on the town. It is not uncommon to see suited men and women in nice dresses dining there.

—*Sy Nguyen*

RIP
Sugar: A Dessert Bar

Sugar was, above all else, one of a kind. Though we live in a city filled with bars and restaurants (and, oh, do we know them) not one combined handcrafted desserts with a slick lounge atmosphere the way Sugar did.

Her wit and charm were unparalleled. Who else could think to call their crepe with chocolate pave, pine nut brittle, maple ice cream, and sautéed banana "Tarzan of the Crepes"? Who else would call her sweetest drink "The Wonka" or saucily call her sour martini the "Sexy Motherpucker"?

I'll remember her as an oenophile who could always tell us what would best compliment her handcrafted desserts. She knew her sweet ports from her full-bodied cabs and would happily share her wealth of knowledge. And should you want something with a little more kick, she would happily guide you through along the rocky (or neat!) way. But she also understood those of us unfortunately designated souls who could not drink. Her hot chocolate with hand-made marshmallows warmed our hearts and souls like a first kiss.

Sugar never lied to us. No, our sweet mistress let us know from the moment we walked passed the dental x-rays that decorated her entryway the dangers of knowing her and though neither my dentist would approve I can tell you that knowing her was worth every filling.

Perhaps what I'll remember most about Sugar is the way she could dance. From hip hop to jazz to house, she could jitterbug off the sugar high like none other. One minute you'd find her twisting with some buttoned down after-work types, the next you'd see her dance grinding with a group on a double date. In her words, this world was to short not to "keep shakin' that glass."

Alas, Sugar has spoiled her last tooth. We'll never get another post-drinking candy bar without thinking of you. Farewell, my lovely friend.

—Louis Pine

Vision
Mega-Spot Perfect for Casual Clubbing
$$
640 N. Dearborn St., Chicago 60610
(at Ontario St.)
Phone (312) 266-1944
www.visionnightclub.com

CATEGORY	Megaclub
HOURS	Wed–Fri: 10 PM–4 AM
	Sat: 10 PM–4 AM
GETTING THERE	Parking is a major hassle—it is downtown after all. A few over-priced lots nearby fill up pretty early, so if you're a late-starter, consider taking the El or Cab it.
PAYMENT	

POPULAR DRINKS	Order up any kind of cocktail and you're in!
UNIQUE DRINKS	How about a little champagne?
DRINKS	Beer, wine, cocktails, champagne
SEATING	Almost always room to sit down and watch the action. Four distinct rooms make for lots of space to explore in this old church. Vision entertains large hordes of beat worshipping, party hungry folks every night, but away from the dance floor a casual corner can usually be found to refuel or whisper into someone's ear.
AMBIENCE/CLIENTELE	With a club this size, this many levels and four different rooms, a diverse set of moods can be had throughout the course of the night. Multiple levels, eccentric paraphernalia and top-notch lighting set the mood for this enormous spot. Music is paramount to the experience at Vision, international DJs often swing through, but the nightly talent is among the best in Chicago. Each night over 400 people mingle techno and hip-hop sounds and with this many bodies, rowdiness is never far away.
EXTRAS/NOTES	Some of the city's more popular clubbing events mixed with other off-the-wall nights and high quality spinners, Vision works hard to please all its patrons. Often voted among the top clubs nationally by indus-try mags, each night has slightly different themes, so do a little research before you go.

—Brent Kado

RIVER WEST/WEST LOOP/WEST TOWN

Blyss

Chill neighborhood bar during the week, hangout for the "twenty-thirty-something" set on weekends.
$$
1061 W. Madison St., Chicago 60607
(at Aberdeen St.)
Phone (312) 433-0013

CATEGORY	Neighborhood lounge
HOURS	Mon–Fri: 5 PM–2 AM
	Sat: 5 PM–3 AM
GETTING THERE	Street parking
PAYMENT	VISA MasterCard AMERICAN EXPRESS DISCOVER
POPULAR DRINKS	Extensive martini list and numerous beers on tap.
FOOD	Pricey menu, but people come here for the drinks.
SEATING	Fairly large with couches, high-tops and booths. Large enough for groups yet okay for a date on a weekday.
AMBIENCE/CLIENTELE	On weekdays, this is laid-back neighborhood joint. So if you're looking to throw on some jeans and throw back a few brews, stop by Sunday-Thursday. Weekends attract 20 and 30 something trucker hat wearing hipsters on the weekends looking for fresh meat. FYI: the male to female ration is 6-to1.
EXTRAS/NOTES	Blyss also caters to the United Center crowd, people going to concerts, Bulls games and Hawks games. Offers free shuttle to and from United Center.

—Spiro A. Polomarkakis

Fulton Lounge
Perfectly designed for the chic-seeking set
$$$
955 W. Fulton Ave. Chicago 60607
Phone (312) 942-9500
www.fultonlounge.com

CATEGORY	Depending on one's mood or the night, Fulton Lounge can be anything from Meat Market to Swank Lounge. The lounge can be utilized as a spot for after-dinner drinks, pre-club warm-ups or late night chill out.
HOURS	Mon–Fri: 5 PM–2 AM Sat: 5 PM–3 AM
GETTING THERE	Fairly easy during the week and somewhat challenging on weekends. You won't find an El stop nearby, but cab service is plentiful.
PAYMENT	VISA MasterCard AMERICAN EXPRESS DISCOVER
POPULAR DRINKS	Seasonal martini's and wine—whites, reds, port and sweet, take your pick!
UNIQUE DRINKS	A great place to go for that never-before had martini. Seasonal specials with names like: "Crème Brulee," "Key-Lime Pie" and "Frosted Raspberry Cosmo" are just a few tasty concoctions available here.
FOOD	If pizza were a delicacy, Fulton Lounge would head the list of top spots for delectable nibble. Try the Pizza Rustica, that's White Pizza with mozzarella, emmenthal and onions.
SEATING	The bar is divided into two sections. A long bar with sleek stools, flanked by mod furniture makes up one half. The other has a chic living room vibe. There's a fireplace, magazine rack and swank furniture—just like most of the lofts in the neighborhood. One of the best reasons to make an appearance at Fulton Lounge is for the bathrooms. Yep, that's right, the commodes. Well-decorated and designed individual stalls make Fulton Lounge a top spot in the restroom scene. No lines for the facilities here - a lobby with an Italian-inspired feel leaves plenty of room to sit and mingle while you wait for your private booth to open up.
AMBIENCE/CLIENTELE	If you want to feel like a mod Sinatra, this is the spot. The music is ambient and jazzy, the crowd is uppity but not snobby. As their website says Fulton Lounge is a "delightful combination of high-end lounge and neighborhood hang." Grab a seasonal martini and strike up a casual conversation in an elegant, easy going spot.
EXTRAS/NOTES	Get here early on weekends for a good seat. Fulton Lounge has some of the best lounge music in the city and the staff is very easy on the eyes. The owner runs a modeling agency, so expect to find a bevy of beauties buzzing from table to table taking orders and requests. *—Brent Kado*

"One martini is all right.
Two are too many, and three are not enough."
—James Thurber

Phil & Lou's

THE West Loop neighborhood bar
and restaurant.
$$
1124 W. Madison St., Chicago 60607
(at May St.)
Phone (312) 455-0070
www.philandlous.com

CATEGORY	Neighborhood bar and restaurant
HOURS	Mon–Thurs: 4 PM–midnight
	Fri/Sat: 4 PM–2 AM
GETTING THERE	Street parking is getting hard (especially nights of events at the United Center—Bulls, Hawks, Concerts) Valet on the weekend.
PAYMENT	VISA MasterCard AMERICAN EXPRESS DISCOVER
POPULAR DRINKS	Tons of great beers on tap.
UNIQUE DRINKS	Phil and Lou's has an extensive martini list
FOOD	Full menu heavy on comfort food. Roasted chicken, meatloaf, steaks. Moderately priced.
SEATING	About 200 capacity inside with room for about 100 more outside. Huge, long bar with barstools and both hi-tops and booths.
AMBIENCE/CLIENTELE	"Come one, come all" seems to be the motto at this casual West Loop staple. Businessmen in suits rub shoulders with twenty-somethings in flip-flops. Many a solo drinker can be found drinking a cold one at the bar and nibbling on an appetizer
EXTRAS/NOTES	With live jazz Thursday through Saturday, this is a great place to come alone or with a group. Phil and Lou's does have the best Philly cheese steak in Chicago and numerous beers on tap to wash it down.

—*Spiro A. Polomarkakis*

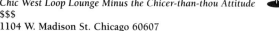

Plush

Chic West Loop Lounge Minus the Chicer-than-thou Attitude
$$$
1104 W. Madison St. Chicago 60607
(at N. Aberdeen St.)
Phone (312) 491-9800
www.plushschicago.com

CATEGORY	Plush is a swank lounge but not the type of place that might scare off those who shop Dots over Diesel. Think of Plush as a sexy cousin that made it big on a reality TV show but still treats you like one of the family.
HOURS	Mon–Fri: 5 PM–2 AM
	Sat: 6 PM–3 AM
GETTING THERE	Fairly easy during the week and somewhat challenging on weekends. You won't find an El stop nearby, but Cab service is plentiful.
PAYMENT	VISA MasterCard AMERICAN EXPRESS DISCOVER
POPULAR DRINKS	Plush is the place for martinis.
UNIQUE DRINKS	Try the "Mango-Tini," the "Vegas Pink Tini" created by by Johnny Vegas or the "Caramel Apple Tini."
DRINKS	Beer, Wine, Cocktails and a phenomenal Martini list.
FOOD	Not too many lounges can boast the quality of food that Plush drops on the table. For starters the crab cakes are just flat out delicious. Many Plush patrons rave about the Apple Ravioli and other menu items

that aim to please the savvy diner include: a succulent salmon dish and a tangy Chiplote Chicken sandwich. And the kitchen is open late. Plush's daily specials will keep your bank account stout and give you plenty of reasons for return visits. Wednesday is half price Martini and appetizers night. Tuesday get half off wine and on Fridays get your fill on $5 Effen Vodka and cheap pizza.

SEATING Small bar area, but don't worry. Plush is all about cozy couches and relaxing ottomans. Think opulent Turkish Palace meets Chicago innovation. Not terribly large, but roomy, you know—Plush.

AMBIENCE/CLIENTELE Plush is without question, well...Plush, but in an unassuming sort of way. While the waitresses seem to border on perfection and the atmosphere of the place is chill-out, Plush makes everyone feel like one of the in-crowd. The opulent Mediterranean decor, dotted with eclectic art makes for a visual spectacle. An immense projection screen provides a slideshow of famous artwork and digital psychedelics, a fitting complement to the Renaissance-era sculptures and avant-garde art peppered throughout the two-room space. The music is very mod and loungey, making Plush a perfect joint to drop by for dinner and warm-up before hitting other West Loop swank spots. Plush also caters to a sports crowd and offers discounts with game day tickets.

EXTRAS/NOTES This is not really a dancing kind of place during the week, but as the night wears on and the cocktails set in, the mellow trance music inspires some to shake their hips and bob their heads. During the week solid DJ's spin to the vogue clique. The reputation of Plush's bartenders is getting around. Known for their moves that would make "Cocktail's" Brian Flanagan jealous, if you catch the cast of drink slingers on the right night, you are in for a real treat.

—Brent Kado

Rhythm
One-of-a-kind spot where you can learn to drum the night away
$$$
1108 W. Randolph St., Chicago 60607
(at Aberdeen St.)
Phone (312) 492-6100
www.drumallnight.com

CATEGORY	Like no other place. A Drum bar
HOURS	Fri–Sat: 9 PM–2 AM
GETTING THERE	Easy street parking
PAYMENT	VISA MasterCard AMERICAN EXPRESS DISCOVER
POPULAR DRINKS	Great beer selection
UNIQUE DRINKS	Any drink's unique when you're beating a bongo.
FOOD	No food, but outside food is welcome
SEATING	Stadium seating for the drum circle and stools and a few high-tops
AMBIENCE/CLIENTELE	Very casual, hip setting with a unique twist on what a bar is supposed to be. Stadium seating provides the setting for an interactive drum lesson followed by

an instructional drum circle. Very laid-back crowd consisting of new and old school hippies, but also professional drummers and wannabe drummers and adventurous.

EXTRAS/NOTES Drum circle lessons start at 9 PM and continues on to a drum circle led by a professional drummer. The cost is $8 cover and rhythm will supply with a hand drum or you can bring your own. There is also a private room in the back that can be rented for $100 and is perfect for a medium size party.

—*Spiro A. Polomarkakis*

Sip Coffee House

West Loop neighborhood bar and restaurant.
$$
1223 W. Grand Ave., Chicago 60622
(at Racine Ave.)
Phone (312) 563-1123

CATEGORY	Independent Coffeehouse
HOURS	Mon–Fri: 7 AM–7 PM
	Sat: 9 AM–7 PM
	Sun: 9 AM–5 PM
GETTING THERE	Street parking isn't too bad.
PAYMENT	
POPULAR DRINKS	Iced Dreamy Mocha
FOOD	Bakery goods and sandwiches. Not pricey at all.
SEATING	Small and very cozy with room for about 15 inside and 10 in the backyard patio.
AMBIENCE/CLIENTELE	Neighborhood independent coffee joint attracts locals and passer-bys to a quaint setting where the coffee is always brewing. No pretentious attitudes here; come in your shorts or come in your suit.
EXTRAS/NOTES	The backyard patio is a phenomenal place to sip on a latte and relax and maybe even channel your inner-creative spirit. Write that book or paint that picture. The setting is very tranquil.

—*Spiro A. Polomarkakis*

Sonotheque

Hip lounge/club without the pretentious additions.
$$$
1444 W. Chicago Ave., Chicago 60622
(at Bishop St.)
Phone (312) 226-7600
www.sonetheque.net

CATEGORY	Lounge/Club
HOURS	Sun–Fri: 7 PM–2 AM
	Sat: 7 PM–3 AM
GETTING THERE	Street parking is somewhat difficult, but they also have valet for $9.
PAYMENT	
POPULAR DRINKS	Many drinks on hand, but you can even resort to a Pabst Blue Ribbon in this lounge/club

SEATING	Not big enough to be a club really, but a little bigger than an intimate lounge. Long Bar, couches. Spacious, but cozy.
AMBIENCE/CLIENTELE	As mentioned earlier, Sonotheque is not quite a club, not quite a lounge. It really is beyond categorizing. It has a real underground vibe with some of the best electronic music in the city, not to mention one of the best sound systems. The people that go to Sonotheque seem to want to be there. Good combination of industry types and good old fashion partiers. Excellent place to drink and be cool.
EXTRAS/NOTES	Sonotheque manages to bring in some very heavy-hitters in the electronic music scene for such a small venue so don't be surprised to see the likes of Thievery Corporation on the wheels of steel.

—Spiro A. Polomarkakis

The Tasting Room
Romantic getaway for those in the know
$$$$
1415 W. Randolph St., Chicago 60608
(Ogden Ave.)
Phone (312) 942-1212 • Fax (312) 942.1268
www.tlcwine.com

CATEGORY	Wine bar
HOURS	Mon–Thurs: 4 PM–1 AM
	Fri/Sat: 4 PM–2 AM
GETTING THERE	Free parking lot in park and street parking
PAYMENT	VISA MasterCard AMERICAN EXPRESS DISCOVER
POPULAR DRINKS	Over 100 wines by the glass and 300 more on the reserve bottle list, what do you think?
UNIQUE	The wine flights are a great option: a few red and white wine choices, as well as a champagne flight and dessert wine flight.
FOOD	The menu consists of appropriate accompaniments to the libations: cheese flights, charcuterie trays, fondue and country specific snacking plates. The average entrée is $8-$15.
SEATING	There are two levels filled with seating options. The large wooden bar on the first floor has plenty of stools at which to park yourself. Both the upstairs and downstairs have numerous two/four tops and sofa/chair seating areas.
AMBIENCE/CLIENTELE	Billie Holiday's sweet voice greets you as you enter this wine bar tucked away in a developing corner of the city. The warm, cinnamon stained floors and earthy brick walls in the lofted space put you immediately at ease and once you sit back in one of the over-stuffed arm chairs, you feel as if you are in the home of your best friend--who happens to have one of the most incredible wine cellars in the city. All around, girl-friends can be found dissecting the last conversation they had with their boyfriend—a study as complex as oenology, itself—while twosomes become intoxicated by both their date and the wine. This is a place to meet your date, not a date. However, there is no need to feel intimidated—go alone, sit at the large wooden bar and you'll walk out more cultured than when you arrived

and with your ego still intact—thanks to the friendly and knowledgeable staff. Feeling 'flight-y', the menu offers a variety of wine, cheese and appetizer tastings themed by country or style. Thank goodness for the upstairs area as this place fills up late night, but even with the extra seating, get there a bit early.

EXTRAS/NOTES The wine bar is connected to the Randolph Wine Cellar, a purveyor of wine and spirits. The store holds weekly wine tastings on Saturdays from noon to 6 PM so that you can taste a few wines while the knowledgeable staff helps you choose your spirited companion for a dinner party that evening—sweet, tart or with just a hint of spice. Additionally, The Tasting Room holds a wine tasting from 6 PM–8 PM on the third Tuesday of every month.

—*Catherine De Orio*

West Gate Coffee
The booze is here, just BYOF
Neighborhood independent coffee shop with a very comforting vibe
$$
924 W. Madison Ave., Chicago 60607
(at Bishop St.)
Phone (312) 829-9378

CATEGORY	Independent Coffeehouse
HOURS	Mon–Fri: 6:30 AM–10 PM
	Sat: 7 AM–9 PM
	Sun: 7 AM–7 PM
GETTING THERE	Street parking not too bad.
PAYMENT	VISA MasterCard AMERICAN EXPRESS DISCOVER
POPULAR DRINKS	Cappuccino
FOOD	Sandwiches, fruits, soups and Homer's Ice Cream
SEATING	Warm and cozy with a long table in the back for groups of 6-8 and scattered tables inside. Room for about 25-30 inside and fifteen outside.
AMBIENCE/CLIENTELE	Neighborhood independent coffee house that is no frills and provides great service. There is an excellent selection of board games, not to mention scores of magazines, so people are encouraged to stick around. There are also games for kids so West Gate does cater to parents in the area. Also comfortable leather couches really make it hard to leave.
EXTRAS/NOTES	Board games and tons of reading material. There also is wi-fi Internet connection for all the surfers out there.

—*Spiro A. Polomarkakis*

"I never should have switched from Scotch to Martinis."

—*Humphrey Bogart's last words*

STREETERVILLE

Jake Melnick's Corner Tap

Where the guys go for massive doses of beer, burgers and sports while the girls shop til' they drop.

$$

41 East Superior St., Chicago 60611
(at Rush St.)
Phone (312) 266-0400

CATEGORY	With its very long wooden bar and multiple upon multiple TVs, there's no doubt that this is DEFINITELY a sports bar. This is a GREAT and much needed addition to the area, considering that it is just a minute's walk away from all of the upscale shops on Michigan Avenue.
HOURS	Mon–Weds: 11:30 AM–midnight ThursvSat: 11:30 AM–2 AM Sun: 11 AM–11 PM
GETTING THERE	Valet for $9 and there is also a garage next door. Street parking is nearly impossible since you're not that far from Michigan Avenue. Don't want to drive? Take the Red line to Chicago Avenue or hail a taxi—there are plenty to go around.
PAYMENT	
POPULAR DRINKS	They are a full-service bar. Even though you will see a patron occasionally taking advantage of the weekly martini specials, you will mostly see majority consumption of BEER, BEER, and BEER - more than 15 beers on tap and 30 bottled.
UNIQUE DRINKS	They do serve martinis and at a sports bar that IS very unique.
FOOD	Burgers are pretty popular here. Splitting appetizers (nachos, popcorn shrimp) during "the game" is also a popular choice as well as the BBQ ribs.
SEATING	This massive sports bar features two main rooms both of which contain several nooks and crannies with an occasional booth or two., but mostly raised tables with bar stools. Room for 200+ inside and around 40 outside.
AMBIENCE/CLIENTELE	This place beams energy. With so many TVs and a satellite dish, Jake's will always have at least a game or two on. Therefore, even during "off" days when the Cubs, Sox, Bears, Hawks or Bulls aren't playing, the most avid sports junkie can most likely find something here to whet his appetite.
EXTRAS/NOTES	It used to be the Blackhawk Lodge until just several years ago. With Holy Name Cathedral right across the street, one can go and pray for their favorite team during halftime!

—*Marcy Wrzesinski*

PJ Clarke's
Bar and Grill
(see page p. 11)
302 East Illinois St., Chicago 60611
Phone (312) 670-7500

NORTH SIDE

LINCOLN PARK

aliveOne
Holy crap—Dave Matthews live!
$$
2683 N. Halsted Pkwy., Chicago 60614
(at Diversey St.)
Phone (773) 348-9800 • Fax (773) 348-9923
www.aliveone.com

CATEGORY	A very touristy, trendy spot—in the Phish Head/Dave Matthews Groupie sort of way.
HOURS	Sun–Fri: 5 PM–2 AM
	Sat: 5 PM–3 AM
GETTING THERE	Okay street parking and metered parking available.
PAYMENT	VISA MasterCard
POPULAR DRINKS	Mostly a beer joint, though they do have a full bar. I recommend the Bell's.
UNIQUE DRINKS	Sixteen beers to choose from should keep most people happy.
FOOD	No food here, but they do have menus from nearby eateries.
SEATING	Twelve stools at the bar, an assortment of tables along the front windows and around the perimeter. There is also a nook in the back across from the pool table, with a couple couches and a table. This bar is not very large, but it's not cozy. There is plenty of room to move around.
AMBIENCE/CLIENTELE	Vintage rock posters and concert photos cover the walls of this small corner bar. Lit candles and subdued red lighting compliment the warms tones of the décor. And you can't miss the artistic rendering of the American flag that hangs above the bar, with silken sunrays spiraling outward across the ceiling. This bar's claim to fame is its all-live jukebox, filled with 100 albums of live performances by some of rock n' roll's greatest. The bar also plays bootlegs videos every night at ten. This is not the place to experience the local flavor of Chicago, but you stand a good chance of meeting people from out-of-state. It's rather touristy—much like Hard Rock Café, but without the food. Although the setting is very casual, the ambience is quite pretentious. You can sport a t-shirt and flip flops, but you better look damn good wearing them—especially if want quick service at the bar. If rock n' roll is you passion, perhaps this would be a good place to stop by for a couple drinks on a Tuesday night, when beers are reasonably priced at $2.50 a pint. The Bell's is excellent.
EXTRAS/NOTES	There is one pool table towards the back of the front bar. There is also a back bar, which is available for private parties.
OTHER ONES	• Cincinnati: 941 Pavillion Street, Cincinnati OH, 45202 (513) 721-6977.

—Melanie Briggs

Argo Tea

The trendiest way to enlightenment.
$$
958 W. Armitage Ave.,
Chicago 60614
(at Sheffield Ave.)
Phone (773)388-1880 • Fax (312) 873-4123
www.argotea.com

CATEGORY	Teahouse. Imagine crossing an independent boutique coffeehouse with your favorite sushi spot, minus the cappuccinos and sushi.
HOURS	Mon–Fri: 6 AM–1 PM Sat/Sun: 6:30 AM–10 PM
GETTING THERE	Smack dab in the heart of Lincoln Park and the trendy Armitage shopping district, you might want to shoot yourself in the head before you attempt to find a front-and-center parking spot. If you do drive, scope out a meter spot, which are plentiful along Armitage. If you park on a side street, remember you need a 143 sticker after 6 PM. Luckily, Argo Tea is only steps from the Armitage stop on the Brown Line and is easily accessible by foot, taxi, or CTA Bus (#73 Armitage and Halsted).
PAYMENT	VISA MasterCard AMERICAN EXPRESS
POPULAR DRINKS	Tea, of course! Their hot and iced Chai teas have a riveting flavor—the perfect blend of sweet and spice that's totally irresistible. If you've never tried a Bubble Tea, then make sure you order one from Argo. Bubble Teas, an incredibly trendy drink in Asia, is a blend of iced tea, milk and chewy "bubbles" of sweetened tapioca. Or take your time and enjoy the serene environment (unless it's rush hour, then it's anything but) by kicking back and sipping from a whole pot of tea. They offer over 40 types of loose tea, from the expected Black and English Breakfast varieties to the exotic Melon White, Fruit Sangria and Green Tea ChocoMint.
UNIQUE DRINKS	All of their teas, which are imported from all over the world, are made with all-natural, organic ingredients. In Chicago, outside of Chinatown, don't expect to find many other teabar/teahouses. While still a fledgling concept, Argo Tea has nearly perfected the teahouse concept by changing the "stuffy" or "for-health-only" image of tea and making it trendy. Aside from the aforementioned Bubble and Loose Teas, some of their signature drinks include Fizzy Tea Sparkles, Teappuccinos, Mate Late, Fruity Tea Sangria and Mocha SmooTea.
FOOD	When you think of tea and food, most likely, crumpets and dainty cakes come to mind. Step into the inviting environment of Argo Tea and that image will quickly disappear. Decently priced, health-conscious and unique, the food available at Argo Tea food is a great place to grab something on the run. They offer an interesting array of sandwiches and wraps, including the Turkey Pretzel Sub, Spicy Tuna Tacos and Vegan Spinach Wrap. Their salads are a little more basic, but they're fresh, tasty and all priced under $6. But you might want to save your appetite for one of their baked goods—from quiches to flaky croissants to assorted cookies and pastries, they're dream-worthy and the perfect complement to any tea concoction.

SEATING The contemporary, minimalist, but inviting atmosphere of Argo Tea unfortunately doesn't offer up much room for seating. So any time of the day you enter, you'll be lucky to get a comfy seat at a table or chair. Stroll in during morning rush hour, and you'll likely be knocked down by a swarm of thirsty tea-drinkers, rushing to catch their train. If you are seeking a respite from urban insanity or hoping to escape to the calm of the East, visit late in the afternoon or evening. At any hour, you might have to shoo away some tea-flies who hang out enjoying the free wireless access. There's also a nice outdoor patio open during the warm weather, which is some of Chicago's prime real estate for people watching.

AMBIENCE/CLIENTELE Argo Tea is the place to meet. It's where Eastern culture meets Western, where the independent tea-house meets the chain. And, because it's where Armitage meets Sheffield, it's an ideal gathering spot. Its green-tea-influenced walls immediately transcend you to a state of enlightenment. And you can't help but be charmed by the wall featuring unique tea pots and a variety of loose teas. They're all available for retail purchase, but make for nice decor. The work of local photographers and artists can be found on the walls, which is always interesting and neighborhood-friendly. The outgoing staff ensures you won't be overwhelmed by the lengthy and unique tea menu. In terms of clientele, you'll see a little bit of everything here. During rush hour you'll catch the health-conscious DePaul students and commuters grabbing a morning pick-me-up. At other times, you'll see the soccer moms taking breaks from soccer games, as well as study groups and poets. If you're on your way home from Banana Republic, Ann Taylor or Urban Outfitters, you'll fit right in.

EXTRAS/NOTES If you enjoy your Argo Tea experience, which you surely will, you can take home some of their loose teas, or purchase teaware, including pots from all over the world. Surprisingly, there's more than tea at Argo, they also serve Illy coffee, from Italy. Catering is available. Free wireless. Wheelchair accessible.

OTHER ONES • Gold Coast: 819 N. Rush St., Chicago 60611, (312)951-5302
• Loop: 16 W. Randolph St., Chicago 60601, (312) 553-1551
• University of Chicago: 5758 S. Maryland Ave, Chicago 60637, (773) 834-0366

—Katie Murray

Beans and Bagels
(see page p. 123)
2601 W. Leland Ave., Chicago 60625
Phone (773) 649-0015

CATEGORY Neighborhood Eatery and Coffeehouse.

Bourgeois Pig

"Ideal place to nurse a cup of coffee while reading for three hours."

$

735 W. Fullerton Ave., Chicago 60614
(at N. Lincoln Ave.)
Phone (773) 883-5282

CATEGORY	Independent Coffeehouse
HOURS	Mon–Thurs: 6:30 AM–11 PM
	Fri: 6:30 AM–midnight
	Sat: 8 AM–midnight
	Sun: 8 AM–11 PM
GETTING THERE	Meters, most residential streets are zoned, parking is extremely tough.
PAYMENT	VISA MasterCard AMERICAN EXPRESS DISCOVER
POPULAR DRINKS	Regular coffee is excellent and each day features a different coffee. The "Pig blend" house coffee, flavored coffees, a variety of herbal teas.
UNIQUE DRINKS	Jamaican Latte (flavored with honey and allspice), Thai Coffee and Tea, Mocha Bianca (white chocolate).
FOOD	The sandwich menu has a literary flair, featuring names like "The Sun Also Rises" (Turkey with hummus and Swiss cheese), and "The Old Man and the Sea" (a tuna sandwich, of course). Pastries, soups, salads and breakfast items are available at reasonable prices.
SEATING	Seating for 20-25 on the first floor; seating for up to 40-50 on the second floor.
AMBIENCE/CLIENTELE	Located in a two-floor Victorian-style building, the Pig is a popular hangout for De Paul University undergrads; it's the kind of place that could easily be a used bookstore in a past—or present—life: worn hardcovers fill the shelves for patrons' perusal. Usually the atmosphere is reserved, but not library-quiet. It's a comfortable place for individuals to read, write, or play checkers, but anyone wishing to engage in spirited conversation with friends won't be shushed. During peak student hours (usually the early afternoon), the place naturally gets a bit crowded, so don't be surprised if you occasionally end up sharing a cozy table with a stranger.
EXTRAS/NOTES	The Bourgeois Pig allegedly has a ghost! One of the baristas told me that she has seen the ghost of an old woman a few times during the early morning or late evening. Also, the Bourgeois Pig features a lot of antiques all over the walls and on shelves. They might be available for purchase if the price and bargaining skills are right.

—*Keidra Chaney*
(*Extras/Notes by: Billy Kenefick*)

"Every player should be accorded the privilege of at least one season with the Chicago Cubs. That's baseball as it should be played--in God's own sunshine. And that's really living."

—*Alvin Dark*

Burwood Tap
An old-school, tucked-away place
featuring $3 beer specials.
$$
724 W. Wrightwood Ave., Chicago 60614
(at Burling St.)
Phone (773) 525-2593

CATEGORY	Neighborhood Bar
HOURS	Daily: 11 AM–2 AM
GETTING THERE	Street parking. Parking is okay.
PAYMENT	Cash only.
POPULAR DRINKS	This is mostly a beer place, but the mixed drinks are strong and tasty as well.
UNIQUE DRINKS	$3 daily beer specials
FOOD	There is a small bar menu, but I'd eat at any one of the nearby neighborhood restaurants first. Then, go to the Burwood for after-dinner drinks.
SEATING	The Burwood is definitely cozy, but there are still places to sit. There are two bars with plenty of stools and about ten small tables.
AMBIENCE/CLIENTELE	The Burwood is cozy and cluttered. The red Christmas lights dangle from the bar year around and are complimented by the shiny red barstools and well … STUFF everywhere. There is memorabilia dangling from the ceiling and exploding off the walls. An enormous swordfish hangs over the bar, a Daley mayoral election poster hangs on the wall; you could spend an hour just walking around and gazing at the pieces that have collected there over the years. The Burwood is old school—you can tell it was there before Lincoln Park became the yuppie capital of Chicago. But it still fits in the neighborhood. The yuppies do go there, but so do old-timers who don't even know what a yuppie is. Who is at the Burwood during the evenings? Well, around Happy Hour, a lot of volleyball and softball team members head to the Burwood to celebrate a win, and when it's time for them to go home and shower, the more nicely dressed bar crowd shows up for their first drink of the evening. The music is 70s/80s pop/rock—very fun and easy to sing along with. The servers are friendly and laid-back.
EXTRAS/NOTES	The Burwood Tap is a wonderful winter Chicago bar. Don't get me wrong—you can happily drink a beer or two there in the summer months, but there is something about its tucked-away feeling that lends itself to snowfall and pink cheeks.

—*Michelle Hempel*

"I feel sorry for people who don't drink. When they wake in the morning that's as good as they're going to feel all day."

—*Frank Sinatra*

R.I.P.:
Marge's

A local watering hole for artists, yuppies, and the occasional Lakeview transient, Marge's was a staple of Old Town until its closing in the summer of 2002. The friendly staff was always happy to see you, even if they didn't know who the hell you were or what your name was. Sundays during football season, you could always hop in for a bowl of chili and one of the best damn burgers in town.

The signature feature of this bar was the floor, full of cracks and holes, and probably wasn't fixed since the day it opened. The only pictures on the wall were of five Chicago legends: Former Mayor Richard J. Daley, Da' Coach Mike Ditka, Late Chicago Tribune columnist Mike Royko, Legendary DePaul hoops Coach Ray Meyer, and fifth picture whose face eludes me (it was possibly Chicago author Nelson Ahlgren, who wrote "The Man With the Golden Arm")

There's no word on the street about why the bar closed down or what the last night at the bar was like. The property is currently up for sale. I would personally try to raise the money and re-open the bar, but I don't have half a million dollars lying around and spare time to do battle with the Old Town neighborhood association.

—*Jeffrey Goodman*

Danny's Tavern
"The House that DJs Built."
$$$
1952 W. Dickens Ave., Chicago 60607
(at N. Winchester Ave.)
Phone (773) 489-6457

CATEGORY	Friendly hipster's hang for listening to music and talking music
HOURS	Sun–Fri: 7 PM–2 AM Sat: 7 PM–3 AM
GETTING THERE	Street parking possible. But as the Bucktown/Wicker Park area continues to explode, you'll need an official city-granted parking permit to park on the side streets. If you're lucky, you'll be able to nab a spot on Damen. Or opt for public transportation—only blocks from the Damen stop on the Blue Line, or take the #50 bus to Dickens or the #73 to Damen.
PAYMENT	Cash only. They don't have time for those silly credit cards.
POPULAR DRINKS	Although the sign outside prominently displays "Schlitz" with beating red lights, you can get much more inside. Step on in and you'll discover people drinking a wide variety of libations—beer ranking at the top of the list. They have an interesting selection of beers on tap and in the bottle. But ask for a Miller Lite and you'll get a rude response, the only "lite"

beer they serve here is Amstel. There is a full bar, so you'll find people drinking a wide range of cocktails including vodka tonics and Red Bull concoctions. And as rumor goes, they make a pretty mean martini.

UNIQUE DRINKS There's nothing totally unique here, except the interior, BUT the well drinks they pour are potent, including their martinis. And, all their drinks are reasonably priced. They do have decent specials: Tuesday nights you can get Chicago-favorite Goose Islands for $2. And on Mondays, there are select beers available for $3.

SEATING You'll find little alcoves in the back, filled with tables and couches. There are also a scattering of tables, couches and chairs throughout the house. Yes, it's like a real house, with no more than a couple of each kind of furniture piece. But if you do snag a seat, their worn-in leather sofas and chairs may be hard to get up from.

AMBIENCE/CLIENTELE Danny's is unique—unlike any other bar in the vicinity, Danny's Tavern used to be a livable, old Chicago house, that someone converted to a rockin' night spot. Dim, dark and slightly mysterious, you'll feel like you're at a college art student's house party, minus the mind-altering *ahem* substances. Each of the rooms has its own, distinct feel, and as you move make your way through them, you'll feel slightly voyeuristic. Votive candles and hanging light bulbs are the only things that light your way, so be careful not to trip and fall. It's a mind-numbing, hazy experience. But come on, who doesn't need one of those every now and then?

EXTRAS/NOTES A couple of things: Danny's features a great variety of music. This is where many DJs get their break. You never quite know what you'll be hearing. But you'll usually find a mellow and eclectic mix of reggae, hip-hop, funk, electronic, jazz and soul sounds. The tunes are cutting-edge without being hard-edge. Monday nights they occasionally play computer-generated music. Music nightly from 10 PM-2 AM. Some might consider Danny's a dance club because it plays rockin' music and it's open late. But, if soul-thumpin' tunes and latex-wearing-pole-dancing patrons is what you want, you'll have to seek elsewhere. What's the noise/ sound level like? It depends on which room you're hanging out in, what time you attend, and what they're playing that night. If you get there early enough and head towards the back room, you can enjoy a nice drink and good conversation. The front room is usually pumping with vibrations—both from music and people — making it difficult to hear anything. As the night tears on, the decibel level spikes, making conversations nearly impossible. Interesting bartender or regulars? Absolutely! You'll see a lot of regulars here, who consider it their "secret hang." So don't be surprised if you're treated like an outsider. Most of the patrons (and the bartenders) are members of bands, hanging out on their night off, or after a show. It's kind of like the contestant pool for Rock Star *INXS*. But you'll also see some of the newer, *yuppie-ish* members of the neighborhood, and a fair number of college kids. So is there a dress code, you ask? Well, sorta'. It's not official, but it might as well be. If you're not in the right apparel, you'll be gawked at. So just what is this dress code?

Anything casual—worn, ripped jeans, old concert tees
shor t-shirts featuring witty, anti-establishment messages.
Think old-school Adidas gym shoes and worn out boots.
One more thing, they also feature poetry and fiction
readings on some nights. Call to learn when poetry
and fiction readings are happening or find how you
can participate. Finally, be warned, Danny's is a smoker-
friendly establishment.

—*Katie Murray*

Delilah's

"Whiskey-A-Go-Go"

$$

2771 N. Lincoln Ave., Chicago 60614

(at Diversey Pkwy.)

Phone (773) 472-2771 • Fax (773) 472-2982

CATEGORY	Whiskey/Rock Bar
HOURS	Sun–Fri: 4 PM–2 AM
	Sat: 4 PM–3 AM
GETTING THERE	Metered street parking only; very limited, not recommended.
PAYMENT	VISA MasterCard AMERICAN EXPRESS DISCOVER
POPULAR DRINKS	Whiskey! Delilah's boasts over 120 different varieties of whiskeys for your drinking pleasure.
UNIQUE DRINKS	Delilah's is easily the most stocked bar in the city, and this is no exaggeration. Besides stocking an insane amount of whiskey, you can find just about any other type of hard liquor you can think of. And you can wash down those shots with your choice of over 100 different kinds of bottled beer.
SEATING	Lots of bar stools with booths near the wall. However, on a busy night, Delilah's is more likely to be a standing affair.
AMBIENCE/CLIENTELE	Delilah's is a great old-school rock bar with two floors. It's loud, gritty, cramped and smoky and has LOTS of booze. No cute décor, no frou-frou cocktails—just loud music and strong drinks. Delilah's is quite atypical of its yuppiefied Lincoln Park surroundings, but it has a devoted fan-base throughout the city that keeps it busy all week. The clientele can vary somewhat from night to night, depending on who is DJing or what the musical theme is for the night. However, in general, the music tends to lean toward the rock side of things, with a crowd consisting of young scenesters, devout rockers and black-clad regulars. Like most bars, the weekend crowd can be a bit of a hodge-podge of drunken revelers, but the bar has enough character that it never seems to lose its gritty charm.
EXTRAS/NOTES	Seriously, this bar's inventory of booze is insane... I've talked to people who have worked here and I've heard the amount of whiskey that is stored upstairs in their stock room is legendary. Talk about overhead! One complaint, the bar is insanely smoky on busy nights. Even to someone that goes out to smoky bars and clubs a lot, it can be a bit overwhelming after a while. However, if you're a smoker and despise the fact that many cities have banned smoking in bars, well...then you'll especially enjoy soaking in the

atmosphere here. Also, upstairs you can find both
pool and pinball. Look forward to $2 Jim Bean specials
and "Elvis Disappearance Day" held every year at
Liar's club on the anniversary of the King's death.

—*Brad Knutson*

Duffy's
The mother of all after work pubs
$
420 W. Diversey Pkwy., Chicago 60614
(at N. Sheridan Rd.)
Phone (773) 549-9090 • Fax (773) 549-9091

CATEGORY	Neighborhood Sportsbar/College Bar
HOURS	Mon–Fri: 11 AM–2 AM
	Sat: 10 AM–3 PM
	Sun: 9 AM–2 AM
GETTING THERE	Parking can be a problem on Diversity. Try parking on a side street.
PAYMENT	VISA MasterCard AMERICAN EXPRESS DISCOVER
POPULAR DRINKS	The three B's: Beer, Bourbon, and Bacardi.
UNIQUE DRINKS	On the weekends, they have a Bloody Mary bar for brunch. You have your choice of vodka and can make it yourself! I made mine nice and spicy. They also provide wine tasting events where you can try various Argentinean and Chilean wines.
FOOD	There are lots of great appetizers to go around like bruschetta, spicy chicken wings, spinach artichoke dip, and fried calamari. Try going on a Wednesday night when all appetizers are only $3.
DRINKS	Wine, Specialty drinks: Bloody Mary's, Mimosa's
SEATING	This bar is huge and can hold your entire office staff for their wonderful happy hour. Seating will not be a problem, but there is an issue with crowd size once that 5 PM work day is out. Be prepared to say excuse me.
AMBIENCE/CLIENTELE	The scene consists of crowds of office worker types and frat boys dying for the well-deserved drink. The wait staff is constantly busy taking orders and delivering the food and drinks. The weekend is a similar scene, but includes dancing to live DJs or listening to bands doing covers. My boss told me that she once saw a U2 cover band where the lead singer looked just like Bono. I guess she found what she was looking for in Duffy's.
EXTRAS/NOTES	Give them your email address and you're entered to win a free happy hour for you and your friends. I've been to two of these, and you can end up drinking for practically nothing. This bar supports and caters to the Michigan Alumni family with the walls painted blue and the TVs usually playing Michigan games. TV's, TV's everywhere, but not a sound to hear.
OTHER ONES	• McGees: 950 W. Webster Pl., Chicago 60614 (773) 549-8200
	• Wrightwood Tap: 1059 W. Wrightwood Ave., Chicago 60614 (773) 549-4949
	• Jack Sullivans: 2142 N. Clybourn Ave., Chicago 60614 (773) 549-9009
	• Durkin's Tavern: 810 W. Diversey Pkwy., Chicago 60614 (773) 525-2515

—*Ian Weiss*

Durkin's Tavern

*A Chicago Lincoln Park tradition,
and one hell of a place to party.*

$$

810 W. Diversey Pkwy., Chicago 60614
(at Halsted St.)
Phone (773) 525-2515
www.bar1events.com

CATEGORY	Durkin's Tavern is a sports bar, but on the weekends it can become quite the party spot.
HOURS	Mon–Fri: 4 PM–2 AM
	Sat: 10 AM–3 AM
	Sun: 11 AM–2 AM
GETTING THERE	Some street parking, but you'll have more fun if you don't have to drive anyway, so take the Brown or Purple line to Diversey.
PAYMENT	Cash only
POPULAR DRINKS	The drafts are always popular here, although you can order any mixed drink "tall" and get twice the booze in a pint glass.
UNIQUE DRINKS	A fun drink is always the Irish car bomb, which is Bailey's Irish cream mixed with Jameson whisky (in a shot glass), which is dropped into a half pint of Guinness. It tastes like chocolate milk!
FOOD	Durkin's has an extensive tavern menu, including everything from appetizers, salads, soups, sandwiches, and "horseshoes." Horseshoes are basically meat on Texas toast, "smothered in fries, covered in cheese." Weekend brunch is also available. Also, they have meal and deal packages, usually with draft beer and burgers/hotdogs.
SEATING	This place is HUGE. Depending on the amount of people, only one or two of their 4 fully stocked rooms may be open. On weekends, expect service from the front door all the way to the back.
AMBIENCE/CLIENTELE	Although Durkin's is a friendly place for anyone, it is a tavern/sports bar and the scene there fits accordingly. The crowd can vary from twentysome-things to thirtysomethings, although an older crowd wouldn't seem necessarily out of place. It's a barstools, tables, and chairs type of bar- no plush couches in the "VIP" lounge. Everyone is VIP here, because the people here are all about having a good time.
EXTRAS/NOTES	This bar is proud to have "the oldest continuous liquor license on Chicago's North side." They also host Purdue Boilermaker games, and the bar has a lot of Purdue memorabilia. This is a great place to bring a bunch of friends to party on the weekends and "Flip it Monday", where you can get your drinks for free if you can call a flipped quarter, is a whole lot of fun. As of Summer '05, Practically everyday is a party with $3 beer on Tuesday, $10 bucket o' winds Wednesday, Free Cook out Thursdays, and $15 meal Fridays. During the week it is less crowded, and quiet enough to bring a date. On the weekends, however, it's a big party and you're invited.

— *Billy Kenefick*

Elbo Room
You'll be up to your ELBOS in good times.
$$

2871 N. Lincoln Ave., Chicago 60657
(at Diversey Pkwy.)
Phone (773) 549-5549 • Fax (773) 549-4495
www.elboroomchicago.com

CATEGORY	Hole-in-the-Wall Music Lounge
HOURS	Sun–Fri: 7 PM–2 AM
	Sat: 7 PM–3 AM
GETTING THERE	Street parking
PAYMENT	Cash only, but you can prepay for tickets online with most credit cards
POPULAR DRINKS	$2 Miller Lite, Cheesecake Shots
UNIQUE DRINKS	The pitcher of water with plastic cups that sits at the bar. They allow you to serve yourself, which I personally find refreshing.
SEATING	Comfy couches on the first floor, everything from velvety benches to folding chairs in the basement.
AMBIENCE/CLIENTELE	Retro vinyl couches and the old 80's style table Pac Man game create comfy, casual environs on the 1st floor, but escape to the basement for a strong local music flavor. Elbo Room has a flair for finding unique bands that really seem to create their own mood. It's dark and dingy down here (you wouldn't want to see it in the light), but it's got a distinct energy. Sundays are Acid Jazz Improv with SUMO; it is a sexy night out if you can bear the Monday morning wake-up call.
EXTRAS/NOTES	Elbo Room t-shirts are available

—Piper Parker

The Field House
A Trixie-free oasis of unpretension in Lincoln Park
$$

2455 N. Clark St., Chicago 60614
(at Arlington Pl.)
Phone (773) 348-6489

CATEGORY	Neighborhood bar/sports bar
HOURS	Mon–Fri: 4 PM–2 AM
	Sat: 11:30 AM–3 AM
	Sun: noon–2 AM
GETTING THERE	Street parking, which tends to be difficult to find during prime time in Lincoln Park. There are a few parking garages in the neighborhood—pricey but convenient.
PAYMENT	VISA MasterCard AMERICAN EXPRESS DISCOVER
POPULAR DRINKS	Beer. One does not come to the Field House for frou-frou drinks.
UNIQUE DRINKS	Every night there is a good beer special.
FOOD	No food, other than the bowls of unshelled peanuts that give the Field House its trademark "crunchy floors." Ordering/bringing food in is allowed and a common practice.
SEATING	Narrow but deep hole in the wall; seating is bar stools and small round tables. Small and cozy; large groups will have to pull several tables together and sit in a long row. Not a romantic spot by any means; people tend to come in threes and fours.

AMBIENCE/CLIENTELE The Field House's awning promises "Cold Beers and Crunchy Floors"—and in this case, there is truth in advertising. People come as they are for pitchers and peanuts as they watch their favorite sports teams (particularly the Cleveland Browns) duke it out on the array of TVs over the bar—the Field House has satellite access to almost any game you'd want to see and enough TVs to accommodate most requests. The Boss (a sort of unofficial patron saint for the Field House) is often playing on the jukebox. Jeans are de rigueur, but the Field House regulars are a friendly bunch who won't make *too* much fun of you if you show up in something more upscale. While the amenable bartenders will happily make you a mixed drink upon request, almost everyone else will be drinking beer.

EXTRAS/NOTES One pool table that a dog is often dozing on. Golden Tee and darts, too.

—Jennifer Carsen

Frank's

Doo-bee-doo-bee-doo, baby.
$$$
2503 N. Clark St., Chicago 60614
(near Fullerton Pkwy.)
Phone (773) 549-2700

CATEGORY	Neighborhood bar/late-night spot
HOURS	Daily: 11 AM–4 AM
GETTING THERE	Street parking (not always easy to find in Lincoln Park). Frank's also validates parking
PAYMENT	VISA MasterCard AMERICAN EXPRESS
POPULAR DRINKS	Standard-issue bar drinks, with an emphasis on fancy martinis.
UNIQUE DRINKS	Did I mention the martinis?
FOOD	No food.
SEATING	Small and intimate—a few primo booths up front (they go fast), seating at the bar, some very small funkily-shaped tables.
AMBIENCE/CLIENTELE	By day, Frank's is a mild-mannered neighborhood bar. By night (late-night, that is), it's a teeming mass of wasted Lincoln Park revelers who have been kicked out of the 2 AM spots. In between, it's a good place to have a drink, a chat, and a smoke. Frank Sinatra albums adorn curving, honeyed-wood walls, and lava lamps and candlelight give everyone a sexy glow. Great jukebox with traditional and new faves. The two TVs in the bar are normally tuned to classic movies rather than sports. Frank himself (the owner, that is—not the ghost of Ol' Blue Eyes) is often in attendance, stationed at the bar by the Golden Tee machine. He's young, blond, and friendly, and looks pleased with what he's wrought—as he should be.
EXTRAS/NOTES	Pool table and Golden Tee.

— Jennifer Carsen

Glascott's

A great bar, for younger or older crowds.
$$
2158 N. Halsted St., Chicago 60614
(at Webster Ave.)
Phone (773) 281-1205

CATEGORY	Tavern
HOURS	Sun–Fri: 11 AM–2 AM
	Sat: 11 AM–3 AM
GETTING THERE	Street parking is available on Halsted or Webster. If you are on a side street, beware of permit parking.
PAYMENT	VISA MasterCard AMERICAN EXPRESS DISCOVER
POPULAR DRINKS	This "Groggery" is a great place to enjoy some ice-cold beer, which would have to be the best seller.
UNIQUE DRINKS	Glascott's is definitely not the place to order a drink with six different types of fruit, topped off with brown sugar and minced mint leaves, and served in a blue oblong glass. Instead, come here to toss back some domestic and imported beers, wine, or some good old-fashioned whisky.
FOOD	Although Glascott's doesn't have a kitchen itself, a deal has been worked out with the neighboring Greek restaurant The Athenian Room. You can order anything from their Greek-American cuisine menu and bring it over. Try the Gyros and Greek fries.
SEATING	Enough space for you and your friends to meet someone else and their friends, but there's also a private party room that can be rented out.
AMBIENCE/CLIENTELE	Really, just a great neighborhood bar. The bartenders are all very friendly and will laugh with you and listen whatever happy or sad tale you want to spin.
EXTRAS/NOTES	They have pool, darts, and Golden Tee '99. You can also request what you want to hear on the jukebox, and the bartenders will get the CD's and play them for you.

—*Billy Kenefick*

The Gramercy

The Gramercy is literally a 'surprise'
hot spot in the Lincoln Ave strip.
$$$
2438 N. Lincoln Ave., Chicago 60614
(at Fullerton Ave.)
Phone (773) 477-8880
www.thegramercychicago.com

CATEGORY	The Gramercy's website says that they are inclusive rather than being exclusive, but judging from the crowd, one would only guess that this restaurant-lounge is one of Chicago's secret society for the trendy and pretty.
HOURS	Sun: 7 PM–2 AM
	Tues–Fri: 7 PM–2 AM
	Sat: 7 PM–3 AM
GETTING THERE	Good luck with Lincoln Ave. parking between Sheffield and Fullerton. Take a cab or catch the El.
PAYMENT	VISA MasterCard AMERICAN EXPRESS DISCOVER
POPULAR DRINKS	Any of their martinis. Try the house special, The

	Gramercy Martini for something different
UNIQUE DRINKS	The Gramercy is the house martini. The blue, pineapple-tasting concoction isn't the most unique or best tasting beverage, but something to at least try.
FOOD	The $8-$9 menu is rather sparse, with simple but good delights such as shrimp cocktails and beef tenderloins. The two words 'minimal' and 'elegant' come to mind in describing the fare at The Gramercy, much like the décor and the atmosphere of this establishment.
SEATING	With its minimalist style, The Gramercy gives the impression that the space is more than is really there. With white lounge seats in the front and in the back, lucky visitors can relax, take in the view, and order food. Stools line the long metallic front bar, though by the end of the night, people move off from these seats as drinkers fight their way to close out tabs, buy more rounds, or just gawk at the pretty bartenders and waitresses who work there. In the very back, there are also some curtained lounge seats for more intimate chilling. Oh, and there's a bar in the back as well.
AMBIENCE/CLIENTELE	Though there didn't seem to be an established dress code, the majority of the crowd is trendy, and one might feel out of place in khakis and a polo shirt. Black pants, vintage jeans, hip huggers, crop tops, and retro shirts abound at The Gramercy. The drone of electronica music plays in the background, fitting perfectly with the theme: 'minimal' and 'elegant'. Pretty, stylish girls sipping their colorful drinks mingling with equally pretty guys resembling a boy-band gathering are a common sight. In comparison to other lounges in the city, The Gramercy does not exude the feeling that you've walked accidentally into a private gathering, which is refreshingly surprising. Maybe being in the proximity of so many fraternity-laden, college bars has allowed for people to loosen up a bit here. In any case, The Gramercy is definitely a diamond in the rough on Lincoln Ave in the LP.
EXTRAS/NOTES	The waitresses and bartenders, all pretty girls, somehow have this power that makes guys opening up large bar tabs willingly.

—*Sy Nguyen*

Halligan Bar
Good music with half price Tuesdays!
A Lincoln Park standard.
$$
2274 N. Lincoln Ave., Chicago 60614
(at Belden Ave.)
Phone (773) 472-7940
www.halliganbarchicago.com

CATEGORY	Irish Pub
HOURS	Mon–Fri: 5 PM–2 AM
	Sat: 11 AM–3 AM
	Sun: 11 AM–2 AM
GETTING THERE	Parking tickets are validated from Children's Memorial hospital just a few blocks away.

PAYMENT	VISA · MasterCard · AMERICAN EXPRESS · DISCOVER
POPULAR DRINKS	If you want to experience the weekday nightlife of Lincoln Park, Halligan's half-price Tuesday is your best bet. Everything is half-off except shots. You can get a pint of Guinness for only $2.50! They also have Blue Moon, and a very large Martini list.
UNIQUE DRINKS	Lots of Martinis are available (all $5 on Thursdays!), and of course they are masters of pouring the Guinness pint. Other drafts such as Blue Moon and Harps are also available.
SEATING	It can get a little crowded at Halligan bar on the weekends. It fits (at max) somewhere between 130-150 people. I recommend sitting on the stools by the window. You can see a lot of people walking by, and sometimes you can yell at them if the bar staff opens the windows (on cooler nights when no A/C is needed).
AMBIENCE/CLIENTELE	Halligan bar is your typical Lincoln Park pub. It is on a corner, so it is shaped like a triangle. The clientele is mostly young, college age, or recent graduates (most likely because of the cheap drink specials). Don't be fooled; even though I think this bar is great for its cheap drinks, it is still a very nice place with multiple TV screens, Guinness decorations, old pictures, and a great jukebox. There is a basement with two extra bathrooms, along with a Golden Tee machine with 18 holes for $2. Halligan Bar is primarily a sports bar/pub, but is also a great place to meet nice local Lincoln Park people. On the weekends, however, it can host quite a raging party and very crowded so if you are not into a scene like that, keep it to the weekdays.
EXTRAS/NOTES	There is a lot of old Chicago Fire Department memorabilia in this bar, along with lots of Guinness posters on the wall. This is a very nice place, despite its strengths in drink specials. The clientele are usually very friendly, and are mostly local Chicagoans. This is a great place to watch a Cubs or Sox game; even if you're from out of town, during a Cubs game everyone is your friend.

—*Billy Kenefick*

Hidden Shamrock
Have another ale and do the Irish Jig! Cheers!
$$$
2723 N. Halsted St., Chicago 60614
(at Diversey Pkwy.)
Phone (773) 883-0304

CATEGORY	Neighborhood/Irish Pub
HOURS	Mon–Fri: 4 PM–2 AM
	Sat: 11 AM–3 AM
	Sun: 11 AM–midnight
GETTING THERE	Parking is tough, but not impossible. If you can't find a meter, drive around the neighborhood, pay attention to Zone postings...they DO ticket.
PAYMENT	VISA · MasterCard · AMERICAN EXPRESS · DISCOVER
POPULAR DRINKS	Jack and Coke or Rum and Coke are two great drinks to order here because the bartenders make them

	strong and don't fill the whole glass with ice.
FOOD	The menu features Irish and Celtic dishes for dinner and breakfast that aren't overpriced.
SEATING	There isn't much seating available at the bar in this cozy place, but there are tables and chairs across from the bar.
AMBIENCE/CLIENTELE	Anything goes in this laid back Irish pub. You can come with a good friend to sit and talk for hours or bring the whole group to jam to the sounds of the band on a Saturday night.
EXTRAS/NOTES	This is truly an Irish bar, not just a dive bar with an Irish name slapped onto it. It's a great place to meet people and to hang with old friends especially with live music. There are also two fireplaces that allow you to get cozy in the winter months.

—*Mindy Golub*

John Barleycorn

Classical music and artwork; no, it's not an auction!

$$$

658 W. Belden Ave., Chicago 60614
(at Orchard St.)
Phone (773) 348-8899 • Fax (773) 929-6512
www.johnbarleycorn.com

CATEGORY	High class neighborhood pub
GETTING THERE	Parking around the bar on neighborhood streets can be a pain, but there are pay lots and valet if you need them.
PAYMENT	VISA AMERICAN EXPRESS DISCOVER
POPULAR DRINKS	Everyday there is usually a special on a different kind of beer, mostly for $2 pints.
UNIQUE DRINKS	The Long Islands are yummy at just $6 a pop.
FOOD	They have appetizing salads all under $6 a piece. Sundays they offer a unique brunch and feature different kinds of soups and sandwiches.
SEATING	The bar isn't as big as it's brother in Wrigleyville, but there are plenty of cozy tables and seating at the bar. There is a patio section too with another bar to accompany it. This is a good place to go with two or three close friends, or even on a date.
AMBIENCE/CLIENTELE	More and more beautiful people come here probably because of the elegant artwork and model ships that line the entire bar. Classical music is played everyday which compliments the bar's upscale venue. There is a gold-painted sculpture that overlooks the bar and you can't help but feel whisked away into a foreign, yet familiar atmosphere.
EXTRAS/NOTES	Barleycorn has an interesting history of being started by an Irish immigrant who bought the building in the 1890s. The bar opened in the 1920s and bootleggers would roll in barrels during prohibition time. A Dutchman bought out the place in the '60s and since then it has been renovated and turned into a well-known pub filled with artwork and interesting artifacts.
OTHER ONES	• Wrigleyville: 3524 N. Clark, Chicago 60657, (773) 549-6000

—*Mindy Golub*

Karyn's Fresh Corner & Karyn's Inner Beauty Center

One of a kind organic and raw all natural upscale vegan gourmet restaurant and juice bar.

$$$

1901 N. Halstead St., Chicago 60614
(at Wisconsin St.)
Phone (312) 255-1590 • Fax (312) 255-1592
www.karynraw.com

CATEGORY	Karyn's is a raw, natural and organic vegan break feast, brunch, lunch, dinner and juice bar. Can be a quick stop for a cold specialty juice, small social gathering for brunch, somewhat romantic, but limited dinner menu and many gourmet all natural and extremely healthy desserts.
HOURS	Daily: 9 AM–10 PM
GETTING THERE	Free Parking lot next door. Also metered parking on the street, close to the El North Avenue stop
PAYMENT	VISA MasterCard
POPULAR DRINKS	Really Rare and Raw-nutmilk, dates, banana, and vanilla 'shake.
SEATING	Inside café, inside restaurant, a few outdoor seats. About 75 seating capacity
AMBIENCE/CLIENTELE	Depends where you are going in the store/restaurant. Just walk in flip-flops are fine, but if you are going to eat you might want to put on some pants.
EXTRAS/NOTES	Even the water here is special purified water. Karyn, the owner has a "Day Spa" she offers yoga classes, cooking classes, nutrition consultations, massage, and even cell analysis. She sells natural beauty products, some grocery store goods at the café.

—*Danielle Deutsch*

THE BEST OF THE BEST
Hotel Bars
(Seven Days a Week)

Hotel + bar = stuffy, ragged tourist trap? No way. Add these two together and experience swanky playgrounds for both tourists and townies. When you meet people in hotel bars, you can be whoever from wherever, sort of like chatting up strangers on the Internet but more up close and personal. As trendy lounges and neighborhood haunts slow during the week, the sexy combo of out of town anonymity plus locals in the know equals a hot hit-the-town trend. Just pick whom you want to be, and where. Fancy closing a deal over cigars and brandy? Gotcha. Trying to pass off that hot-glued designer bag as authentic over fru-fru flavored martinis? Consider it done. Whatever your fantasy, whether you're from Chicago or away, these bars will take care of you. By all means, don't limit yourself to the handy list here. Make your own fun and duck in somewhere you discover 007 style. We'll never tell. *Wink.*

MONDAY
Basil's at Talbot Hotel
Secret identity: Gold Coast go-getter
Skip the overpriced opulence of the Magnificent Mile. The hunter green wallpaper and wood paneling feels a little like a financial planner's office, but the kooky dog paintings, architectural sketches and pictures of Chicago history in the early 1900s are well worth the brandy-snifter ambience. Even the overhead television is framed as artwork. Roll the dollar or two saved on drinks into a tip for the bartender. You might be a regular, you never know.
(20 E. Delaware Pl., (312) 944-4970, Daily: 6:30 AM–midnight)

TUESDAY
Kitty O'Shea's at Hilton
Secret identity: Irish passport
Tucked in between shopping to the north and museums to the south, this Michigan Avenue pub offers great people watching from a summer sidewalk patio. Inside, snack on Guinness chocolate cake, shepherd's pie and other Irish meal items. Wash it down with a pint of ale served by a brogued bartender in a football (soccer, you hooligan) shirt. All of this may come off as a little try-too-hard, but in a city with a man name Daley as mayor, who cares? *(720 S. Michigan Ave., (312) 922-4400, Daily: 11 AM–1:30 AM)*

WEDNESDAY
Peninsula
Secret identity: Player's clubber
From the cigar toking players in the intimate main bar (called The Bar, what else) to the east meets west in the Midwest schtick of Shanghai Terrace, you feel like you can get both what you want and what you need. Particularly if you happen to want and need a berry infused mojito and a lobster quesadilla. If the agenda says girls night out, try the all- you-can-melt-in-your-mouth chocolate bar on Friday and Saturday. *(108 E. Superior, (312) 337-2888 Daily: 3 PM–1 AM)*

THURSDAY
Trader Vic's Tiki Lounge at the Palmer House
Secret Identity: Tiki chic
Get, your, um, tiki groove on. After the shock wears off (this place is the real deal) down a few mai tais and bask in the bamboo hued glow. A favorite of late nighters in service industries and bookish boozers, the potent, signature mai tais cost $4 on Thursdays.
(17 East Monroe St., (312) 726-7500, Tues–Thurs: 4 PM–11:30 PM Fri/Sat: 4 PM-1 AM)

FRIDAY
Whiskey Sky at W
Secret Identity: New money
The hotel scrapes the sky at the southern tip of the area affectionately known as the Viagra triangle. You might find yourself on the outside looking in at the uber-French design. Don't be intimidated. Go on in already. Rub elbows with a club-hip but less obnoxious crowd of loungers. Oh, the drinks are good, try any champagne-topped cocktail on the impressive drink list.
(644 N. Lakeshore Dr., Daily: 4 PM–2 AM)

SATURDAY
Le Bar at Sofitel

Secret Identity: Europop star

Slide into Le Bar in your sharpest threads nad try to hold your best Eastern European accent as you try to convince the wealthy lawyer in town to file a deposition that you're the hottest thing to come out of Latvia since...well, ever. If that fails pick anything from there impresive top shelf and have a ball. *(20 E. Chestnut St., (312) 324-4000, Sun–Weds: 3 PM–midnight, Thurs: 3 PM–1 AM, Fri/Sat: 3 PM–2 AM)*

SUNDAY
Pump Room at Omni Ambassador East

Secret Identity: Rat pack flashback

This Chicago landmark might be off your radar, unless you're old enough to have liked ballroom dancing the first time around. Stop in for a distinct change of pace from the lowbrow mayhem of Rush Street around the corner. Ghosts of celebrities past haunt what once was the place to be in the days of bouffant hair, white gloves and pearls. Think: Sinatra, chandeliers and Baked Alaska for two. Hey, if you can make it here, you'll make it anywhere in this kind of town. Features a luxurious if somewhat pricey bar menu until closing and live jazz on Friday and Saturday. *(1301 N. State Pkwy., (312) 266-0360, Daily: 6:30 AM-midnight)*

—Janet E. Sawyer

Katacomb

A sultry late night, low ceiling-ed joint.

$$$

1909 N. Lincoln Park West, Chicago 60614

(at Wisconsin St.)

Phone (312) 337-4040

CATEGORY	Late-night lounge
HOURS	Weds–Fri: 8 PM–4 AM
	Sat: 8 PM–5 AM
	Sun: 10 PM–4 AM
GETTING THERE	Parking is a nightmare.
PAYMENT	VISA MasterCard AMERICAN EXPRESS
POPULAR DRINKS	Any mixed drink should do you well.
FOOD	I've heard rumor of food here, but I've never seen anyone eating.
SEATING	There are several seats at the bar and about fifteen tables and private nooks scattered throughout. Don't expect to sit down if you arrive too late.
AMBIENCE/CLIENTELE	Katacomb is the place where worlds collide. Since it is one of the only Lincoln Park lounges with the coveted late night liquor license, you can expect to run into anyone you ever knew who wants to be out late on a Saturday night. The lighting is low and so are the ceilings. The walls are plastered to look like a catacomb and little paintings of people in sexual positions are painted on the plaster. DJs play a mix of dance, hip hop, and soul music. The crowd is a

mix of well-dressed party-ers in their 20s and 30s. If you're looking to be out late, but you don't want to be at a downtown club or a frat-party meat-market place, Katacomb is where you should end your evening.

EXTRAS/NOTES Katacomb is the most fun when you get there a little early, and by early, I mean midnight to 1 AM, so you can get a seat at the bar or at one of the little tables, and watch everyone else stumble in. There IS a cover to get in (usually $5-10 for ladies, $10-15 for guys), so don't go here if you're looking for an inexpensive evening.

—*Michelle Hempel*

Kendall's
The best Thursday night on Lincoln.
$$
2263 N. Lincoln Ave., Chicago 60614
(at Belden Ave.)
Phone (773) 348-7200

CATEGORY	A big-time sports bar.
HOURS	Mon–Fri: 3 PM–2 AM
	Sat: 11 AM–3 AM
	Sun: 11 AM–2 AM
GETTING THERE	Street parking on Lincoln is available; if you are parking on a side street be sure to watch for permit signs.
PAYMENT	VISA MasterCard AMERICAN EXPRESS DISCOVER
POPULAR DRINKS	Being a part-time sports bar, I would recommend some Jaeger Bombs (Jaegermeister and Red Bull). You can't go wrong with that!
UNIQUE DRINKS	Nothing too unusual about Kendall's drink selection. It is just a very effective watering-hole-good old fashioned beer and booze in mass quantities. With sixteen drafts on tap, along with a selection of thirteen different bottled beers, the beer is a primary drink.
FOOD	They have a great bar menu, with appetizers, chicken sandwiches, burgers, and pizza. On Fridays they have the "Drinkin on Lincoln" special with a pizza buffet and domestic drafts 6-9 PM for only $10.
SEATING	Kendall's can fit a lot of people. It has a very long bar, tables and chairs all over (the good ones are by the windows), and a back room that is more secluded. The bathrooms are in the back, which can be difficult to get to if you are at the front.
AMBIENCE/CLIENTELE	Generally, Kendall's attracts all kinds of people, especially because of its great weekly specials. The typical Kendall's visitor is young, college age (or slightly older), and most likely from the neighborhood. Not too many hipsters here- it's a sports bar. On Thursdays and Fridays this place goes CRAZY. If you are looking to get plastered, surrounded by huge TV screens and tons of young Chicagoans, Kendall's is for you. And yes guys, girls love this place- especially on Thursdays and Fridays. Dollar bottles Thursday and the drink up on Friday ($10 unlimited drafts and pizza buffet 6–9 PM Fridays) is the best time to come here.

EXTRAS/NOTES	Kendall's has two pool tables, and the standard Golden Tee game in the back. On a quieter week-night, this is a great place to place to shoot some pool and watch one of the 28 screens broadcasting from twelve satellites. On the weekends, you better be ready to party hard in a very crowded, loud, but fun sports bar.

—*Billy Kenefick*

Liar's Club
Rhymes with 'Friar's Club'
$$$
1665 West Fullerton Ave., Chicago 60614
(at N. Clybourn Ave.)
Phone (773) 665-1110
www.liarsclub.com

CATEGORY	Neighborhood rock bar during the week/dance club on the weekends
HOURS	Sun–Fri: 8 PM–2 AM
	Sat: 8 PM–3 AM
GETTING THERE	Street parking...spots are very limited during the weekend
PAYMENT	VISA MasterCard AMERICAN EXPRESS
POPULAR DRINKS	Beer/mix drinks
UNIQUE DRINKS	$1 PBR on Sunday and Monday
SEATING	Bar stools and booths...plus a dance floor, complete with disco ball, in the back
AMBIENCE/CLIENTELE	Dark with minimal decoration, except for a giant fez hat on the ceiling and fez hat lampshades at the booths and some random rock memorabilia on the walls. During the week, Liar's Club is a casual rock bar filled mostly with regulars. On the weekends, the bar caters to the drunken Lincoln Park crowd with DJs and dancing.
EXTRAS/NOTES	There is an upstairs room with pool and pinball that often gets rented out for private parties. Besides the typically crowded weekend nights, Punk rock night on Sundays is one of the more popular nights at the bar, brining in large crowds of regulars. Overall— (as noted above) Liar's Club has two very distinct personalities: the laid back rocker during the week and the dance-party yuppie on the weekends.

—*Brad Knutson*

"I think if I were a woman I'd wear coffee as a perfume."

—*John Van Druten*

Lion Head Pub and The Apartment

Where frat boys and businessmen unite.

$$$

2251 N Lincoln Ave, Chicago 60614
(at W. Webster Ave.)
Phone (773) 348-5100
www.lionheadpub.net • www.apartmentlounge.com

CATEGORY	Loft-like lounge, complete with recliners, beds and a fireplace
HOURS	Apartment: Thurs–Fri: 9 PM–2 AM Sat: 9 PM–3 AM Lion Head: Mon–Fri: 3 PM–2 AM Sat: 11 AM–3 AM Sun: 11 AM–2 AM
GETTING THERE	Park in the Grant Hospital garage and get your ticket validated at the bar- $4 w/ validation. Street parking is difficult.
PAYMENT	VISA MasterCard AMERICAN EXPRESS DISCOVER
POPULAR DRINKS	At Lion Head Pub Beer is the beverage of choice here: twenty taps, thirty bottles, daily specials. Full bar in both bars. At the Apartment it's Martini's and Jager Bombs.
UNIQUE DRINKS	Nothing too unusual. Great shooters and cocktails.
FOOD	The Lion Head Pub has a full menu of traditional American bar fare: appetizers, sandwiches, dinners, and dessert. All reasonably priced. Wings, Burgers, Fries, etc.
SEATING	At the Lion Head, bar stools, pub tables. At the Apartments it's recliners, couches, pub tables, and beds. Capacity for both bars is 75–100.
AMBIENCE/CLIENTELE	These two bars make an interesting combination; drawing a largely male clientele of college students and professionals, it seems symbolic of a 'rite of passage'. The Lion Head is a traditional English-style pub. The large, wooden bar and fireplace offer a relaxing backdrop, a stark contrast to the busy city streets. This is a great place to go with friends. It's very casual and laid back. No frills. Just grab a friend, have some beers, and thank yourselves for taking time away from your busy schedules to just enjoy the day. Upstairs, The Apartment is anything but traditional- for a bar. A mock-up of a flat- complete with a kitchen, bathtub, and two bedrooms- this is a unique home-away-from-home. They even have Playstation. DJ's spin hip-hop and retro tunes to get the party started. Primarily, this bar draws a younger crowd, and it gets pretty packed. Like a typical house party, this is a place to meet people while you get your buzz on. Get there early if you want to relax in the spacious pad, play some pool, or have a chance at the remote control. And ladies, please don't go alone!
EXTRAS/NOTES	Daily drink specials on beer at Lion Head. "Buzz Me Up" special on Thursdays, when all drinks are half price. In the Apartment Billiards/Pool, Darts. Also, Free wi-fi at Lion Head Pub.

— *Melanie Briggs*

Lucille's Tavern & Tapas

Cozy booths, great booze and tapas – perfect for a first date!

$$$

2470 N. Lincoln Ave, Chicago 60614
(at Fullerton Ave.)
Phone (773) 929-0660

CATEGORY	Low-key/Tapas bar
HOURS	Daily: 5 PM–2 AM
GETTING THERE	Street parking, but it's a nightmare.
PAYMENT	[VISA] [MasterCard] [American Express] [Discover]
POPULAR DRINKS	Across the board. They do have a fantastic martini list, but they also have good microbrews on tap and a better-than-usual wine list.
UNIQUE DRINKS	Usually a good wine by the glass special
FOOD	Lucille's has a "tapas" menu, but don't expect traditional Spanish tapas dishes. You can get Asian ribs or goat cheese pizza or the soup of the day. My personal favorite is the "dip platter." Featuring healthy portions of hummus, salsa, and spinach dip, with warm pita and multi-colored corn chips, this platter is a perfect accompaniment to your beverage of choice.
SEATING	Lucille's features tables, booths and bar stools. During the week you shouldn't have trouble finding a seat. After 11 on the weekend is another story.
AMBIENCE/CLIENTELE	Besides the delicious tapas dishes, the other thing that makes Lucille's stand out is the music. In the days where all bars seem to play Top 40 pop and/or the hip-hop sensation of the day, it's pretty nice to lean back against a booth and listen to Springsteen, Bob Seger, or Fleetwood Mac. Of course, on the weekends, the music gets a touch more contemporary, but that's because the younger crowd is often overflow from nearby Bordo's and The Grammercy. That's why Lucille's is a perfect weeknight place. It's relaxing, the food is great, the drinks are excellent, and the other patrons keep to themselves. Lucille's is actually the perfect "first date" place. The dark wood and exposed brick make an excellent backdrop as you enjoy martinis and tapas and get to know one another.

—*Michelle Hempel*

Maeve

Maeve a.k.a "She Who Intoxicates" lives true to her name.

$$$

1325 W. Wrightwood Ave., Chicago 60614
(at Wayne Ave.)
Phone (773) 388-3333

CATEGORY	Wine bar/Neighborhood pub
HOURS	Mon–Fri: 4 PM–2 AM
	Sat: noon–3 AM
	Sun: noon–2 AM
GETTING THERE	Street parking. It's okay.
PAYMENT	[VISA] [MasterCard] [American Express] [Discover]
POPULAR DRINKS	Wine! Maeve features 22 different wines by the glass.

UNIQUE DRINKS	$5 martini specials on certain nights.
SEATING	There are many places at the bar and several four top tables. It wouldn't be great for huge groups, but groups of up to six should do fine.
AMBIENCE/CLIENTELE	Maeve looks like a classic neighborhood Chicago bar with its wood paneled walls and dark wood bar. But, the great wine and martini lists raise the sophistication bar. While it may be off the beaten bar path, people who visit Maeve once tend to want to come back. The clientele is diverse, particularly since Maeve is located right across the street from the ever-popular Rose Angelis restaurant. You can put your name in for the two-hour wait at Rose Angelis and head over to Maeve to enjoy a few pre-dinner cocktails. Rose Angelis will call you when your table is ready.
EXTRAS/NOTES	Occasionally Maeve features wine tasting events.

—*Michelle Hempel*

Old Town School of Folk Music

(see page p. 49)
Live entertainment/folk music center
909 W. Armitage Ave., Chicago 60625
Phone (773) 728-6000

Peet's Coffee & Tea

Peet's is the American way: Plenty of selection and the service to back it up.
$$
1000 W. North Avenue, Chicago 60622
(at N. Sheffield Ave.)
Phone (312) 475-9782
www.peets.com

CATEGORY	Coffee bar selling beans and loose-leaf teas
HOURS	Mon–Fri: 6 AM–8 PM
	Sat/Sun: 7 AM–8 PM
GETTING THERE	Free lot, busy on Saturdays. Red line North/Clybourn stop is one long city block away.
PAYMENT	VISA MasterCard AMERICAN EXPRESS
POPULAR DRINKS	The standards—because at Peet's they never taste standard: Café latte, cappuccino, and regular joe.
UNIQUE DRINKS	Masala chai ("Peet's own blend of tea and spices"), the Swirl (espresso, milk, chocolate and caramel over ice and whipped cream on top
FOOD	Muffins, cookies, biscotti and plenty of gourmet chocolate
SEATING	Four bar stools, eight or nine tables with chairs or pew-like benches.
AMBIENCE/CLIENTELE	Shoppers, business types, regulars, all in harmony through the magic of coffee and eclectic, somewhat jazzy, tunes.
EXTRAS/NOTES	At least ten varieties of coffee beans are available,

as well as over 30 different teas. You can sample any coffee at the bean counter and a purchase of beans gets you a free cup of coffee. Peet's carries fresh beans (delivered to the shelf within 24 hours of roasting) and the smell alone is enough to encourage curling up with a good book, if there was a place to curl up. As it is, the space at this location is limited and the seats, hard.

OTHER ONES　　Pete's is all over the U.S.. In Illinois try:
　　　　　　　• Evanston: 1622 Chicago Avenue, Evanston, 60201
　　　　　　　　　　　　　　　　　　　　　　　　—Sarah B. Brown

Rose's Lounge
Macedonian matron offers oasis of repose from collegiate chicanery.
$
2656 N. Lincoln Avenue, Chicago 60614
(at N. Sheffield Ave.)
Phone (773) 327-4000

CATEGORY	Old man bar laced with people under thirty who do not wear baseball caps
HOURS	Daily: 5 PM–2 AM
GETTING THERE	Street parking on Lincoln.
PAYMENT	Cash Only
POPULAR DRINKS	"Only two choices in this city," said The Streets' Mike Skinner, "KFC and Mickey D's." Last time we checked, there were only two beers on tap in Rose's, Old Style and Guinness, but as of April 2005, they appear to have spawned a Miller Lite tap. A frosty mug of either Old Style or Miller Lite will set you back a whopping buck, and with Guinness, only costing 3 dollars, one could easily become thunderously drunk for under ten dollars at Rose's.
UNIQUE DRINKS	From time to time, Rose is known to concoct her own shots for regulars, often involving Bailey's and, as always, on the house.
FOOD	Rose is more than happy to provide a bowl of pretzels to go along with that dollar pint of Miller Lite. One time she even offered a delightful cheese and bread treat she had baked in her own home oven.
SEATING	A dozen bar stools, a scattering of tables, Rose's is the perfect intimate enclave after a Saturday night movie at the 3 Penny theatre.
AMBIENCE/CLIENTELE	Very low-key and subdued in the evening hours, there is scarcely more than five people in the entire bar. A very kind and welcoming clientele, though, so there is no need to fear a Wild West saloon-style stare-down as you enter.
EXTRAS/NOTES	Rose's offers an oasis of Old World charm on a strip that suffers all too greatly from collegiate sports bar brouhaha. Maintained with maternal care and pride by wily octogenarian, Rose, the beer is cheap and the ambiance is thicker than the clouds on Venus. With lively regulars, a pool table, Christmas lights the year round, and a jukebox that operates on 1959 technology, to step into Rose's is to step out of time. Listening to a 45 of "99 Red Luftballons" on tinny speakers while toasting your friends with 3-dollar

mugs of Guinness reconfigures all previous notions of the word "quaint." Balanced back behind the shelf of bottles is a map of Macedonia. Rose will be happy to show you where she's from as she pours you a complimentary shot—laden with Baileys, a sugary treat—a sweet drink from a sweet lady.

—*Josh Cox*

Sangria Restaurant & Tapas Bar
Experience the inspiration of authentic Latin traditions.
$$$
901 West Weed St., Chicago 60622
(at W. North Ave.)
Phone (312) 266-1200 • Fax (312) 397-0589
www.sangriachicago.com

CATEGORY	Restaurant bar by day, Latin lounge by night.
HOURS	Lounge
	Sun–Thurs: 'til midnight
	Fri: 'til 4 AM
	Sat: 'til 5 AM
HOURS	Restaurant
	Sun–Thurs: 5 PM–10 PM
	Fri–Sat: 5 PM–midnight
	Also open for lunch on Saturday and Sunday
GETTING THERE	Free lot (Free with validation before 8 PM— lot east of the restaurant on Fremont), Street parking difficult, Valet $4
PAYMENT	VISA MasterCard AMERICAN EXPRESS DISCOVER
POPULAR DRINKS	Sangria, of course, but full bar and wine list with selections from Spain, Chile and Argentina are also available.
UNIQUE DRINKS	Specialty sangria drinks: champagne, mango, white peach, and raspberry, served by the glass or the pitcher.
FOOD	Authentic Central American, South American, and Spanish cuisine. Full menu: appetizers, soup/salad, entrees. Hot and cold tapas from twenty Latin countries, Paella, *Ceviches* (citrus-cured seafood). Healthy, lifestyle-conscious recipes: Vegetarian, Lo-carb, and Lo-fat dishes.
SEATING	Capacity: 200 main dining room; 40 in the cafe; 40 in the lounge; 30 outdoor, Private Party room holds 200
AMBIENCE/CLIENTELE	Sangria has a very colorful décor, with a nice blend of warm and cool tones, as well as round and angular shapes. The restaurant has a unique, modern design, with polished wooden floors, mosaic tiling on the walls, and a rich variety of colors throughout. The lighting is very subdued, but the energy is high as Latin rhythms resonate through the bar and dining area. After dinner, couples make their way to the dance floor (in the middle of the dining area) to dance the night away. Even if you don't know how to dance, it's very entertaining just to sit back and watch those who do.

EXTRAS/NOTES Try the Pastel de Chocolate Caliente—warm choco-
late cake w/ vanilla ice cream served over coffee
cream sauce or the Seasonal Sorbet, topped w/ fresh
berries. Interested in opening your own Sangria?
They have an application page on their website.

—*Melanie Brigg*

HOW ABOUT SOME
LIVE MUSIC TONIGHT?

The **Empty Bottle** is the premier venue in Chicago for catching
bands on the brink of globe-chewing ubiquity. Long before
Interpol and Franz Ferdinand were headlining festivals, they rose
up through the ranks at venues like the Bottle. Before the Von
Bondies had a major label deal and Jack White had yet to pummel
the face of VB singer Jason Stollsteimer, Mr. White Stripes himself
could be seen at the Bottle in support of his liege. The Bottle is
also a springboard for musician/employees. Consider the case of
Rob Lowe (no, not the sex taper/West Winger). A lynchpin of local
group, 90 Day Men, Rob went from escorting belligerent New
Year's Eve revelers away from the malevolence of a microphone-
wielding Har Mar Superstar to becoming the latest addition to
Brooklyn's critical darlings, TV on the Radio. The drinks are
cheap, too, as the matchbooks profess, so don't hesitate to double
up — you don't want to miss a minute of the show. (1035 N.
Western, (773) 276-3600, www.emptybottle.com)

Lakeview's **Bottom Lounge** has had its share of booking coups.
In March of 2005, herky-jerky Canadian popsters Hot Hot Heat
could have easily filled the Metro but they played this intimate
Lounge instead, bringing with them, the buzz of San Diego glam
band, Louis XIV. One month later, Juliette Lewis answered all
naysayers with a blistering, kick-in-the-shins performance at the
Lounge, which has also provided its stage for life-changing
performances from The Locust, The Ssion, and Tracey & the
Plastics. If the music's too much for you, the bar is in a separate
room, where cocktails are on equal footing with beer in the price
department, making for affordable inebriates. (3206 N. Wilton
Ave., (773) 975-0505, www.bottomlounge.com)

Martyr's in Lincoln Park has some of the best acoustics in
Chicago, good enough for local uber-producer Steve Albini to use
it for a weekend residency for his band, Shellac. Martyr's is also a
favorite of rising British bands. Both Keane and Delays played
Martyr's before moving on to bigger stages. Arizona singer-song-
writer Roger Clyne always draws a big crowd, too. If the Bottom
Lounge is the surly punk cousin of the Chicago rock circuit, and
the Empty Bottle is its snobby older indie brother, Martyr's is the
resigned AOR uncle, who likes his rock with a healthy dollop of
folk – brushes on snares, gently strummed lullabies. (3855 N.
Lincoln Ave., (773) 404-9494, www.martyrslive.com)

The Irish-owned and operated **Abbey** draws a crowd as diverse as
the acts it books. From Japanese guitar-slinger Guitar Wolf to
Welsh rap collective Goldie Lookin' Chain, it's not all just
Riverdance and Guinness at the Abbey. Both a restaurant and a

pub, purists of sport can follow all the major European tourneys here. A dinner reservation will provide you with preferred seating at the show. (3420 Grace St. (at Elston), (773) 478-4408, www.abbeypub.com)

Steppingstone venues, **Beat Kitchen** (2100 W. Belmont) and **Elbo Room** (2871 N. Lincoln) offer much-needed exposure to local bands hungry for the coveted stages of the Empty Bottle, Double Door, and Metro. Located within blocks of each other, you can make a night of it, checking out local talent as the mood suits you. If you're up for supporting the Chicago scene, especially those bands that have yet to fall under the local media spotlight, make a discovery for yourself at either the (Beat Kitchen, (773) 281-4444, www.beatkitchen.com) or (Elbo Room, (773) 549-5549 www.elboroomchicago.com)

—*Josh Cox*

EDGEWATER

Moody's Pub

A cozy fireplace in winter and a beer garden in summer— what's not to love?

$$

5190 N. Broadway St., Chicago 60660
(at Rosedale Ave.)
Phone (773) 275-2696

CATEGORY	I lived on the north side for two years before I realized that the tan-brick and wood-clad building was not a bank. This is definitely a pub.
HOURS	Daily: 11:30 AM–1 AM
GETTING THERE	There is a free parking lot. Parking is also available on the street. For those who don't want to drink and drive (and with beer this cheap it's easy to enjoy one-too-many), take the Red Line train to the Thorndale stop.
PAYMENT	Cash only, but there are ATMs located at nearby Broadway Bank.
POPULAR DRINKS	Moody's serves draft beer, and there are some good deals on pitchers of Michelob, Anchor Steam, Beck's, and Berghoff's. Or try the sangria; it's quite refreshing on a hot summer's night. Bar liqueurs are $3.75, top shelf are $5.00.
UNIQUE DRINKS	Moody's has a small selection of cocktails on the menu, including the Moody, a combination of Amaretto, orange juice, and a splash of soda.
FOOD	Burgers are why people come to Moody's—big, juicy, old-fashioned style hamburgers cooked to order. You need both hands to heft these half-pound beauties. Burgers are $6.25; add cheese for another 50 cents— and they come with fries. The Moody Bleu burger was divine, and I had to order extra onion rings because friends kept stealing mine. If you're not in the mood for a burger, try the sloppy joes—they're just like Mom used to make.
SEATING	Although the dining room is charming, there are way

too many tables crammed in to move about comfortably, especially in the evening when it gets crowded and there may be a short wait. If you plan on eating inside, get there early and grab the table next to the big, round window. Or, better yet, unwind in the beer garden. The huge patio with its ivy-covered walls and overhanging trees muffles out the city noise. A water fountain lends a nice European touch.

AMBIENCE/CLIENTELE It's dark, *really dark*, inside and even the outdoor garden is dimly lit. Still, nothing beats sitting under the trees, sipping an ice-cold beer. Since it's dark, wear whatever you want, no one can see you anyway. Just watch out for the birds over your head—they like to leave surprise droppings.

EXTRAS/NOTES (Voted "Best Burger in Chicago" by the *Chicago Tribune, Chicago Sun-Times*, and *Chicago Magazine*. Plus, my male friends sum up the staff this way: "Cute waitresses with foreign accents and short skirts."

—J. Asala

ROGER'S PARK

Ennui Café and Gallery
Neighborhood coffee joint for the stridently anti-Starbucks crowd.
$
6981 N. Sheridan Rd., Chicago 60626
(at Lunt Ave.)
Phone (773) 973-2233

CATEGORY Independent Coffeehouse
HOURS Mon–Fri: 7:30 AM–1 PM
Sat–Sun: 7:30 AM–1 PM
GETTING THERE Take the Red Line to Morse. Ennui is just northwest.
PAYMENT Cash only.
POPULAR DRINKS Coffee, espresso drinks, and tea of all types.
FOOD Bakery items (scones, muffins, etc.), sandwiches, breakfast staples. All reasonably priced.
SEATING Room for about 40-50 or so when a live band isn't playing.
AMBIENCE/CLIENTELE The chairs don't match, the floors are a bit creaky, newspapers are strewn about tables, one rather large fan provides the air conditioning in the summer. And yet the "drive-thru" mentality of many coffee chains is also absent here. Grizzled professors reading Trotsky and dreadlocked musicians convene along side middle-aged neighborhood activists.
EXTRAS/NOTES One patron describes Ennui as "a loner's dream"—a pro or a con depending on one's worldview. I suppose Cafe Ennui is a coffeehouse in the truest sense of the word: no chi-chi dinner menu, no Venti double Frappuccino's, and more importantly, no pretense. Ennui features dog-friendly outdoor seating, and is a strong supporter of neighborhood art and music (Ennui is a sponsor of the *Rogers Park Jazz Series*). Smokers can rejoice, the coffeehouse is not non-smoking. Also, live jazz three nights a week.
—*Keidra Chaney*

Siena Coffee

A place to get a sip or grab a bite.
$$

2308 N. Clark Street, Chicago 60614
(at Belden Ave.)
Phone (773) 665-7182

CATEGORY	Hole in the wall coffee shop
HOURS	Mon–Fri: 6:30 AM–6 PM
	Sat: 7 AM–6:30 PM
	Sun: 7:30 AM–5 PM
GETTING THERE	Limited parking (meter, permit and street). Pay lot a block away on Belden.
PAYMENT	VISA MasterCard
	With $5 Minimum
POPULAR DRINKS	Daily dark, light and flavored roasts brewed. A really good selection of teas from The Republic of Tea.
UNIQUE DRINKS	Delicious fruit smoothies.
FOOD	Muffins, breads, scones, fruit, fare from Salad Spinners and sushi
SEATING	A few bar stools line up against the front window and along one wall. One glass-topped table in the center.
AMBIENCE/CLIENTELE	Quick stop for coffee or lunch in a very cozy and inviting space.
EXTRAS/NOTES	The Korean-born owner, whose mother lived in Japan, serves maki and miso soup daily at lunchtime. Siena Coffee is also the only coffee shop between North and Fullerton, and east of Lincoln.

—Sarah B. Brown

Southport City Saloon

This Saloon ain't just for cowboys.
$$

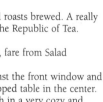

2548 N. Southport Ave., Chicago 60614
(at Wrightwood Ave.)
Phone (773) 975-6110 • Fax (773) 929-9294

CATEGORY	Neighborhood bar/restaurant
HOURS	Mon–Fri: 11:30 AM–2 AM
	Sat: 11:30 AM–3 AM
	Sun: 11 AM–2 AM
	(Restaurant serves until 10 PM Sun-Wed;
	11 PM on Thurs; and midnight on Fri/Sat.)
GETTING THERE	There is street parking that is usually easy. Weekends can be a bit more difficult however.
PAYMENT	VISA MasterCard
POPULAR DRINKS	If you're a beer drinker, the Southport has a modest selection of draught beers. They do carry their own signature Southport Lager, which is worth a taste.
UNIQUE DRINKS	During the summer hours, a necessary treat is the frozen Mango Martini. Not only is it one of the more delicious libations to saturate your palate, but it's damn pretty to look at too.
FOOD	The restaurant boasts a full menu. Appetizers include a shrimp cocktail, quesadillas, wings and more. The dinner menu is excellent. The burger is out of this world as are the other sandwiches. The steaks and entrees are worth several trips back. I highly recommend the pork chops. Other quality menu items are the ribs, BBQ chicken on the bone, and the Southport Chicken. The highlight of the kitchen's

cuisine is the weeknight only, Blue Plate Special. This creation cooked up by Chef Jose makes the Southport a worthwhile dinner destination every night of the week. Meatloaf, Italian sausage, sweet and sour chicken, and chicken parmesan are just a few of the different dishes you can expect. Friday nights play host to the Friday Fish Fry and the New England clam chowder. Saturday provides prime rib specials with the occasional king crab leg dinner as well.

SEATING

Seating is ample at the long bar as you step in the door. There are also several tables in the bar that could accommodate several large groups while still leaving room for couples to find a spot. The restaurant is two tiered, the lower of which is very romantic with a fireplace.

AMBIENCE/CLIENTELE

This is a very casual atmosphere. A person can show up wearing a suit and tie and dine with a person wearing shorts and sandals and not feel unusual. The crowd usually consists of larger groups on the weekends. The Southport's spaciousness makes it ideal for this. They also cater to private parties. Those that come here are neighbors for the most part. There are a host of regulars to both the bar and restaurant and the bartenders/servers tend to learn your name after a few appearances. However, many groups take cabs here for dinner due to its central locale among Chicago hot spot. It makes for a great meeting place for people around the city to have dinner and drinks. Many either stay in the bar afterwards, or travel on to other locations.

EXTRAS/NOTES

There is a pool table in the back along with a Golden Tee machine. The building itself is over 100 years old. It used to be a dry cleaner in the early 1900s. Ask to see a menu for the story of the building on the back. It's quite interesting. There is an outdoor patio with a small bar. This has to be the most charming beer garden in the city of Chicago. Decorated with hanging lights and artifacts all over the high fences, this is a wonderful place to take a date or meet a group of friends. Tables are accommodating to either, equally. There are also televisions placed throughout the bar and restaurant for viewing of whatever sporting event might be taking place. For big games, count on extra TV's being brought out to the patio. There's nothing quite like sitting in the warm evening breeze, enjoying a mango martini and watching a Cubs game.

—*Michael P. Fertig*

"Without question, the greatest invention in the history of mankind is beer. Oh, I grant you that the wheel was also a fine invention, but the wheel does not go nearly as well with pizza."

—*Dave Barry*

The Tonic Room

*Great gin, great music, and
a lot of Chicago history.
And remember, Cealed Kasket
hates you.*

$$

2447 N. Halsted St., Chicago 60614
(at Fullerton Pkwy.)
Phone (773) 248-8400
www.tonicroom.com

CATEGORY	This is a very hip lounge bar.
HOURS	Sun–Fri: open until 2 AM
	Sat: open 'til 3 AM
GETTING THERE	Look for street parking on Halsted. If you are on a side street, be careful of the permit zones.
PAYMENT	VISA MasterCard
POPULAR DRINKS	Gin and tonic!!
UNIQUE DRINKS	In Lincoln Park, the land of sports bars, The Tonic Room is a nice place to drink some good gin.
FOOD	Strictly booze and beers here.
SEATING	There is a bar, a few tables, and a lot of plush leather coating the walls. The Tonic Room is a mix between a bar and a lounge; it can definitely get cozy in there.
AMBIENCE/CLIENTELE	This place is a very mellow lounge bar. The lighting is on the dim side, and all along the walls are old antique liquor bottles, some dating back to the prohibition era. The lounge couches are very comfortable and they usually wrap around small candle-lit tables. The clientele can be anyone from hipsters and hip-hop heads to your average local looking for a stiff drink. Everyone is welcome at The Tonic Room, and diversity is embraced.
EXTRAS/NOTES	When you enter The Tonic Room and sit at the bar, you may notice a "Cealed Kasket Hates You" shirt for sale above the bar. Cealed Kasket is a heavy metal band that is comprised of some of the staff from the bar. Do yourself a favor; when you stop by The Tonic Room ask the bartender where and when the next show is, because they are one of the best bands I have seen in a long time. The Tonic Room is also full of Chicago history. According to Chip the bartender, it used to be a barbershop during prohibition, with a speakeasy in back and in the basement. It was strongly tied to the Irish Mafia, whose members used to drink and frequent the bar after prohibition. Chip insisted that the bar was haunted, and that he has seen a few ghosts wandering around behind the bar. Also, in the basement there is part of a wall that is bricked off. Behind the bricks is an old tunnel that goes underneath Halsted. During prohibition, people could go from bar to bar underground and The Tonic Room was part of the tour.

—*Billy Kenefick*

"Beer is proof that God loves us and wants to see us happy."

-—*Benjamin Franklin*

Webster's Wine Bar

One of the best date places in Chicago.

$$$

1480 W. Webster Ave, Chicago 60614
(at Clybourn Ave.)

Phone (773) 868-0608

CATEGORY	Wine bar
HOURS	Mon–Fri: 5 PM–2 AM
	Sat: 4 PM–3 AM
	Sun: 4 PM–2 AM
GETTING THERE	Free lot.
PAYMENT	VISA MasterCard AMERICAN EXPRESS Discover
POPULAR DRINKS	Wine – there is a HUGE wine list and several pages of wines by the glass.
UNIQUE DRINKS	Did I say they had a great wine selection?
FOOD	Their menu features many appetizers that go well with wine.
SEATING	You definitely want to sit down at Webster's. It will seat at least 50.
AMBIENCE/CLIENTELE	Webster's Wine Bar is one of Lincoln Park's tried and true date places. It's located near many tasty restaurants, and it's a stone's throw from the large Webster Place Cinema. Can anything be better than dinner, a movie, and wine? It's dark and cozy inside, usually filled with couples. You'll also see small groups of women chatting over flights of red and white varietals.
EXTRAS/NOTES	There are usually good specials on wine by the glass. Ask the friendly bartenders for help.

—Michelle Hempel

Zakopane Lounge

Where everyone's a wee bit Polish.

$$

1734 W. Division St., Chicago 60622
(at Paulina St.)

Phone (773) 486-1559

CATEGORY	Neighborhood Bar, Historic Bar.
HOURS	Mon-Fri: 7 AM-2 AM
	Sat: 7 AM-3 AM
	Sun: 11 AM-2 AM
GETTING THERE	Parking lot at Division/Paulina, street parking is manageable.
PAYMENT	Cash only
POPULAR DRINKS	Beer is largely served here (they have Bud, Old Style and Michelob Amber on tap), though the barmaids do serve up standard mixed drinks and shots.
UNIQUE DRINKS	Everything seems unique when it's served by a real Polish barmaid with a real scoop-neck top.
FOOD	None, aside from packets of peanuts and tangy cheese chips.
SEATING	Some scuffed-up tables line the wood-paneled walls; seating at the bar.
AMBIENCE/CLIENTELE	It might be considered a dive to some, but Zakopane's Formica-topped bar is lovingly tended to by a trio of Polish-accented barmaids. Dusty Polish pensioners belly up to the bar while unkempt young hipsters shoot pool. Occasionally the back room

	opens for dancing and live rock-polka music.
EXTRAS/NOTES	This humble bar has steadfastly maintained its Polish authenticity (despite watching the neighborhood around it grow WASPy and wealthy), catering to Eastern European locals and friendly regulars looking to avoid the nearby yuppie crush. The jukebox provides a most diversified selection, offering Polish pop hits, George Strait, Englebert Humperdinck and Led Zepplin. For the budget-conscious, the drinks are CHEAP!

—Gina M. DeBartolo

OLD TOWN

Coffee Expressions

With six Starbucks within a mile radius, why not support a local business run by the good guys?

$$

100 W. Oak St., Chicago 60610
(at Clark St.)
Phone (312) 397-1515
www.chicagoexpressions.com

CATEGORY	Coffee Expressions is an independently owned and operated coffee shop that actively supports the local art and music scene.
HOURS	Mon–Wed: 7 AM–6 PM Thurs–Sat: 7 AM–8 PM Sun: 9 AM–5 PM
GETTING THERE	Street Parking
PAYMENT	VISA MasterCard
POPULAR DRINKS	"The Mango Mystery Tour" comes highly recommended. It is a smoothie consisting of mango, strawberry, and pineapple.
UNIQUE DRINKS	The most unique drink at Coffee Expressions is the "Poison Apple." When I asked what was in it, Dan the manager said it was a secret.
FOOD	This is a coffee shop that prides itself on having "real food." Their menu includes all kinds of sandwiches, fresh pastries, and baked goods. It is a great place for a light breakfast or a tasty lunch, and the prices are kind on the wallet.
SEATING	There is everything from tables and chairs to couches here. It is suitable for a casual business meeting or a nice and easy lounge session.
AMBIENCE/CLIENTELE	Coffee Expressions is popular because of its independent and homely feel. It is run and maintained by staff that is not only friends with the customers, but also with each other. Art from local artists is showcased on the walls, and cool music is always playing. Live music, including a weekly open mic night, is also featured here.
EXTRAS/NOTES	They have board games to play with. There also is local local art showcased and for sale on the walls. Before it was Coffee Expressions, it was known as "Cathy's Place" and some locals still refer to it that way. The live shows and the open mic's are all BYOB (encouraged).

—Billy Kenefick

R.I.P.
The Prodigal Son Bar & Grill

Many came for the free bacon Wednesdays and "you-bring-it-we'll-fry-it" for a buck on Thursdays. Some came to play Q-bert, and others, to throw darts against a real cork board with real, potentially hazardous steel-tipped darts. Still others showed up just to see their band, or any band for that matter. And, of course, everyone came for the beer and grilled cheeses.

Once a Lebanese restaurant called Uncle Tannous, Prodigal Son was a rare breed: an all-styles kind of dive in preppy, aging-frat-bar laden Lincoln Park. The bar was often smoky and dim, and shadowed by dark images along one wall depicting the story of the biblical Prodigal Son. Despite the potential for gloom, the space was enlivened by festive Tiki decor and a marquis-style Elvis sign lighting up one of the walls.

If the interior wasn't intriguing enough, the menu would surely have caught your eye. With 12 different grilled cheese sandwiches, such as the Ernesto (cream cheese and green olives) and the Burger-Cheese (American cheese, _ burger, tomatoes and red onion) all $7 or less, Prodigal Son turned this easy meal gourmet. But the only thing harder than deciding what to eat, was deciding what to drink, and from what country. During college, I was first introduced to Belgium beers such as La Chouffe and Rochefort 10 at Prodigal, and enjoyed my first beer tasting here as well. My personal favorite from the Prodigal Son collection, however, was Ayinger Celebrator, with its own plastic mini-ram decoration (let's just say I have a "collection").

Sadly, in 2003, a fire started in the empty upstairs apartment and—unbeknownst at the time—permanently shut down the Prodigal Son. Now, the building has been demolished and the lot on Halsted St. stands empty, probably waiting for the next brick condominium with commercial space on the ground level to be occupied by a salon or boutique—a predictable Lincoln Park building.

After graduation, I joked with my Wisconsin family that I had found my "hang-out" bar and that was the reason why I had to continue living in Chicago. I could go to Prodigal Son any night of the week, by myself and without telling anyone where I was going, and still run into a friend there. Many of us talked with and listened to owners John and Joel, while watching kung fu movies and selecting songs on the jukebox. I experienced incredibly brilliant bands, and incredibly horrible bands, often with a can of PBR in my hand. I ate and drank and "squandered…wealth in wild living."

No matter what drew us in the beginning, patrons of Prodigal Son had found their home in this bar. And though the bar is lost to us now, and we are all a bit wayward, we still hope to one day taste the fattened calf.

—Sarah B. Brown

Twin Anchors
Come for a drink... Stay for the ribs!
$$
**1655 N. Sedgwick St,, Chicago 60614
(at Eugenie St.)**
Phone (312) 266-1616 • Fax (312) 943-3528
www.twinanchorsribs.com

CATEGORY	Restaurant bar
HOURS	Mon–Thurs: 5 PM–11 PM
	Fri: 5 PM–midnight
	Sat: noon–midnight
	Sun: noon–10:30 PM
GETTING THERE	Valet parking. Street parking can be hard, watch for zone parking signs. Taxis will be close by as well.
PAYMENT	VISA MasterCard AMERICAN EXPRESS DISCOVER
POPULAR DRINKS	Try a Bloody Mary ($5), made to taste, garnished with your favorites
UNIQUE DRINKS	It's Chicago, so drink what you want.
FOOD	Full restaurant menu, about average prices for the city. Ribs are $20 and are widely regarded as some of the best ribs in the City (perhaps the world). Steaks, chicken, burgers, salads fill out the rest of the menu. Bar snacks are complimentary, but you don't want to fill yourself up with that if you're going to be eating.
SEATING	Seating available at the bar. Some booths. Dining area has tables. About medium sized. If you want to eat, you'll wait a little bit, but turnover is pretty quick. A seat will open up at the bar pretty fast for you to sit and nurse a drink. Good for groups of 4 or more. They don't take reservations for dinner, but they do their best to accommodate large groups. I went there once with a group of about 16 people and it was no trouble.
AMBIENCE/CLIENTELE	Classic wood finish bar and framed reviews, pictures of icons and Chicago cityscapes give the bar a nostalgic look without being kitschy or cheesy. It's casual, but you'll find the suit and tie businessman still in their duds from work. Dress code is casual, but don't come in looking like a total schlub. You'll be able to smell the famous zesty rib sauce from a block away.
EXTRAS/NOTES	Try the cheesecake. Rob and Lisa (bartenders) are nice, always up for a conversation. Regular patron Mike Prendergast used to live above the restaurant and still loves it to this day. He just wishes they still had America in the jukebox. Jukebox in the corner (even had Wilco's Yankee Hotel Foxtrot). This was Frank Sinatra's place for ribs when he would come to town, so you know it's gotta be good. On Sunday's during football season, it's a good place to have a burger, drink a beer, and watch Da' Bears!

—*Jeffrey Goodman*

"I love to drink martinis. Two at the very most. Three and I'm under the table. Four and I'm under the host!"

—*Dorothy Parker*

LAKEVIEW

Annex 3

Order up a screwdriver and say hello to Beyonce for me!

$$

3160 N. Clark St., Chicago 60657
(at Belmont Ave.)
Phone (773) 327-5969

CATEGORY	Gay, Lesbian, Local Lounge/Bar
HOURS	Mon–Sat: 10 AM–2 AM
	Sun: 11 AM–2 AM
GETTING THERE	Parking is difficult. Take the Brown or Red Line to Belmont and head east (2 minute walk). Also, 22 Clark Bus, 77 Belmont Bus, 36 Broadway, 8 Halsted.
PAYMENT	VISA MasterCard AMERICAN EXPRESS DISCOVER
POPULAR DRINKS	The hard stuff—gin and tonic, whiskey sours and, believe it or not, the screwdriver.
SEATING	Seating for around 60+. Fifteen or so around the bar and plenty of tables are scattered throughout the bar in front near the "stage" and in the back area.
AMBIENCE/CLIENTELE	This place is fun, festive and a party any time of the night or day. A3 caters to a mostly gay/lesbian crowd, but straights are always welcome here with open arms. Twice a month, amateur female impersonators strut their stuff, paying tribute to icons like Cher, Tina Turner, Patti LaBelle, Madonna, Barbara Streisand and Bette Midler and divas like Beyonce and Mary J. Blige with a few pop stars thrown in for good measure like Britney Spears, Christina Aguilera, and Pink.
OTHER ONES	• Check out the Baton (same owner) at 436 N. Clark St., Chicago 60610, (312) 644-5469. Professional female impersonators nightly since 1969.

—Michelle Burton

Belair Lounge

This place has enough character and characters to keep you entertained.

$$

426 W. Diversey Pkwy, Chicago 60614
(at N. Sheridan Rd.)
Phone (773) 549-6967

CATEGORY	Local Dive
HOURS	Mon–Fri: 'til 2 AM
	Sat/Sun: 'til 3 AM
GETTING THERE	Street Parking is extremely difficult—it takes a lot of patience and skill to find a space here. You might get lucky around the park, just east of Sheridan or south of Diversey otherwise try the park around inner Lake Shore Drive or metered parking on Broadway.
PAYMENT	VISA MasterCard
POPULAR DRINKS	Guinness—$3.00 pints!
UNIQUE DRINKS	The Guinness special, of course!
SEATING	The space is very small, but the patrons are so friendly that you won't feel uncomfortable at all. There's room for around 15 around the bar, two hi-top tables against the east wall for eight and seating for around six in the window.

AMBIENCE/CLIENTELE	This quaint bar is owned by a genuine Irish man and he keeps the Guinness flowing into the wee hours of the morning. The jukebox supports typical mainstream music with a little Frank Sinatra or Bob Marley sprinkled in here and there. The patrons are usually regulars that usually stick around from open to close. This is part of what gives this little lounge its character.
EXTRAS/NOTES	This place has lots of characters you won't find next door at Duffy's or a sushi bar. Have a question about Chicago history? Ask the guy sitting next to you, he'll know.

—*Grant Christman*

Bungalow Lounge

The Bungalow is how Lakeview does a lounge.
$$$
1622 W. Belmont Ave., Chicago 60657
(at N. Lincoln Ave.)
Phone (773) 244-0400

CATEGORY	Lounge
HOURS	Sun–Fri: 6 PM–2 AM
	Sat: 6 PM–3 AM
GETTING THERE	Free lot at Lincoln and Melrose. Street parking is okay.
PAYMENT	VISA MasterCard AMERICAN EXPRESS DISCOVER
POPULAR DRINKS	It's a martini and mixed-drink crowd.
SEATING	There are several seats at the bar and about 15 -20 small tables scattered around. Don't expect to sit down on a weekend if you arrive too late.
AMBIENCE/CLIENTELE	Bungalow is one of those bars that has a severe personality transplant from weeknight to weekend. On the weeknights it has a relaxed, easy-going feel to it. But with Friday and Saturday, comes the inevitable electronic/techno music and those who love it. Bungalow is full of pretty people in great clothes, mostly in their late 20s—early 30s. Bungalow is how Lakeview does a lounge. It looks and feels like the super trendy hot spot lounges downtown but has about half the attitude.
EXTRAS/NOTES	Bungalow often offers special $5 cocktails and occasionally sponsors wine tastings and other events.

—*Michelle Hempel*

Café Avanti

Everything you'd expect from a charming neighborhood café.
$$
3714 N. Southport, Chicago 60613
(at Waveland Ave.)
Phone (773) 880-5959

CATEGORY	Independent coffee house
HOURS	Sun–Thurs: 7 AM–11 PM
	Fri/Sat: 7:30 AM-midnight
GETTING THERE	Some metered parking, but harder to find space

during the weekend.

PAYMENT	
POPULAR DRINKS	"Café Avanti" Mocha
FOOD	Standard café fare: cookies, cakes, biscotti.
SEATING	Seating for over 50—main room—seating for larger groups in the back room.
AMBIENCE/CLIENTELE	This casual neighborhood coffeehouse located down the street from the Music Box Theater and blocks away from the Metro entertainment center attracts a fair share of late-night movie buffs and concert goers, but more often than not, quiet and friendly. Water and free dog biscuits makes it a pet-friendly atmosphere.
EXTRAS/NOTES	Artwork from local and students artists is often for sale.

—Keidra Chaney

Cesar's

*Bring on the Mega! (*hic*)*
$$$
3166 N. Clark St., Chicago 60657
(at Belmont Ave.)
Phone (773) 248-2835 • Fax (773) 248-4733
www.killermargaritas.com

CATEGORY	Margarita bar and Mexican restaurant
HOURS	Mon–Thurs: 11 AM–11 PM
	Fri/Sat: 11 AM–midnight
	Sun: 1 AM–8 PM
GETTING THERE	Free lot across the street at Marshalls/DSW Warehouse complex. Otherwise—CTA red line, CTA bus route #22 (Clark) or 77(Belmont)
PAYMENT	
POPULAR DRINKS	Jumbo Lime margarita, on the rocks, with salt. Ordering is a complex process here, with multiple questions posed by the menu—follow this list and you will achieve margarita heaven (and a major buzz).
UNIQUE DRINKS	The margaritas are fast and furious here, coming in multiple varieties and increasing sizes.
FOOD	Full Mexican food menu that is darn tasty when paired with the essential margarita or Mexican beer.
SEATING	Seating is spread out over the main dining area on the first floor, and some tables in the main bar below. Good size, but the crowds on weekends fill it quickly.
AMBIENCE/CLIENTELE	Cesar's divides itself neatly between the first floor and basement. Upstairs, mariachi tunes are pumped through the sound system, the hum of casually dressed drinkers and eaters joins in, and the warm colors, plants and tile floors lend a cozy feel. TVs are placed around the restaurant, often showing the Cubs game or a good TNT movie. Downstairs the music is more eclectic and pop-oriented. The chatter is a higher pitched hum as people waiting for tables at the bar gulp down margaritas on an empty stomach and begin to talk just a LITTLE BIT LOUDER. It's darker down here—candles and the illuminated bar are the only guides for those who need a bit of help. The smell of quesadillas and tacos permeates, resulting in a bit of drool for those who drank their

first jumbo a bit too quickly and the cravings are starting. As for the margaritas, they come in fun and oddly shaped glasses, increasing in size all the way up to the "bucket-like" Mega! They are sweet, strong, refreshing and intoxicating. Perfection!

EXTRAS/NOTES	Live music on special occasions, such as the Cincopoluzza, the week of Cinco de Mayo.
OTHER ONES	• Lakeview: 2924 N. Broadway, Chicago, 60657, (773) 296-9097

—*Amy Lillard*

The Closet

"Come out, come out, wherever you are."

$

3325 N. Broadway Ave., Chicago 60657

Phone (773) 477-8533

CATEGORY	Lesbian/Gay, Neighborhood Bar, Karaoke
HOURS	Mon–Fri: 2 PM–4 AM
	Sat: noon–5 AM
	Sun: noon–4 AM
GETTING THERE	Parking is pretty bad anytime after 5 PM during the week and on weekends it's nearly impossible anytime of the day or night. You might score a meter on Broadway or Belmont after driving around the block several times, but save yourself the hassle—walk, take the El or hop in a cab if you can. A word of advice: pay attention to zone postings, you will get ticketed or worse—towed!
PAYMENT	Cash Only.
POPULAR DRINKS	Cocktails are pretty popular here, but they won't mind if you order up a beer!
UNIQUE DRINKS	Do you have something in mind? They have it all, and a pretty lesbian bartender will make it special for you.
SEATING	The space is pretty small with mostly stools to sit your butt on while you watch fun music videos or the occasional sports game (depending on the night).
AMBIENCE/CLIENTELE	Everyone and their mother drinks at the Closet, from your high school P.E. teacher to her partner to the straight couple that likes to go Karaoke bar hopping. Although small in size, the bar appears open and inviting with its use of mirrored walls. The scene is all about having a good time, listening to good tunes, and meeting nice people.
EXTRAS/NOTES	This place has been around since the '80s and Thursday Karaoke night attracts a huge crowd. Aside from the great diversity that other bars should aspire to, the bartenders are a part of the community and often remember your face.

—*Ian Weiss*

"I never drink coffee at lunch. I find it keeps me awake for the afternoon."

—*Ronald Reagan*

Cody's

*The booze is here, just BYOF
(Bring Your Own Food) if you're hungry.*
$$
1658 W. Barry Ave., Chicago 60657
(at Paulina St.)
Phone (773) 528-4050

CATEGORY	Neighborhood Bar, Dive
HOURS	Mon–Fri : 2 PM–2 AM
	Sat: noon–3 AM
	Sun: noon–2 AM
GETTING THERE	Street parking
PAYMENT	Cash only. ATM on premises
POPULAR DRINKS	Beer
UNIQUE DRINKS	Various types of shots on special $2–$2.50, check the board to see what is up.
FOOD	Chips are $1/bag. They allow outside food in the bar and have menus from nearby restaurants that deliver. Feel free to order it to the bar. If you're there at the right time, maybe some pizza will be available at the bar. You can also grill outside on the patio area, just call ahead to make sure there isn't a private party booked and just bring whatever you want to grill. Pretzels served in pint glasses at the bar are free.
SEATING	Bar holds about 15-20 people. Stools and tables around the walls. Some cushioned wall-seats as well. Plenty of space to stand.
AMBIENCE/CLIENTELE	Very casual. Low-key neighborhood crowd mainly. Some artists and urban professionals mixed together.
EXTRAS/NOTES	Golden Tee and coin-op pool. Plenty of dart boards to be had; Two in the bar, two outside and a three board wall in the private party room. There are dart and pool leagues, see the bartender for more info. Party room and patio are available at no cost for rental on a first come, first served basis. Contact the bar to reserve either/or. There is also a Bocce ball court out on the patio area. Darts and bocce balls are available at the bar for rental, just leave your driver's license. It is also a dog-friendly bar, as long as you keep an eye and a leash on your dog. Self-proclaimed "The Best Bar On The Block" may just be that. What other place has coasters with a ruled ledger on them for convenient writing of phone #'s or a scorecard for a card game. They sell cigarettes behind the bar. Bar has a dingy character with the dusty wooden floor, Old Style lamp over the pool table, Schlitz lamps over the bar and the bust of a deer with a tiara and x-mas lights.

—*Jeffrey Goodman*

Coobah

A little Latin flavor in an unlikely area
$$$
3423 N. Southport Ave., Chicago 60657
Phone (773) 528-2220
www.coobah.com

CATEGORY	Trendy Restaurant/Bar
HOURS	Mon–Fri: 5 PM–1 AM
	Sat: 10 AM–3 PM; 5 PM–2 AM
	Sunday: 10 AM–3 PM; 5 PM–1 AM

	Bar open weekdays 'til 2 AM
GETTING THERE	Free lot in the back.
PAYMENT	VISA MasterCard AMERICAN EXPRESS DISCOVER
POPULAR DRINKS	This restaurant/bar is known for its Latin inspired drinks such as Mojitos, Sangria, and Caipirinha.
UNIQUE DRINKS	The fact that this mostly boutique filled street contains a Latin bar is unique enough to fill anyone's curiosity.
FOOD	There is a full menu including interesting Caribbean and Latin dishes like jerk chicken appetizers, lamb with saffron potato gratin and a blue corn crusted fish with chilled lime dressed vegetables. If you want to see how much your date will spend on you, this is the place to do it. Although, not outrageously expensive, dinner and drinks might set you back more than other bars in this area. But on the plus side, you can eat as late as 1 AM Tuesdays thru Friday and 2 AM on Saturdays; a practice unfamiliar to many Chicago restaurants.
SEATING	I've never really waited long for a table at Coobah. Most tables are arranged for smaller parties of four or less, but Coobah can accommodate slightly bigger groups. A reservation for larger parties might be a good idea.
AMBIENCE/CLIENTELE	This romantic and fun spot is great for your weekend starter, night cap, or even main event. The food is wonderful with lots of exceptional dishes that will leave you thirsty for that wonderful Mojito with fresh mint. Go there during the weekday and enjoy a more relaxed environment compared to a more crowded Coobah on the weekends.
EXTRAS/NOTES	On various nights anything from Latin Funk to Afro-Beat and Dub can be heard. Check the schedule on their website for specifics. The wonderful staff can help you decide on any drink you are unfamiliar with. Sit at the bar with them and you can hear some interesting stories. The bathrooms are very avant-garde with large faucet handles that have multi-pronged wheels.

—*Ian Weiss*

Fizz Bar
I feel the Fizz...I can feel the Fizz!
$$
3220-3222 N. Lincoln Ave., Chicago 60657
(btwn. W. Melrose St. and W. Belmont Ave.)
Phone (773) 348-6000
www.fizzchicago.com

CATEGORY	Fizz is many different things at many different times, one minute it's trendy and upscale, the next, it has a low-key neighborhood pub feel.
HOURS	Mon–Fri: 4 PM–2 AM
	Sat: Noon–3 AM
	Sunday: 10 AM–1 AM
GETTING THERE	During the week, street parking is fairly easy, but it can be a bit challenging on weekends. There are meters on Ashland, Lincoln and Belmont.
PAYMENT	VISA MasterCard AMERICAN EXPRESS DISCOVER
POPULAR DRINKS	This is really easy. Two words: Tiki Wednesdays.

UNIQUE DRINKS

Bartender extraordinaire Erik Johnson served me his specialty Mai-Tai in a volcano bowl and set the damn thing on fire. I have been drinking since my high school days and along with an additional beer, I was in good spirits. He tells me this is an actual equivalent to three drinks. You can also try a Mojito as the staff will actually grind the fresh mint right in front of you. The Sneaky Tiki menu—yes, Wednesday nights rock, along with Mai-Tais and Mojitos. Fizz also rums you down with Zombies, Pina Coladas, Castaways, Bahama Mommas, etc. Tuesday nights offer half price bottles of wine, Fridays are $4 Vodka Lemonades and Saturdays give you a $5 Skyy Martini.

FOOD

Fizz offers some of the best bar food I've ever had. There is a full menu of sandwiches, pizzas, appetizers and desserts. Try the Chicken Taco Wrap—excellent! I also recommend the Southwestern Soup. The prices are very reasonable and portions are hearty.

DRINKS

Beer, wine, stiff cocktails, fruity concoctions, the whole nine!

SEATING

Large space that's perfect for bigger parties. There's seating for around 20 at the bar along with around 20 tables throughout the bar. There is also a large beer garden that is heated in the winter and a party room upstairs for special events.

AMBIENCE/CLIENTELE

Fizz is one of those "good time" joints that mixes a little trend, a little "old-school" and a lot of fun. Like I've mentioned, the mix here is interesting. It can be casual or upscale…your choice. The one thing that needs mentioning is the staff. They are extremely friendly and ready to show you a good time. I had the pleasure of meeting Eric the bartender, along with one of the servers, and the owner. I believe you can tell a good place by the conversations you get into. I mean, come on…anyone can just sling drinks. The conversations ranged from the bar business to the old neighborhood, drinking and writing exploits to music and at one point it was decided that the bartender and I must have been brothers separated at birth. It is kind of hard to put my finger on the general atmosphere of this place except to say that Fizz is the kind of bar you can stroll into for the first time and the people make you feel at home or as if you'd been hanging out there for years. While my visit was too short, I had a great time and kudos to the great people at Fizz as I now have a new Wednesday night drinking home.

EXTRAS/NOTES

You can purchase Tiki glasses and other "island" drink paraphernalia. Oh, and here's something to think about: an old neighborhood kind of guy and fellow Fizz patron offered me the following mantra: "Alcohol is a tool, not a toy."

—*Brian Diebold*

"It's wonderful to be here in the great state of Chicago…"

—*Dan Quayle*

G&L Fire Escape

I've never actually seen a fireman in this joint!

$$$

2157 W. Grace St., Chicago 60618

(at Leavitt St.)

Phone (773) 472-1138

CATEGORY	Neighborhood Pub/ Fireman Bar
HOURS	Mon–Fri: 7 AM–2 AM
	Sat: 7 AM–3 AM
	Sun: 11 AM–2 AM
GETTING THERE	Street parking is easy.
PAYMENT	Cash only
POPULAR DRINKS	Shot and a beer joint.
UNIQUE DRINKS	Ask Patty for an upside down Margarita. You tilt your head back, she pours in the liquor and shakes your head to mix it.
FOOD	No food. People often order in.
SEATING	Very small and cozy. Bar seating and a few tables.
AMBIENCE/CLIENTELE	This would be a pyromaniac's dream come true. Known as a fireman's bar or hangout, the walls are covered with fireman paraphernalia. Paintings, pictures, helmets, axes…you name it. Of course, its funny but I've never actually seen a fireman in the joint. Oh well. This is a typical neighborhood joint where you dress down, swill beer and try to find the door as you leave. My favorite night is Saturday. Patty B. works the bar and is one of Chicago's finest bartenders around. Her attitude just keeps you coming back for more. I have rarely met people who can have as much fun as Patty completely sober. She is truly high on life! Not to mention the fact that she is a blond bombshell and I have the hots for her…
EXTRAS/NOTES	I think there might be a video golf game but I'm often distracted by the hot bartender! This would be a great breakfast bar if they served food!

—*Brian Diebold*

The Globe Pub

A world of difference.

$$$

1934 W. Irving Park Road, Chicago 60613

(at Lincoln Ave.)

Phone (773) 871-3757

www.theglobepub.com

CATEGORY	Sports bar/ Neighborhood Pub
HOURS	Mon–Fri: 11AM–2 AM
	Sat: 10 AM–3 AM
	Sun: 10 AM–2 AM
GETTING THERE	Street parking can be difficult at times.
PAYMENT	VISA MasterCard AMERICAN EXPRESS DISCOVER
POPULAR DRINKS	Full line up of Microbrews.
UNIQUE DRINKS	Three Microbrews caught my eye. Dirty Dick's, Old Jock and Holy Grail.
FOOD	Full menu includes sandwiches, a good NY Strip Steak, a Catch of the Day, a full menu of Quesadillas and wraps. A little pricey.
SEATING	Large enough for any party. Back room adds a lot of space.

AMBIENCE/CLIENTELE	The Globe Pub has taken what was once a premier Chicago music spot and turned it into a sports bar. The old Lyons Den was one of my favorite hangouts and a great place to see a band. Now there are dozens of TV's all with a different game on them. Good for sports enthusiasts. If you can stomach bad singing, or think someone can stomach yours, there is Karaoke on Thursday nights. Four words sum up the clientele: Beer swillin' sports fans.
EXTRAS/NOTES	Specials almost every night (Mon. $6 pitchers of PBR, Thurs. $4.00 Captain Morgan Drinks, Sat. $3.00 Heineken and $3.50 Belhavens). Also, videogames and dartboards available.

—*Brian Diebold*

Hungry Brain
Feed your brain with drink at this local dive.
$$
2319 W. Belmont Ave., Chicago 60618
(at N. Oakley Ave.)
Phone (773) 935-2118

CATEGORY	Dive Bar
HOURS	Tues–Sun: 8 PM–2 AM
GETTING THERE	Street parking mainly, the American United taxi stand is around the corner, so taxi's should be rolling by every so often.
PAYMENT	Cash only
POPULAR DRINKS	Single malt scotch ($7) for those who appreciate the finer things in life… otherwise, BEER!
UNIQUE DRINKS	Nothin' here but the good ol' standards.
SEATING	Comfortable. Bar seats about 20. Some tables/chairs with booths and vintage couches along the walls. There is a stage at the front of the bar, also housing some tables/chairs/couches. Good for a large group, spacious enough in the bar where you won't be running over each other.
AMBIENCE/CLIENTELE	Casual dress. Very artsy crowd… mainly artists, musicians, writers and theater people (Viaduct Theatre is around the corner on Western). Definitely bohemian with the odd local concert posters and abstract art on the wall, retro mass-Beer marketing tools like lamps and clocks from Schlitz, Pabst, etc.... The old school lighted beer tap is one-of-a-kind. Divey, but comfortable as the tables are spread out well and couches beckoning to soothe one's rump. Ask if art on the wall is for sale, but the one painting with the dude having a brain operation is not for sale, so do not inquire about it.
EXTRAS/NOTES	The name of this bar comes from a Jerry Lewis movie where he drops out of society to become a beatnik in San Francisco. Unlike its name, the bar is very nondescript from the outside; you might miss the bar altogether. On the South side of Belmont, look for the storefront with the yellow brick facade neon Leinenkugel sign in the window. This bar was formerly the Improv Institute, hence you will see the raised stage area occupied with couches and tables (unless there is a gig that night). The Schlitz beer theme is appar-

ent throughout the bar, although they don't sell it by the can anymore. The jukebox on the wall contains everything from Hank Williams to Prince, along with some other obscure rock music. They do not sell cigarettes and they do not allow pipe or cigar smoking. Galaga/Ms Pac Man video game in the front, Arkanoid in the rear near the restrooms. T-shirts are available for $10, Girlie t's for $12. With regular specials ($2 Pabst!) and improvisational jazz on Sundays and literary readings on Thursdays, this place is a must!

—*Jeffrey Goodman*

Intelligentsia

Even communists like this Intelligentsia.

$

3123 N. Broadway St., Chicago 60657
(at Barry Ave.)
Phone (773) 348-8058
www.intelligentsiacoffee.com

CATEGORY	Independent Coffeehouse stout of heart and mind.
HOURS	Mon–Thurs: 6 AM–10 PM
	Fri: 6 AM–11 PM
	Sat: 7 AM–11 PM
	Sun: 7 AM–10 PM
GETTING THERE	As a general rule, parking on Broadway is the definition of insanity. There is metered street parking theoretically available, but rarely open. Best bet—use the 36 Bus route or hike from the Belmont El stop.
PAYMENT	VISA MasterCard AMERICAN EXPRESS DISCOVER
POPULAR DRINKS	I sat down to a sumptuous cup of hot cocoa, and highly recommend. The foam was gingery and sweet, and the cocoa was perfect temp and taste.
UNIQUE DRINKS	Other famous drinks include their lattes, which are brewed and feature "latte art," meaning they are served with a rosetta pattern you are reluctant to ruin.
FOOD	There are a few sandwich options in the cooler, such as roasted turkey panini and other wrapped items. The majority of the food is nummy treats—brownies, cake slices, giant rice krispie treats, and ginormous cookies that come on pretty blue plates (making me feel all grows up!) The shop also allows patrons to bring sandwiches in from other nearby restaurants. My recommendation? Grab a Fresh Choice sandwich on the way, saddle up to a prime people-watching seat at the window, and then order hot cocoa and a chocolate chip/peanut butter cookie for dessert. Although I went home with a stomachache, it was worth it.
SEATING	The space is full, with lots of couches, armchairs, communal tables, and bar stools along the wall and window. There is also an outdoor seating area with about eight tables that is a fabulous place to people watch in the summer. They've even considered the pups! Outside the shop is an area to clip your dog's leash, with a sign inviting you to come in, pick up some coffee, and get a dog treat.

AMBIENCE/CLIENTELE The music pumping out of the hanging speakers was eclectic and soothing, featuring indie-pop type tunes and an entire album by Elliott Smith (which I must admit biased me from that point on. Any joint playing the Elliott is my new favorite). The interior reminded me of a loft in size and scope, with exposed piping and Spartan white walls framing the cozy seats and seating arrangements and colorful, original artwork. The colors, the seating, the soft bright lights, and the leafy plants dotting the corners make the shop an ideal living room surrogate or study lounge. Filling the seats was a casual clientele, with a few after work refugees taking a breather in their suits and reading the news over a pot of tea. Some patrons drank while working furiously on what I imagine to be the "next big thing" in novels, screenplays, or corporate takeovers. Others just lounged, taking full advantage of the furniture while enjoying their coffee or individual pots of tea. Maybe the couches at home aren't so appealing. Permeating the air as customers filled the shop was a nice alternative to the overpowering smell that some coffee joints have. In contrast, Intelligentsia can truthfully boast of an "aroma," a combination of fresh beans, the mix of ingredients for drinks, and the bakery. The drinks themselves strike the perfect chord to finish this ode to coffee and companionship, offering choices for the earthy tea drinker, the caffeine junkies, the health nuts with bottled juices and protein-packed smoothies, and the occasional customer channeling their inner child (thus my hot cocoa and cookie choice).

EXTRAS/NOTES The front area of the shop offers the custom made drinks and treats, and the back area sells coffee by the pound, espresso machines, coffee brewers, utensils, mugs, and other merchandise, including t-shirts. You won't feel bad about spending a lot of dough here, what with the food and the additional stuff for sale—Intelligentsia prides itself on seeking out coffee growers and importers that are environmentally and socially responsible. The shop has grown astronomically since its start, expanding out of two sites for production and sale of wholesale coffee. They have now settled their operation in the Roasting Works on Fulton Street, which also offers tours to the public. In March of 2005, three baristas at Intelligentsia were even finalists in the Specialty Coffee Association's 2005 United States Barista Championships.

OTHER ONES • Loop/Downtown: 53 W. Jackson Blvd., Chicago 60604 (in the Monadnock building), (312) 253-0594

—Amy Lillard

"Coffee and cigarettes, you know? That's, like, the breakfast of champions."

—Jim Jarmusch

Julius Meinl
Austrian for "Fancy-Schmancy."
$$
3601 N. Southport, Chicago 60613
(at Addison St.)
Phone (773) 883-1862 ext.115 • Fax (773) 883-1862
www.meinl.com/southport

CATEGORY	Upscale Coffeehouse/Restaurant/Dessert Bar.
HOURS	Mon–Thurs: 6 AM–10 PM
	Fri: 6 AM–11 PM
	Sat: 7 AM–11 PM
	Sun: 7 AM–10 PM
GETTING THERE	Street parking when you can get it. Don't even consider it on Cubs gamedays
PAYMENT	VISA MasterCard AMERICAN EXPRESS DISCOVER
POPULAR DRINKS	Meinl's offerings outside the normal menu (seasonal, or at least reserved for sit-down drinkers) are where it's at. I chose a gingerbread latte with nutmeg, whipped cream, and ginger—nummy!
UNIQUE DRINKS	This entire place is predicated on uniqueness. It is the only Meinl shop outside of Vienna. It is a rarity in that it is a coffeehouse with the air and trimmings of a restaurant, not a restaurant that happens to serve coffee. And the drinks just come with the freakin' coolest setup—traditional Viennese style, served on a personal tray with a glass of water, pretty napkins, sugar packet, and wrapped cookie.
FOOD	There is an extensive menu with reasonable prices, including sandwiches, soups, salads, and even traditional Austrian breakfast (soft poached egg, sliced ham, emmantalian cheese, and toast). On top of this, the bakery case has a built in homing beacon, drawing in any semi-alive being. The day of this review the case boasted beautiful cakes, tortes, cookies, and biscuits, as well as their famous molten chocolate cake and apple strudel.
SEATING	The place is huge. There is ample seating inside and out. With the seating comes full waitstaff service. You can also opt to buy coffee and treats for take-out, but your options do not include the entire menu.
AMBIENCE/CLIENTELE	The entire environment is one of class. The spacious shop has wood floors and tables surrounded by red and green leather seats, lit by soft hanging bulbs. Meinl history is everywhere—black and white framed photos of the original stores in Vienna, framed labels and posters with the Meinl coffee boy logo, and classical piano music softly playing overhead. Of course, with the patio doors flung open to the warm Spring evening, that history is updated and revised to include modern Chicago—cars and buses honk outside along with the whirring of the espresso machines. The crowd is an older, after-work crowd, at least on a Monday evening. There's an unofficial business casual attire, supported by the nattily dressed waitstaff. Patrons are here for dinner, for coffee, or for more socializing than some coffeehouses seem to offer. Perhaps it's the truly unique feel of a very polished and proper environment. Customers aren't treated to snobbery, but they can feel the international vibe. As for the offerings themselves. Once my gingerbread latte arrived, I couldn't detect any other smells of other food or baked goods—my plate smelled like Christmas in April! The

drinks are warm, tasty and rich, meaning that no matter the strength of the bakery counter's pull, I had to resist or risk exploding all over the pretty flower centerpiece. Another time. In fact, this is the ideal place for "another time," truly a destination worth going to after walking off your dinner.

EXTRAS/NOTES As noted, this is the only Meinl "Kaffeehaus" outside Vienna, and it's 140 years in the making. Julius Meinl coffee survived the ravages of the 20th Century on Eastern Europe to be considered one of the best suppliers of coffee in the continent. In the store and on its extensive website Julius Meinl offers merchandise for sale: coffees, machinery, cups/mugs, sweets, gift baskets, and even posters.

OTHER ONES • Only in Vienna

—Amy Lillard

Justin's

That Justin—good friend, good partier.

$$

3358 N. Southport Ave., Chicago 60657
(at Roscoe St.)
Phone (773) 929-4844

CATEGORY Low-key sports bar/neighborhood bar/restaurant bar

HOURS Mon–Fri: 11 AM–2 AM
Sun: 11 AM–3 AM

GETTING THERE Street parking. Bad plan—take the El. The Brown line Southport stop is less than half a block away.

PAYMENT VISA MasterCard AMERICAN EXPRESS DISCOVER

POPULAR DRINKS Beer on tap. Specials everyday written on the chalkboards spaced around the front bar.

UNIQUE DRINKS Actual, genuine, secluded, and comfortable beer garden that feels like a garden. Accept no imitations or sidewalk cafes—this is the real deal.

FOOD Full menu—cheap, good pub grub. Kitchen open till midnight on weekends!

SEATING Ample seating here in a front and back room and an extremely comfortable and casual beer garden.

AMBIENCE/CLIENTELE Lots of worn furniture and scuffs on the floor to indicate the number of parties and partiers have been here over the years, but it only adds to the comfort level. The crowd is a mixture of post-college preps, girls and guys getting their night started, and neighborhood folks just getting some beer and grub. It's a popular joint, evidenced by the presence of marketers—on my visit I got a free Stella Artois mug and chocolate! It's also a familiar joint—the waitresses are regulars and are prone to treat their regular clients very well (speaking from experience—we love "Peg"). Around the bar patrons can find plenty to do—TVs are all tuned to the Cubs games, darts and Golden Tee draw crowds, and the TouchTunes machine lets drunk girls play Gwen Stefani multiple times in a row (which can be good or bad). The bar gets some of its character from the random collection of things on the wall—beer signs and lights from every persuasion, antique, and defunct baseball card machines, lacrosse

sticks, posters, and my favorite—the graphic chart devoted to penises of the animal kingdom. Really.

EXTRAS/NOTES A personal example will demonstrate the loyalty that Justin's can inspire, and the comfort it can strangely provide. On 9/11 I left work early to meet my boyfriend, turned away from his work at the Sears Tower that morning. In a daze, he and I, his former roommates, friends and other wandering souls ended up at Justin's. In the midst of crumbling towers, uncertain futures, and sick souls we gathered around a table down the block at the Justin's beer garden, tended to by equally shell-shocked but comforting staff. We connected with each other, friends and strangers, watching the TVs now turned to CNN, watching each other, and feeling just a little bit better to be in good company. We felt comfortable going to Justin's that day, knowing it would provide what it did and what few bars do—simple, real companionship.

—Amy Lillard

Katerina's
Come and savor Chicago's artistic flavor.
$$$
1920 W. Irving Park Rd., Chicago 60613
(at N. Wolcott Ave.)
Phone (773) 348-7592

CATEGORY	Piano bar/Upscale lounge, Coffee bar
HOURS	Mon–Fri: 5 PM–2 AM
	Sat: 11 AM–3 AM
GETTING THERE	Street parking
PAYMENT	VISA MasterCard AMERICAN EXPRESS
POPULAR DRINKS	Martini's. They have a full bar, mostly wine and cocktails– as opposed to beer. The martini list hosts a handful of interesting drinks starting at $9, top shelf is $12. I recommend the Chocolate Martini. Espresso drinks and loose leaf tea are also served here, though not as popular since the establishment received their liquor license.
UNIQUE DRINKS	Sour Cherry Martini- an original creation: Skyy Vodka, Visinatha, and fresh lemon.
FOOD	They have a full menu of Mediterranean cuisine, from appetizers, soup, and salad, to entrees and dessert. The food is moderately priced with appetizers starting around $7 and entrees around $12, but well worth the money. The spanikopita (spinach pie) is fantastic.
SEATING	Katerina's hosts a hodgepodge of chairs and tables, giving the swanky lounge a rather humble feel. The tables are mostly two-seaters (12), making it very cozy, but tables could be pushed together for larger groups. One large table is set by the front window. Fifteen stools line the copper-topped bar.
AMBIENCE/CLIENTELE	It's a coffeehouse turned swank lounge, but not the pretentious kind. After receiving their liquor license in 2002, coffee made way for cocktails, but the clientele remained. The people here are very down to earth and often have an artistic flare. Subdued lighting, complimented by candlelight, sets a relaxed

and intimate mood. Blue velvet curtains hang in the front windows. An eclectic assortment of chairs and tables line one wall of this narrow but deep lounge, leading the way to an antique grand piano. Casual or dressy, this place is what you make it. The mood is light, the music is intriguing, and the martinis are fantastic.

EXTRAS/NOTES Jazz, Greek Blues, Funk, Classical, and Latin bands play nightly from around 9:30 PM to 10 PM. On Friday they have two shows, one at 6 PM and another at 10 PM. Weekday covers are $5-7, weekends are $10.

—*Melanie Briggs*

L & L Tavern

Safe haven for smokers, artists and the average Joe.

$$

3207 N. Clark St., Chicago 60657
(at W. Belmont Ave.)
Phone (773) 528-1303

CATEGORY	Dive Bar, hole in the wall—but in the best way.
HOURS	Sun–Thurs: 2 PM–2 AM Fri–Sat: noon–2 AM
GETTING THERE	Lakeview is one of the busiest and most congested areas in the city. If you can, leave your car at home or the hotel and hop on the Red Line or the Brown Line to Belmont.
PAYMENT	Cash only
POPULAR DRINKS	$1.50 PBR's.
UNIQUE DRINKS	Great martini's that seem a little out of place at this beer and shot bar.
FOOD	Popcorn machine
SEATING	The bar seats around fifteen or so and there are a couple of hi-top tables in the window, a few short tables scattered throughout and two or three hi-top "booths" against the North wall.
AMBIENCE/CLIENTELE	Actors, musicians, writers and all other creative types flock to this unpretentious tavern offering $1.50 PBR's and $2.50 whiskey shots every day. One lone TV set displays whatever game happens to be on and the jukebox features a great mix of music including everything from jazz and country to old school rock and alternative.
EXTRAS/NOTES	L&L Tavern is never a "miss." Go there any time of the day or night and there's always an interesting group of characters chatting it up with one of the bartenders, discussing script ideas, putting a band together or just hanging around watching a game or listening to a little Velvet Underground on the jukebox. Drink specials are a given and smokers will never feel out of place here. Leave your hang-ups at the door and prepare yourself for a good time—old school style.

—*Michelle Burton*

Life Spring
Drink your veggies!
$$
3178 N. Clark St., Chicago 60657
(at Belmont Ave.)
Phone (773) 327-1023 • Fax (773) 327-1030

CATEGORY	Community health food store with juice bar
HOURS	Mon–Fri: 9:30 AM–7:30 PM
	Sat: 9:30 AM–6:00 PM
GETTING THERE	You can find parking during the weekdays but keep your eyes peeled at night for those hard to find spots. Weekends are busy. No parking lot. Metered parking, forget it during Cubs games.
PAYMENT	VISA MasterCard AMERICAN EXPRESS DISCOVER
	$5 min. to charge
POPULAR DRINKS	Order up a lightning bolt with frozen yogurt or have your drink made your way-spiced up with lots of ginger or low key straight up carrot juice. Or try colorful red beet and spinach.
FOOD	Only pre-packaged foods are available.
SEATING	Two large rooms. Not good for large groups. Strictly on the go shopping and quick pick me up.
AMBIENCE/CLIENTELE	Very casual day in and day out. Very Earthy.
EXTRAS/NOTES	This well-established family owned juice bar and vitamin shop offers a small variety, but cheap veggie juices and energy drinks filled with many healthy ingredients including ginseng, protein powder, and powerful wheat grass shots. Life Spring caters to you-they will mix and match drinks-just ask! It has two rooms jam packed and filled with floor to ceiling shelves with many sized jars of vitamins, herbs, protein powder, crèmes, and ready-made vegetarian frozen packaged foods. The staff is very friendly and there is always plenty of help on hand-if you need a special order they will do their best to bring it/stock it at their store. A perfect quick stop for a five-a-day veggie pick-me-up and quick shopping for the health guru. Although there are no extra thrills about ambience, the store's convenient location is easily accessible by the El red stop. Life Spring easily satisfies all your vitamin and healthy eating habit needs. The juice bar is a small space in the back of the store, two bar stools.
OTHER ONES	• Chicago: 1463 W. Webster Avenue 60614, (773) 832-000, but no juice bar.

—Danielle Deutsch

The Long Room
They ain't lyin'…its long!
$$
1612 W. Irving Park Rd., Chicago 60613
(at Ashland Ave.)
Phone (773) 665-4500

CATEGORY	Neighborhood Pub/Lounge
HOURS	Mon–Fri: 5 PM–2 AM
	Sat: 5 PM–3 AM
	Sun: 7 PM–2 AM
GETTING THERE	Street parking is easy.

PAYMENT	VISA MasterCard AMERICAN EXPRESS
POPULAR DRINKS	Good imported beer. Belgian ales like Delerium Tremens.
UNIQUE DRINKS	They have a domestic beer from Downingtown, PA called Victory Golden Monkey.
SEATING	Long bar with lots of seating. A few tables and booths and a nice sized beer garden out back.
AMBIENCE/CLIENTELE	This bar used to be called Bluebird Liquors. What an improvement! The clientele has gone from probable ex-con to trendy young professionals. It's a jazzy type atmosphere with dark rooms, low-key people and a friendly helpful staff. I sat and guzzled a Monkey at what has to be one of the longest bars I've ever seen. Some say it stretches over 60 feet! They ain't lyin'…its long. The biggest improvement is the beer garden. It used to be used as a junk pile for the entire bar's excess crap but the Long Room has built a bi-level deck complete with lighting, tables, chairs, and planters. They also have an eight-foot privacy wall so the neighbors can't see you making a drunken fool of yourself. Check it out on Sunday nights as they feature live jazz. I don't know, throw on a beret and snap your fingers as if you understand the groove, man.
EXTRAS/NOTES	Jazz band plays every Sunday from 10 PM to 1 AM. Also, check out their nightly specials (Sun. $3 Warsteiners, Thurs. $3 Skyy Martinis, Wed. $2 Jim Beam shots. Mon. $2.50 Midwestern Microbrews on tap.) They still serve PBR and Schlitt's in a can! They also have a funky wine cabinet that allows them to tap their wines.
	—Brian Diebold

Martyr's

Music and Mayhem at Martyr's!
$$$
3855 N. Lincoln Ave., Chicago 60613
(at Grace St.)
Phone (773) 404-9869 • Fax (773) 404-9869
www.martyrslive.com

CATEGORY	Live Music/Club
HOURS	Sun–Fri: 5 PM–2 AM
	Sat: 5 PM–3 AM
GETTING THERE	Free lot after 6 PM Street parking is easy.
PAYMENT	VISA MasterCard AMERICAN EXPRESS
POPULAR DRINKS	Shot and a beer.
UNIQUE DRINKS	Nothing unique, just shot and a beer
FOOD	Bar fare-sandwiches, pizza, wings, etc…
SEATING	Bar seating plus tables unless there will be dancing.
AMBIENCE/CLIENTELE	Martyr's is becoming a premiere spot for live music. A lot of local and national acts make their way through Martyr's. This place is kind of a casual mix between neighborhood bar and nightclub. Local artists are featured as they pay tribute to a lot of dead rock stars. I used to see a Grateful Dead cover band here all the time. There was a bartender there named "Toast" who used to get me my drinks for free. It's great if you are going out to see a band.
EXTRAS/NOTES	This is one of the few places that still has a pinball machine!
	—Brian Diebold

Matilda
Neighborhood bar, lounge atmosphere.
$$
3101 N. Sheffield, Chicago 60657
(at W. Barry Ave.)
Phone (773) 883-4400
www.baby-atlas.com

CATEGORY	By default, Matilda fits in the typical Chicago neighborhood bar, though the décor, ambience, and crowd say otherwise.
HOURS	Tues–Fri: 6 PM–2 AM Sat: 6 PM–3 AM
GETTING THERE	Take a cab or catch the El.
PAYMENT	VISA MasterCard AMERICAN EXPRESS DISCOVER
POPULAR DRINKS	Any of their martinis, Kevin's Long Island Iced Teas, many beers on tap and in bottles, various red and white wines.
UNIQUE DRINKS	Deceivingly strong, yet easy going down, Kevin's Long Island Iced Teas will knock you on your arse if you don't come prepared.
FOOD	The medium priced fare at Matilda is diverse and much better than food you'd find in the area at another neighborhood establishment. Going beyond burgers and chicken wings, visitors can choose from a few salads (the Weeds selection sticks out), pasta, though the best and most exotic thing on the menu is the Ostrich medallions served with a light green mustard sauce and mozzarella balls.
SEATING	Except for the retro décor, in the front of the bar, stools and high tables dot the place, giving the impression that this place is just a regular bar. However, there are lounge chairs in the back and downstairs in Baby Atlas (Matilda's bar within a bar) giving the whole place a cool lounge, vibe. It does get a bit cramped as the two pool tables get in the crowd's way.
AMBIENCE/CLIENTELE	A plethora of people can be found at Matilda. Many different styles are attracted to this watering hole, and for good reason. Here, it is not an uncommon sight for hip Lincoln Park trendsetters to be mingling with people who look like they just came from the gym. At Matilda, one shouldn't take things at face value. The decorations, with LSD overtones, contrast nicely with the stained wood trim that runs along the bar. You can get a 10 dollar martini but also buy a Miller Highlife. Even the bouncer, a huge, biker-looking, intimidating fellow is really good-natured and good for a great conversation. The mix of many different styles is what makes Matilda work. Not tied down to any theme, it feels natural to 'go as you are'. All the mixed drinks this reviewer has had have been well made, and though there are rarely any drink specials, once a few Thursdays a month there are wine, champagne or martini tastings paired with appropriate food one can attend for a reasonable price.
EXTRAS/NOTES	There is one regular old drunk man who just sits at the bar and laughs, points at you, and mumbles.

—*Sy Nguyen*

Matisse

The underground grunge lounge for Lakeview locals.
$$$
674 W. Diversey Pkwy., Chicago 60657
(at Orchard Ave.)
Phone (773) 528-6670
www.matissechicago.com

CATEGORY	Potpourri Spot - make it what you want. Underground feel with an often typical Lakeview crowd.
HOURS	Mon–Fri: 4 PM–2 AM
	Sat/Sun: 11 AM–2 AM
GETTING THERE	Street, metered. Very Difficult. Just few blocks from the Diversey El stop. Cabs not a problem.
PAYMENT	VISA MasterCard AMERICAN EXPRESS DISCOVER
POPULAR DRINKS	Chocolate Martini, Chocolate covered Cherry and Lemon Drop.
UNIQUE	White Wine Sangria, Wango Tango and Bullberry are specialties.
FOOD	Reasonably priced menu with daily specials to make the budget happy. The menu is standard upscale bar fare. Nothing is bad on the menu. Try the Teriyaki Chicken Wrap or sweat pear and chicken panini. For desert the chocolate quesa is sure to tingle the tummy.
SEATING	A tight place in colder weather, but a top-rate warm weather patio eases congestion. Sit outside and watch people heading down to shop at the corner of Diversy and Clark. Inside seats are all created equal, with no outside views or stage competing for attention, pick a table, any table and enjoy.
AMBIENCE/CLIENTELE	On one night this Lakeview escape might serve as a meeting place for neighborhood yuppies and on another night you might find arty couples talking shop while sipping on wine. Weekends bring in more of a designer crowd, using Matisse as a launching point for the evening festivities. But even if you have to fight for a seat in this petite pub, the music aims to soothe and usually matches a martini or vodka tonic nicely.
EXTRAS/NOTES	Mattise is named after legendary French painter Henri Matisse.

—Brent Kado

My Place for Tea

True to its name—not a coffee bean in sight.
$$
901 W. Belmont Ave., Chicago 60657
(at Clark St.)
Phone (773) 525-8320
www.myplacefortea.com

CATEGORY	Tea House
HOURS	Mon–Sat: 10 AM–8 PM
	Sun: 1 PM–6 PM
GETTING THERE	Parking is sparse, but the shop is seconds away from the Belmont Red Line Stop.
PAYMENT	VISA MasterCard AMERICAN EXPRESS DISCOVER

POPULAR DRINKS	Chai tea lattes made in several flavors, including vanilla and chocolate. Bubble teas include traditional tapioca pearls and vanilla flavored "choobees."
UNIQUE DRINKS	Banana tea smoothie, made with green tea, fresh bananas and honey.
FOOD	Asian style buns filled with chicken or pork. Pastries, including carrot cake and brownies.
SEATING	Seating for roughly ten and is ideal for couples.
AMBIENCE/CLIENTELE	Owners Enrico and Minerva Zamora have given this storefront café the homey feel of a B&B. Settle down in the cozy window couch and flip through magazines or browse through the colorful and funky selection of tea kettles and serving sets for sale. The majority of teas for sale are caffeine free- but black coffee blends are available for traditionalists. The chai tea lattes are sweet, tasty and non-dairy.
EXTRAS/NOTES	There are few better places in Chicago for fine and exotic teas: varieties of green, white, herbal oolong, and the increasingly popular red (rooibos) tea are available here. The café also serves as a gift shop: tea pots, cups, kettles and other tea accessories are for sale at the store, and online.

—Keidra Chaney

Mystic Celt

Irish individualism indeed!

$$

3443 N. Southport Ave., Chicago 60657
(at W. Newport Ave.)
Phone (773) 529-8550
www.mysticceltchicago.com

CATEGORY	Irish Restaurant/Bar
HOURS	Mon–Fri: 11 AM–1:30 AM
	Sat: 9 AM–2 AM
	Sun: 9 AM–1:30 AM
GETTING THERE	There is limited street parking on the main streets. If you find a spot on a side street, you'll need a permit.
PAYMENT	VISA MasterCard AMERICAN EXPRESS DISCOVER
POPULAR DRINKS	Jameson! Shots of the Irish Whiskey are $3 on Tuesdays.
UNIQUE DRINKS	Actual Irish owners! Actual Irish waitresses/waiters! Actual Irish clientele! Actual Irish disdain for U2! (I know—couldn't believe my eavesdropping ears. Irish lasses and lads who didn't like their country's major export? I could barely imagine a Midwesterner who doesn't seem to like U2.)
FOOD	Full menu featuring appetizers, salads, burgers, and traditional Irish dishes—shepherd's pie, bangers and mash, etc. Very cheap ($7-12) and a lot of food.
SEATING	Lots of open space, intermixed with tall tables, comfy booths, couches and a private party room in the back. There is also sidewalk seating on Southport.
AMBIENCE/CLIENTELE	Thick, dark wood abounds here, as it does in many Chicago Irish bars. The walls are sparsely decorated, mostly with Guinness and Jameson signs and a few works of art. The bar is part liquor, part books (my favorite combo!). The scene here is the jeans and

high heels/button-down brigade. People here are out for the night, and the bar responds with DJs on Friday and Saturday nights. But early, after work, it's a bit more casual in tone. On the night of this review, the waitresses chatted up the recent U2 concerts with the Irish regulars, and a duo of moms had their babies in tow. The drinks here are simple—mostly imports on tap, lots of cognacs/ports/whiskeys, and occasionally the fusion drinks of mojitos and margaritas. Combined with tasty and cheap pub grub and "authentic" Irish dinners, it's a great place for dinner and drinks on a weeknight or weekend.

EXTRAS/NOTES Extensive daily specials all summer long. On Monday: $3 microbrew pints, 1/2 price bottles of wine, and 1/2 Price Appetizers. Tuesday: $3 micro-brew pints, $3 Jameson mixed drinks, $4 Celt burger (bigger than 1/2 pound!) with fries. Wednesday: $3.00 microbrew pints, $2.50 Miller Lite pints, 25 cent jumbo wings, $6.95 steak sandwich and fries, $7.95 Irish bacon and cabbage. Thursday: Mystic Summer Blast $15 Buckets of Corona, $4 margaritas, raspberry vodka lemonades, mojitos and $1 chicken flautas , also, $7.95 fish and chips and $6.95 meat-loaf sandwich. Saturday: $4 bloody marys. Sunday: brunch buffet $9.95 and $4 bloody marys

—*Amy Lillard*

O'Donovan's
THE trendy Irish bar.
$$$
2100 W. Irving Park Rd., Chicago 60618
(at N. Hoyne Ave.)
Phone (773) 478-2100 • Fax (773) 478-1675
www.kincadesbar.com/odonovans

CATEGORY Trendy/Beautiful People/Corporate Bar, Irish bar

HOURS Mon–Fri:11 AM–2 AM
Sat: 11 AM–3 AM
Sun: 10 AM–2 AM

GETTING THERE Small lot next door, but street and metered parking is not too hard to find.

PAYMENT

POPULAR DRINKS Irish beers and single malt scotches. Glenlivet and Glenfiddich available.

UNIQUE DRINKS Try a single malt scotch like Glenlivet or Glenfiddich

FOOD Good food with a full menu. Daily specials include a $10 all you can eat Sunday brunch and Buck Burger Mondays.

SEATING Very spacious with a long bar and lots of tables. Large back eating area and an indoor/outdoor beer garden.

AMBIENCE/CLIENTELE Dress up or down type atmosphere here. O'Donovan's is a prime example of what happens when young owners get together, pool their money and open a few bars. They have taken what was once the best German Restaurant in the city of Chicago (Schulien's) and turned it into a trendy Irish bar. The food and drinks are good, but pricey. Go on special nights that attract you, only beware Monday Dollar Burger Night. Especially in the winter with Monday Night Football,

EXTRAS/NOTES this night packs them in and you could wait forever to get a table. O'Donovan's has a fun feel, if you are in the preppy, trendy mood. This place is known for nightly food specials. They also offer Midnight Munchies. From midnight to 1:30 AM you can get burgers, chili or cheese fries or Nachos for a dollar. But for a real treat, ask for Al. He is the resident magician who will come to your table and do card tricks.

—*Brian Diebold*

WHERE THE REAL IRISH HANG OUT

Over the years, just like every other heritage and nationality, the Irish have spread all over Chicago. There are neighborhoods that have Irish Pride, like the South Side, but on St. Patrick's Day everyone is Irish in Chicago. To point out one or two bars where "real Irish hang out" would be like trying to single out one or two golf balls in a bucket of two thousand. The real Irish are everywhere in Chicago.

For the purpose of this book, however, a few bars could be singled out to help people get started on their Irish pub crawl of Chicago. One is **Fado'** (100 W. Grand Ave. (312) 836-0066) that features all of the draft you can drink, and some great Irish food like "Bangers and Mash" and the traditional Irish Breakfast. They also broadcast football live from the old country, and even sponsor a soccer team of their own.

Another bar that is more Irish for its name and attitude would be the famous **Butch McGuire's** (20 W. Division (312) 787-4318). This is not so much a traditional Irish pub as it is a place to go and get pissed like a true Irishman. With a late liquor license (open 'til 4 AM!), it's a place you can start and end your evening in a very social atmosphere. For a late bar, the no cover and absence of a line goes a long way at 2 AM This bar is also famous for being a "matchmaker" bar, responsible for thousands of weddings since its inception in the 1960's.

The people you will find at Butch's range from college kids to prime-time lawyers and Chicago politicians (many of which tend to be Irish). There is a full menu featured, and during the Christmas and St. Patrick's Day season the bar is completely covered in decorations that are definitely worth seeing—especially the model train that runs throughout the entire bar.

So here is a head start to helping you find out where some Irish people hang out. But remember, Irish Eyes are always smiling on Chicago.

—*William Kenefick*

Pepper Lounge
Hipster lounge with bold personality and
fabulous food.
$$$$
3441 N. Sheffield Ave., Chicago 60657
(at Clark St.)
Phone (773) 665-7377
www.pepperlounge.com

CATEGORY	The Pepper Lounge is a combination of multiple categories…gay bar, hipster, trendy, and swank. The fact that it can dip into a variety of classifications is what adds to its fun personality.
HOURS	Tues–Thurs: 6 PM–midnight Fri/Sat: 6 PM–1 AM Sun: 11 AM–10 PM
GETTING THERE	Street parking is a nightmare in this part of town, regardless of whether it is a Monday or Saturday night. Your best bet is to take a cab or public transportation. There is a nearby parking lot that offers rates based on the hours/duration you will be parked there. Side street parking is only an option if you have a residential permit.
PAYMENT	VISA MasterCard AMERICAN EXPRESS DISCOVER
POPULAR DRINKS	There are over 15 martinis on the drink menu here…popular selections include the Sex and the City inspired Cosmopolitan and Flirtini—for a drink that is equally as spicy as the lounge's name itself, try the Bloody Martini, made with Absolut Peppar, tomato juice, and a teeny tiny splash of Tabasco.
UNIQUE DRINKS	The interesting thing about Pepper Lounge is that you wouldn't expect these digs amidst Wrigleyville pubs. However, the gay community of Lakeview and Boys Town has several classy establishments and this is one of them. The lounge itself could easily fit into another part of town, however…crossing over to the artsy Wicker Park/Bucktown area.
FOOD	One of the best features here is the food. The menu is impressive, with a full selection of appetizers…Beef Tenderloin Medallions with Shiraz ($11), soups/salads…Spinach Salad with Warm Goat Cheese ($7), entrees…Lamb Tenderloin with Balsamic Syrup ($22) are just a few options. Don't miss the dessert, either; the Tart of Varies Berries with Grand Marnier and whipped cream is to die for ($6). Brunch is served on Sundays from 11 AM-4 PM, with a gourmet variety of dishes ranging from $9-11, as well as more traditional sides starting at $3. Of course, no brunch would be complete without the classic Bloody Mary or mimosa. Both are well mixed here and a wonderful compliment to any brunch. Another perk? The kitchen is open late night, which certainly adds to the Thirsty Pepper's popularity.
SEATING	The seating at the bar is extremely limited and somewhat crammed, mainly because of the high volume of patrons. The restaurant/dining area is generally small, making this a very intimate experience. Most of the tables are extremely close together, making this a perfect spot for couples and groups that aren't a stranger to this type of city dining.
AMBIENCE/CLIENTELE	The scene here is posh, but never overly trendy. Most of the clientele heard about this place through friends of friends, not through advertisement or city hoopla.

Upbeat music is heard throughout, but never deters from conversation. The interior is firey and bold, well representing the lounge's apropos title…and dramatic chandeliers and artwork give this spot a sort of plush, Parisian feel.

EXTRAS/NOTES Owner and Chicago native Beth Berlin is actively involved in the community and with charities through the Pepper Lounge. The lounge participates in Dining out for Life, the Human Rights Campaign, The Hearts Foundation, and Who's That Girl.

—*Kristy Stachelski*

TEN OF OUR FAVORITE FICTIONAL CHICAGOLAND NATIVES:
(in no particular order)

1. Punky Brewster, Punky Brewster

2. Harriett Winslow, Family Matters

3. Balki Bartokomous, Perfect Strangers

4. Dr. Mark Greene, ER

5. Shirley Kenyon, Straight Talk

6. Rob Gordon, High Fidelity (the movie, not the book)

7. Jake and Elwood Blues, The Blues Brothers

8. Dick Tracy, Dick Tracy

9. Clark W. Griswold Jr., National Lampoon's Vacation

10. J.J., Good Times

Sheffield's Beer & Wine Garden
From conventional to elusive, the beer you're looking for is at Sheffield's.
$$
3258 N. Sheffield Ave., Chicago 60657
(at Belmont Ave.)
Phone (773) 2881-4989
www.sheffieldschicago.com

CATEGORY This is definitely a neighborhood bar bent on providing drink that inevitably stimulates lively conversation. Weekends and post-Cub games offer a

bigger, more excitable crowd. Go Monday through Wednesday or weekend afternoons if you want to enjoy your beer.

HOURS	Mon–Fri: 3 PM–2 AM
	Sat: 12 PM–3 AM
	Sun: 12 PM–2 AM
GETTING THERE	The neighborhood is a mix of street, metered and permit parking, however, Sheffield's is a block from the Red and Brown lines stopping at Belmont.
PAYMENT	VISA MasterCard AMERICAN EXPRESS DISCOVER
POPULAR DRINKS	American domestic brews, of course, but also an array of top-fermented beers (Sam Smiths, Bells, and a decent selection of Belgians).
UNIQUE DRINKS	Microbrew draft and bottled beer, Melbourn Bros. Apricot beer, Lindeman's Framboise (raspberry beer)
FOOD	No food, bring your own or order in.
SEATING	Tables, a dozen barstools in front (more in back), picnic tables in the beer garden and a red cushioned bench by the front door.
AMBIENCE/CLIENTELE	The crowd is both young and old (but not too old) alike. Casual is the way to go, unless you feel the urge to impress others with your keen fashion sense. However, you may have to share the limelight with other fashionistas during peak hours.
EXTRAS/NOTES	A pool table is in the back, where there are plenty of seats and a fireplace. If you enjoy experimenting with your beer tastebuds, ask about joining the "Joseph Sheffield Memorial Beer Society," which, after drinking your way through a list of about 50 beers, you earn a commemorative shirt and 2 pint glasses. Like to drink cheap? The "Bad Beer of the Month" will only cost you around $2 (see Schlitz).

—*Sarah B. Brown*

Silvie's Lounge
Silvie's is the silver lining of the North Side.
$$
1902 W. Irving Park Rd., Chicago 60613
(at Wolcott Ave.)
Phone (773) 871-6239
www.silvieslounge.com

CATEGORY	Neighborhood Pub turned Night Club.
HOURS	Mon–Fri: 4 PM–2 AM
	Sat: 4 PM–3 AM
	Sun: 7 PM–2 AM
GETTING THERE	Street parking is easy
PAYMENT	Cash only
POPULAR DRINKS	Shot and a beer joint.
UNIQUE DRINKS	Beer and a shot!
FOOD	Tasty frozen pizzas fulfill your beer munchies here.
SEATING	This is a surprisingly large place with bar seating with tables and a back room for music.
AMBIENCE/CLIENTELE	I remember walking by this place every day on the way home from work and wondering "Is this place ever open?" Really, the outside is very dark. But, inside this place is great especially for live music. Local bands typically fill the joint and it can get really hopping.

Casual atmosphere and people dominate the scene. This is also a great place for dart players. They have an entire room dedicated to the game, with at least six boards going all at the same time. If you get the chance, talk to Silvie, the owner. She knows about everything from politics to small business ownership and has an opinion about everything.

EXTRAS/NOTES Live music and dartboards galore!

—*Brian Diebold*

Sopo

After graduation, matriculate into Sopo's hot post-college scene.

$$

3418 N. Southport Ave., Chicago 60657
(at W. Roscoe St.)
Phone (773) 348-0100 • Fax (773) 348-0500
www.sopochicago.com

CATEGORY	Trendy Joint, Neighborhood Bar, Beautiful-People Spot.
HOURS	Mon–Fri: 5 PM–2 AM
	Sat: 10:30 AM–3 AM
	Sun: 10:30 AM–2 AM
	Kitchen open until 1 AM
GETTING THERE	Metered spots available but may be difficult to find on the weekends
PAYMENT	VISA MasterCard AMERICAN EXPRESS DISCOVER
POPULAR DRINKS	Their specials are homemade white and red sangria, only $2 on Wednesdays, and weekend brunch hours. Order this drink by the glass or by the pitcher and it comes to around the same amount. Don't worry. There is plenty to go around, even though practically everyone orders them on Wednesday nights. Or enjoy a Blue Moon beer with a nice wedge of orange, their drink special on Tuesdays.
UNIQUE DRINKS	Get up at a normal hour on Saturday or Sunday morning to enjoy their amazing Bloody Marys. I don't know what they put in it to make it so good. But, you will not regret ordering this spicy tomato-ey goodness. Just don't get carried away by this $2 drink special. You can walk it off by traveling along the boutique filled street of Southport.
FOOD	I know you've heard this line before, but seriously, Sopo has by far the best bar food for the best prices that I have ever experienced. Wonderful appetizers fill the menu with selections like zucchini and corn quesadillas and Chicken skewers with a banana bar-beque dipping sauce, all are half price on Wednesday. Try having a honey wheat chicken teriyaki wrap with a glass of red sangria, I know I will.
DRINKS	Beer, wine, stiff cocktails, fruity concoctions, the whole nine!
SEATING	This place gets packed, so seats fill quickly. If you plan on eating, come early. If not, you can enjoy the packed area by the bar to enjoy your beverage and schmooze with other patrons waiting to "eat well, drink better," their motto.
AMBIENCE/CLIENTELE	Awesome music is always playing. I AM particularly

fond of their love for the Postal Service and other Indie rock groups, usually pouring out of their speakers. Sitting in the back by the kitchen tends to be quieter and more relaxed than the rushed feeling you get by being in the front. Most people there are in their mid twenties filling their college void, but enjoying the trendy vibe sent out by the stylish New Yorkesque décor.

EXTRAS/NOTES Sopo is filled with beautiful and friendly waitresses/ bartenders who will refill that Sangria faster than you can say, well, "I want more Sangria." Their daily specials are unbelievably cheap and last all night long. Weekday specials range from $3 beers on Mondays to $5 Martinis on Fridays. There really isn't a dress code, BUT metrosexual attire is encouraged.

OTHER ONES • Bar Celona: 3474 N. Clark St., Chicago, 60657 (773) 244-8000
• Matisse: 674 W. Diversey Pkwy., Chicago, 60614 (773) 528-6670
• Lot 48 948 W Armitage Ave., Chicago, 60614 (773) 871-8123

—*Ian Weiss*

Star Bar

Classy neighborhood establishment
where the crowd is rarely trying too hard.
$$$
2934 N. Sheffield Ave., Chicago 60657
(at Oakdale Ave.)
Phone (773) 472-7272

CATEGORY Star Bar is the perfect pre-jazz club atmosphere (or even post-jazz club hangout, for that matter). It also caters to those looking for an upbeat, casual night out, without the fuss of shoving your way through an overly packed crowd and screaming over too loud bar tunes.

HOURS Daily: 6 PM–2 AM (except for Sundays; Brunch is served at 10 AM)

GETTING THERE Street parking is difficult; on residential side streets, a valid permit is required. However, Sheffield is metered…good luck finding a spot on a weekend. Valet is available at next door jazz hot spot, Pops for Champagne.

PAYMENT VISA MasterCard AMERICAN EXPRESS DISCOVER

POPULAR DRINKS I highly recommend the Bloody Mary; upon requests, bartenders will whip up fresh, blue cheese stuffed olives to compliment your drink, at no additional cost.

UNIQUE DRINKS Most bars in this Lakeview/Lincoln Park neighborhood are traditional in the sense of Irish, American, Karaoke…but Star Bar is actually a champagne bar. Their list is extensive, and you will often see couples or groups celebrating with a bottle or two (or three…).

FOOD There is food, but it is on the pricey side, and somewhat limited. I've sampled the cheese platter, which comes with crackers, fruit slices, and nuts…but it will cost you around $12. Worth every penny, if you are looking to compliment your wine or champagne

without a heavy meal attached, and there are several cheeses to choose from. Star Bar also serves brunch on Sundays (along with every other neighborhood bar in this area) from 10 AM-2 PM. The brunch menu is short and sweet, but doesn't lack quality…I recommend the lox platter, which is a huge portion that includes the lox, bagel slices, cream cheese, and fresh tomato. Another favorite? Eggs Benedict over crab cakes. Average brunch entrée is $8-$12.

SEATING

Seating at the bar is for approximately 10-15; tables in the front of the bar seat approximately 15-20, and the cozy booths along side the bar seat about 20-25. Additional seating in the back caters to at least 10. Bar stools are actually more like chairs here, and are stylish in keeping with the starry eyed theme of this watering hole—a starburst is cut out of aluminum/ metal on the back of each seat. Tables up front are standard 4-seaters, and mainly appeal to groups and couples that care to catch a glimpse of passer-bys and endless taxis rolling down Sheffield. The booths are roomy and cozy, and the seating in back caters to a more private crowd that wants to section off their territory.

AMBIENCE/CLIENTELE

Star Bar's sparkling personality and good looks create a casual yet simultaneously upscale atmosphere. You can easily sport jeans at this establishment, but leave your sneakers behind: heels and flashy earrings to spice up that denim works better here. Guys are clad in classic button down shirts and an occasional suit jacket here and there, but rarely is a sports jersey or sweatshirt spotted. Everything from Diana Krall to David Bowie is playing in the background here, and not only can you listen, you can feast your eyes on the several TV screens that suspend from the bar's ceiling. Crowd chatter gets loud, but not as loud as the music. Still, having a conversation isn't nearly as tough here as you'd think it would be, this bar gets packed on the weekends. The highlight of Star Bar comes in the winter months, when the establishment's fireplace roars in the back of the bar, nearby cozy seating and dim lights. This is definitely a place you'd want to be stuck at in the midst of a blizzard. In other not so cold months, the bar's interesting, star-themed light fixtures cast a charm of their own…never too bright, just enough light. This isn't the type of place that inspires you to drink a cold beer, although there are certainly plenty of options available, including my favorite, Stella Artois. Most of the crowd sips cocktails… favorites seem to be wine, martinis, and of course the signature champagne.

EXTRAS/NOTES

Unless you want to look like an out-of-towner, dress classy.

—*Kristy Stachelski*

"I find the Sox haters lame, and once it goes beyond good-natured fun, have no use for it. Cubs fans that hate Sox fans strike me as insecure…now, hating the Cardinals, that is an entirely different business."

—*Billy Corgan*

Ten Cat Tavern

Grab a glass of scotch and check out the back room!

$$$

3931 N. Ashland Ave., Chicago 60613
(at Irving Park Rd.)
Phone (773) 935-5377

CATEGORY	Artsy-type Pub
HOURS	Sun–Fri: 3 PM–2 AM
	Sat: 3 PM–3 AM
GETTING THERE	Small lot is free and street parking is easy.
PAYMENT	Cash only
POPULAR DRINKS	Microbrews
UNIQUE DRINKS	Large selection of scotches.
FOOD	Bar snacks on Fridays.
SEATING	Rather large with bar seating, a back room and beer garden.
AMBIENCE/CLIENTELE	Full of artists and wannabes, this is a casual, typical bar with no surprises other than the vintage pool tables and weird back room that makes you feel like you are sitting in a Wisconsin lounge. This place also used to be a thrift store and you can almost smell the nylon and polyester. Otherwise, local art is featured on all the walls.
EXTRAS/NOTES	Vintage pool tables that are well maintained. Video golf and the like.

—Brian Diebold

Trader Todd's

Fruity drinks, karaoke, Ogre.
No other place in the world.

$$$

3216 N. Sheffield Ave., Chicago 60614
(at Belmont Ave.)
Phone (773) 975-8383

CATEGORY	Karaoke Bar/Sports Bar
HOURS	Mon–Fri: 4 PM–2 AM
	Sat: 11 AM–3 AM
	Sun: 11 AM–2 AM
GETTING THERE	Street parking. Parking is okay.
PAYMENT	VISA MasterCard AMERICAN EXPRESS DISCOVER
POPULAR DRINKS	Trader Todd's has a juicer right on the bar so the fresh-fruit martinis are quite popular.
UNIQUE DRINKS	You need to try the Marathon Martini!!! It is so delicious you'll swear there's no alcohol in it … but if you drink three, you'll need help getting off the bar stool … unless you fall off. Also popular at Trader Todd's is the "shot-ski." Basically, you first convince 2 or 3 friends that it's time for a shot. Then, your server brings around a wooden ski that has holes cut into it for shot glasses. Your friends line up and the server tips the ski so that the shots fall into your mouth. They also scream "1 … 2 … 3 … SHOT SKI" as you gulp it down.
FOOD	There is a full bar menu with a Cajun twist.
SEATING	There are about 10 tables and 10 stools at the bar. The beer garden in back seats 50.
AMBIENCE/CLIENTELE	Trader Todd's is a silly place. There is no other way

to put it. It's silly. What's surprising is that even though everyone, including the staff and owners, acknowledges how silly it is, this place is just TOO much fun. The karaoke atmosphere is light-hearted and welcoming, the servers are busy but funny, and the drinks are delicious! The tropical décor is somehow paired with a sports theme—the Cubs in particular. You'll also find a delightful mix of people. Young and old, sober and drunk, sports fans and singers. People love Trader Todd's because it's a happy, funny place.

EXTRAS/NOTES When you know what you want to sing—put your name in! The karaoke is VERY popular at Trader Todd's and sometimes it takes a long time before the DJ calls your name. Trader Todd's has a free shuttle bus service to and from Wrigley field on game days. DO take advantage of this. DON'T, however, plan on going there for a fun time immediately following a day game. Lately they've had one guy singing with an acoustic guitar in the afternoons—it's not how you want to celebrate a victory or drown your sorrows. Wait until later in the evening when the karaoke and fun music starts. Trader Todd's has some odd connection with Don Gibb, otherwise known as "Ogre" from the Revenge of the Nerds movies. He is always there; he even partnered with Todd (the owner) to brew up "Ogre" Beer, which is served at the bar.

—*Michelle Hempel*

EVERYONE'S A STAR AT THESE POPULAR KARAOKE BARS!

Karaoke bars are an acquired taste. But for those who've already acquired a craving for a spicy blend of exhibitionism, liquor, and the spotlight, there are more than enough choices of where to go to get your 15 minutes of fame. Here's a sampling of standout locations:

Trader Todd's with its Jimmy Buffet-inspired faux island theme and breezy attitude means that Todd's is definitely not a hipster spot, but perfect for a small group looking for a low-pressure, laid back way to unwind. The songlist is traditional karaoke fare –(REM's "End of the World as We Know It," anyone?) and a few off-beat choices like one-hit wonder Aqua's "Barbie Girl." (3216 N Sheffield Ave., (773) 975-8383)

The entertaining, and occasionally surreal atmosphere at **Sidekicks** is definitely worth a visit. There are cheap eats, video monitors and a hit parade of karaoke standards—it could be considered the gold standard for old-school karaoke bars. Dedicated regulars are serious about their karaoke, with performers that range anywhere between "unknown talent—and "sonic train wreck." (4424 W. Montrose Ave., (773) 545-6212)

Live bands are the new hot trend for karaoke and Friday nights at **Pontiac Café** attract an enthusiastic group of regulars, but don't

be intimidated, this group is always welcoming to new "talent." The songlist is heavy on alternative and rock classics, played by one of three bands that appear at various Live Band Karaoke gigs in neighborhoods across the city each week. (1531 N. Damen, (773) 252-7767) You can also see the bands at The Original Mother's (26 W. Division, (312) 642-7251) and Blue Iguana (2919 N. Sheffield (773) 935-7500) for more information on the bands, their songlists and the bars that host live band karaoke in the city, go to www.livebandkaraokechicago.com

Movie Buffs and tone-deaf types have a non-musical option to enjoy the Karaoke craze at **Déjà Vu**. With "movie-oke," a film is projected on a large screen while participants mimic the dialogue displayed on a monitor. Every Saturday night. (2624 N. Lincoln Ave., (773) 871-0205)

—*Keidra Chaney*

BOYSTOWN

Sidetrack
It's raining men, hallelujah…it's raining men!
$$
3349 N. Halsted St., Chicago 60657
(at Roscoe St.)
Phone (773) 477-9189
www.sidetrackchicago.com

CATEGORY	Video bar catering to the gay/lesbian community… but ALL are welcome.
HOURS	Sun–Fri: 3 PM–2 AM
	Sat: 3 PM–3 AM
GETTING THERE	You can try parking around here, but it's extremely difficult. You might get lucky several blocks north on Addison or try to snag a meter a block or so west on Clark. Watch out for Zone postings, you will get ticketed and if they can maneuver your car out of a parking space they will tow you—then good luck finding out where they took your car!
PAYMENT	VISA MasterCard
POPULAR DRINKS	Any kind of martini or frozen drink is especially nice during the hot summer months—they taste fruity, but careful, they really sneak up on you! Order one at the rooftop bar…aaaaah, refreshing!
UNIQUE DRINKS	Everything is great during Cocktail Hour. From 3–8 PM Monday–Friday and 3–4 PM Sunday, various mixed drink specials are offered.
FOOD	No food, but plenty of restaurants around—get your hand stamped, go eat then come back to party some more!
SEATING	This place is huge. Choose from several "bars" on two levels (inside and outside) including: the Cherry Bar, Glass Lounge, Deck Bar, Rooftop Bar and the Main Bar. The indoor bars all have loft-like ceilings (for an open, airy feel) and shiny hardwood floors throughout.

AMBIENCE Okay, so it's mostly men, but this is probably the largest video bar in the city and the atmosphere is extremely friendly, warm, and festive. If you want to forget your problems, this is the place to do it. Video themes range from show tunes and comedy to retro, classic and dance. Feel free to dress up or down here, no one cares. All are welcome here, so don't be shy!

EXTRAS/NOTES Check the website for upcoming events like wine tastings.

—*Michelle Burton*

CRUISING FOR A GAY BAR?

Chicago has one of the largest gay populations in the country with a vast selection of gay bars, boutiques, clubs, restaurants, publications and events. If you're looking for the best of the best gay bars, well, we did our "best" to choose five places that will appeal to a variety of different tastes and styles. Be sure to check out the "bonus" section for a few spots that are worth the $10 cab ride.

One of the oldest gay clubs in the city, **Berlin** first opened its doors in 1983 and has developed one of the most loyal followings a club has ever seen in Chicago. It doesn't matter where you're from or what you do, this north side nightclub goes above and beyond to welcome all. With no cover Sunday through Thursday and cover under $5 the rest of the week, you'll be able to save your dollars for great deals like $2 rolling rock. Open seven days a week until 4 AM (Saturday until 5 AM), Berlin features the best Deejays and Veejays the city has to offer from Greg Haus and "DJ Benz" to veteran and resident DJ, "DJ Larissa" and Heather Doble. Come early enough (around 10 PM) and you can score a spot at the main bar or the booth in front (great for people watching) or stake your claim near one of the small stages in the middle of the room or along the mirrored walls. The dance floor gets packed around midnight, but don't worry, although small, Berlin has a total of three bars to choose from. They offer a wide variety of top shelf liquors, a large variety of beers and wines and the bartenders can whip up everything from the obscure to the trendy to the average. If you must drive, prepare to spend a good chunk of time looking for a parking space. This area is extremely popular and very active 24 hours a day, seven days a week. Cabs are plentiful and the club is located a few steps away from the Belmont El stop. (954 West Belmont, (773) 348-4975, www.berlinchicago.com)

At **Spin** you can dance the night away or chill out with a VJ, you can play pool or lounge on a sofa—this Lakeview nightclub has there are three rooms to satisfy any mood you're in. People call this a gay bar, but it's not your typical gay hangout. You'll find a fair amount of straights playing pool, watching videos or chatting it up over $2.50 MGD's. The main bar plays videos from the '80s, '90s, and today. You'll see and hear the DJ/Mix version of every song under the sun and then some. On the dance floor you'll hear deep house, electronic, techno, and dance. The bartenders are extremely friendly (genuinely) and the crowd is always energetic, fun loving and polite. Be sure to check out the "Shower Contest"

every Friday where anyone and I mean ANYONE can enter the contest and strut their stuff (no nudity, of course) for $200 in cash prizes. (800 W. Belmont, (773) 327-7711,www.spin-nightclub.com)

While **Atmosphere** draws a mostly gay/lesbian crowd, the friendly bar staff and patrons are warm and welcoming to all. The drinks are reasonably priced, the atmosphere is laid-back and there's no pressure to pose here. The interior boasts exposed brick walls, hardwood floors, a huge bar that's just as long as the dance floor and additional cushy (quiet) seating in the rear lounge. With candles flickering in the front window and a DJ booth overlooking a sizeable dance floor, you can come here to sit and chat with friends or your significant other, or to dance the night away to house music and popular dance hits. It's up to you. On off nights, videos from the '80s to the present are shown, and complimentary bar snacks are a-plenty. They have a pretty good selection of beers on tap including Blue Moon and Guinness. And the bartender makes some of the most sinful shots I've ever tasted. Think, Frangelico, Bailey's, Godiva..mmm..mmmm..good! Sunday night features tunes from the '70s to the 90s, and Atmospheres hosts many special events and benefits, so call first to see what's up. Don't worry though—all benefits and special events are open to the public, and there's never a cover charge, ever! (5355 N. Clark St., (773) 784-1100, www.atmospherebar.com)

Sidetrack is a massive video bar that caters to the gay/lesbian community, but straights won't feel out of place here. Choose from several "bars" on two levels (inside and outside) including: the Cherry Bar, Glass Lounge, Deck Bar, Rooftop Bar, and the Main Bar. The indoor bars all have loft-like ceilings (for an open airy feel) and shiny hardwood floors throughout. The cocktail list is endless (martinis and frozen drinks are popular) and they also offer a large variety of domestic beers and imports. The atmosphere is extremely friendly, warm and festive. If you want to forget your problems, this is the place to do it. Video themes range from show tunes and comedy to retro, classic and dance. Feel free to dress up or down here, no one cares. All are welcome here, so don't be shy! (3349 N. Halsted, (773) 477-9189, www.sidetrackchicago.com)

Crew is brand new, but its already on most peoples' top ten list, and rightly so. Located between Andersonville (one of Chicago's popular gay areas) and Boystown (the number one gay area in the city), Crew happens to be the only gay sports bar in the city. During the hot summer months, patrons can enjoy the comfy sidewalk café until midnight and inside, sports buffs can settle into one of wood high top tables and watch the game on Crew's 92 inch screen or one of the many smaller TVs while sipping on one of 50 beer selections from the bar. The menu features everything from appetizers like fondue and quesadillas to salads, burgers and wraps. But, of course, Crew doesn't forget the alcohol. With great deals like $10 buckets of rolling rock, this bar's a crowd pleaser. Between all the baseball, football, soccer and basketball the folks at crew still manage to throw in a few DJs and VJs here and there. (4804 N. Broadway, (773) 784-CREW, www.worldsgreatestbar.com)

—*Michelle Burton*

Spin

Dance the night away or chill out with a VJ.

$$

800 W. Belmont Ave., Chicago 60657
(at Halsted St.)
Phone (773) 327-7711
www.spin-nightclub.com

CATEGORY	Gay, Lesbian, Bi with a fair amount of straights wandering about.
HOURS	Mon–Fri: 4 PM–2 AM Sat: 2 PM–3 AM Sun: 2 PM–2 AM
GETTING THERE	Parking is a nightmare. Leave your car at home and hop in a cab or take the Brown or Purple Line to Belmont and walk a few blocks east to the club. If you must drive, there are several self park garages located at Broadway and Barry and Broadway and Roscoe near the Best Western Hotel. Word of advice, don't try parking in the bank parking lot across the street, they tow fast!
PAYMENT	Cash only
POPULAR DRINKS	Absolut Flavors and imports.
UNIQUE DRINKS	Try the oatmeal cookie drink (or shot). It's like dessert in a glass, but it packs a punch!
FOOD	No food, but plenty of eateries in the area.
SEATING	Three "rooms," all have full service bars. The main bar (large rectangle shape) seats around twenty comfortably. The small room in the northeast corner off the main bar room seats four or five at the bar and offers two comfy chairs for lounging. The retro lounge has a dance floor and seats seven or so at the bar, eight at two hi-top tables and you'll find several plastic couches and chairs near the window— great for people watching.
AMBIENCE/CLIENTELE	People call this a gay bar, but it's not your typical gay hangout. You'll find a fair amount of straights playing pool, watching videos or chatting it up over $2.50 MGD's. The main bar plays videos from the '80s as well as the '90s and today. You'll see and hear the Dj/Mix version of every song under the sun and then some. On the dance floor—deep house, electronic, techno and dance. The bartenders are extremely friendly (genuinely) and the crowd is always energetic, fun-loving and polite. FYI—Vasili, one of the greatest bartenders ever, will hook you up with just about anything. Want an oatmeal cookie shot? Ask Vasili. Searching for the perfect martini? Ask Vasili. He usually works in the retro lounge.
EXTRAS/NOTES	Spin offers some of the best drink specials in the city, like: $3 Stoli cranberry and lemonade Mondays, $1 well and domestic Wednesdays and $6 MGD/Lite pitchers every Thursday. The cover charges are minimal and they only charge on Wednesdays ($5) and Saturdays ($5). Other drink specials include: $10 Long Island and import beer pitchers along with free pool (Sundays) and $3.50 Malibu Rum Fridays. Check out the "Shower Contest" every Friday where anyone, and I mean ANYONE, can enter the contest and strut their stuff (no nudity, of course) for $200 in cash prizes.

—*Michelle Burton*

WRIGLEYVILLE

Blarney Stone

"Kiss MY Blarney Stones!"
I heard him say. Brilliant!?
$$
3424 N. Sheffield Ave., Chicago 60657
(at Clark St.)
Phone (773) 348-1078

CATEGORY	Sport bar/ Cubs Bar
HOURS	Sun–Fri: 11 AM–2 AM
	Sat: 11 AM–3 AM
GETTING THERE	Pay lots. Street parking can be tough.
PAYMENT	Cash only
POPULAR DRINKS	$1 Shots.
UNIQUE DRINKS	Kamakazees and Lemon Drops. $7 Irish Car Bombs.
FOOD	Dig it! $1 Tacos (they remind me of the old Duk's Tacos) and Hot Dogs with purchase of beer during and after the Cub games. Kick-ass tacos, blue cheese burgers, chili, burritos. A lot of bar type food, but dirt cheap and tasty.
SEATING	Decent sized bar and a few tables in front. Another room to the side also has tables. Spacious I'd say. Small outdoor seating area.
AMBIENCE/CLIENTELE	Definitely a casual Cubbie bar, as they pack the place after the games. This place does not have the attitude or fame that other Wrigley bars carry but this is a plus for me. It is not as crowded and ridiculous as Cubbie Bear or Bernie's, but there are a lot of fun people hanging out after a game. While sometimes crowded, it is not impossible to get a drink and the staff here is awesome! They have all gone out of their way to make me feel welcome as I now spend most of my time in the Wrigleyville area. No Wrigleyville bar will ever top Bernie's, but the Blarney Stone has become one of my favorite hangouts!
EXTRAS/NOTES	Golden Tee, pool table, foosball and a video arcade type game that includes a pornographic photo search. I've played this a few times with the female bartender!

—*Brian Diebold*

Cubby Bear Lounge

Wrigleyville; where true Cubs fans
drink beer.
$$
1059 W. Addison St., Chicago 60657
(at Clark St.)
Phone (773) 327-1662 • Fax (773) 472-7736
www.cubbybear.com

CATEGORY	Sports Bar
HOURS	Sun–Fri: 8 PM–2 AM
	Sat: 8 PM–3 AM
	Open at 10 AM during Cubs season.
GETTING THERE	Parking on the street is a nightmare on the weekends and during Cubs season. There are plenty of pay lots,

but the one next to Taco Bell is usually the cheapest.

PAYMENT	VISA · AMERICAN EXPRESS
POPULAR DRINKS	Beer, beer, and more beer.
UNIQUE DRINKS	You can't go wrong with $1 drafts on Thursday nights.
FOOD	There is a full menu available with the average price of an entrée around $6. It's pretty cheap for a good burger, but, as you might have guessed, prices go up during the Cubs season.
SEATING	There is plenty of seating around the bar and at tables, and this is a great place to bring a big group.
ABBIENCE/CLIENTELE	Everyone comes in their favorite Cubs or Bears t-shirt, which is expected. Walking in, you are immediately surrounded by old sports memorabilia and tribute to great players, such as Ernie Banks. Any time of the day, any time of year, the casual atmosphere doesn't change. It's a cool hangout for locals to grab a couple beers after work or on the weekends, and a hot spot that is jam-packed during Cubs season.
EXTRAS/NOTES	There is always live music every week. Great local bands play here and are worth seeing since Phish once played here before they were famous. The stage is nicely sized so you can't miss the show. If you want to play Pop-A-Shot basketball or Golden Tee, go to the café side of the bar two doors down.
OTHER ONES	• The Cubby Bear North, on Milwaukee Rd. in Lincolnshire, also Sports Corner and Rooftops are owned by the same people.

—Mindy Golub

Cullen's
Where everyone's Irish.
$$
3741 N. Southport Ave., Chicago 60613
(between Grace St. and Waveland Ave.)
Phone (773) 975-0600 • Fax (773) 975-9151

CATEGORY	Authentic Irish Pub. Center of Northside Irish fun— good food, good drinks, good entertainment, and good people.
HOURS	Mon–Fri: 11 AM–1:30 AM Sat/Sun: 9 AM–2 AM
GETTING THERE	Street parking is possible, but often difficult. It's entirely dependent on the time of your visit. Valet and pay lot are both available. Or take public transportation—Cullen's is only a few blocks north of the Southport stop on the Brown Line. And it's accessible by the #22 Clark, #9 Ashland or #80 Irving Park buses. Cabs are usually easy to get.
PAYMENT	VISA · MasterCard · AMERICAN EXPRESS · DISCOVER
POPULAR DRINKS	Guinness, Guinness and more Guinness. It's definitely a favorite at a bar that's perfected the "two-minute pour." They don't just slop some beer in a glass and hand it over—they understand it takes time, the right angle, and a little bit of Irish love to make Guinness taste it's best. But of course they offer other Irish favorites on tap, like Harp, Smithwicks, and cider. And a little shout out to their European counterparts, they also have Boddington's from England, Hack

Pschorr from Germany, Amstel Light from the
Netherlands and Blue Moon from Belgium, all on tap.
If you want a beer from a can or a mixed drink,
they'll gladly give you that too, Cullen's has a full bar.

UNIQUE DRINKS
The only thing unique about Cullen's drinks is how
good they are, in such a fun location. A place that
knows how to pour a good Guinness is pretty price-
less now-a-days. So that is naturally their specialty.
They also have a selection of the half-and-half drinks
popular in so many Irish pubs, such as the Black-
And-Tan (Guinness and Harp), a Snakebite (Harp
and cider), as well many other concoctions created
from mixing two types of beer.

FOOD
Bar food and Irish food aren't typically known as
culinary delights. And when you mix the two, the
results can be downright scary. Not so at Cullen's,
where pub grub is anything but grubby, and it's
garnished with Irish and American influences. If you
want filling, affordable comfort food, Cullen's is a
sure bet. Their shepherd's pie and meatloaf are both
served piping hot, and full of rich flavor—many say
Cullen's meatloaf is the best in Chicago. You won't be
disappointed if you order the fish and chips, or the
good ol' burger. And for a classic favorite with a little
kick, try the steamy, crusty mac 'n cheese made with
aged Irish cheddar—it packs quite a bit more punch
than the good ol Kraft 'cheese and macaroni.' And
after a long night of drinking, nothing satisfies like
the authentic Irish breakfast that they serve on
weekends. Whatever you're eating, Cullen's mix of
generous portions and quality ingredients will please
every taste bud. In the fall or winter, enjoy these
hearty meals huddled in a cozy, wooden booth that
has an uncanny ability to draw you in for hours. In
the summer, chomp on some of their lighter fare like
salads and appetizers while you chill on their patio,
watching the buzzing activities on Southport.

SEATING
The problem with Cullen's is that it's so darn good,
it's always packed. With great beer, food, entertain-
ment and people, it's no wonder finding a seat in this
bar is a momentous challenge. The main room (the
original bar before the other room was added) is
where most the action takes place. A large portion
of the main room's real estate is consumed by the
beautiful, vintage mahogany bar. If you don't get a
seat at one of the few (but very comfy booths) or a
spot at the bar, you'll be standing…along with most
of the crowd. So if you want to sit, you better get
here early. But come on, standing isn't so bad when
you have a few beers in you, the music is going, and
you're surrounded by smiling Irish eyes.

AMBIENCE/CLIENTELE
The feel of the Temple Bar district in Dublin, but
only blocks from Wrigley Field…can you beat that?
Cullen's is the real deal. From the person who
answers the phone to the boy who wipes up the
table, the majority of these folks are straight from the
emerald isle. When the person pouring your drink or
serving your food has a brogue, you know what
you're getting is not some shamrock-shaked down
version of Irish food and drink. But it's not just the
workers with an Irish background, so are the patrons.

This is where the Irish plumbers and au-pairs come to party, meet each other…and occasionally, hang out with Americans. But if you're last name isn't McDougell or O'Duffin, don't shy from this place. Cullen's is littered with the Southport regulars—couples and groups of gal pals in their 20s and 30s strolling in for a drink. And with the close proximity to the Mercury and Music Box Theatres, you'll find many art-lovers seeking a nice nightcap. You'll also see some cub-paraphernalia-clad drinkers giving their taste buds (and kidneys) a break from all that Wrigley-poured Budweiser.

EXTRAS/NOTES Bar staff is straight from Ireland, they're friendly, and their accent will get you every time. There's always a charming group of Irish men and women to strike up a conversation with—both the bartenders and bar-goers. Cullen's doesn't have a pool table, or darts. The business here is drinking, eating, enjoying good music and having a good time. There aren't too many secrets about Cullen's, everyone knows what a great place it is, which is why it's always packed.

—Katie Murray

Emerald City Coffee
Where the Wicked Witch can take a breather.
$$
3928 N. Sheridan Rd., Chicago 60613
(at Dakin St.)
Phone (773) 525-7847

CATEGORY Independent coffeehouse encouraging hotel-length stay

HOURS Mon–Fri: 6 AM–7 PM
Sat: 7 AM–7 PM
Sun: 8 AM–7 PM

GETTING THERE Street parking available. But even better—it's less than half a block from the Sheridan Red Line stop.

PAYMENT Cash only.

POPULAR DRINKS The Red Eye is the coffee of the day with two shots of espresso. The coffees have nifty names, like Chicago Blues Blend. There are also tasty smoothies.

UNIQUE DRINKS Here's a warm concept that will sound pretty darn good when fall rolls around (and we actually like the changing of the seasons): hot caramel apple cider. It just sounds like a fall drink, and it might take the sting out of the inevitable change from fall to Chicago winter.

FOOD Tasty Grinders are a high point. These are toasted sandwiches on Italian bread. They're under five dollars, and a lunchbox, combining the grinder with chips, cookie, and drink, is only $6.50. The shop also offers egg bagel sandwiches and bagels with cream cheese for cheap. The baked goods are laid out neatly on the counter and include scones, muffins, cookies, and biscotti. There is often a special offered that combines coffee and a baked treat for around $3-4.

SEATING The shop is small, but intimate. Two seat tables are spread around the perimeter, while the central area has comfy recliners surrounding a coffee table. Very cozy.

AMBIENCE/CLIENTELE Maybe it was the carpet, or the warmly painted walls, or the endearing clutter. But entering the Emerald City Coffee shop felt like walking into a large studio apartment owned by an eclectic artist, which just happens to have a kitchen-centered business set up inside. The walls are painted with murals of the El, a coffee machine, and a Seattle scene, and covered with hanging framed art and shelves filled with flea market knick-knacks. The addition of two wall air conditioning units and ceiling fans merely added to the apartment-like ambience. With XRT playing softly over the boombox speakers strategically placed around the store, the homages to the El placed around the store, and the rumble of the actual El penetrating the air, patrons are treated to cozy comfort in a very Chicago environment.

EXTRAS/NOTES On the day I patronized Emerald City, it was a beautiful spring day, the first Sunday Cubs game of the season. So it was appropriate that Emerald City was holding drawings for tickets to the impossibly expensive rooftop viewings. As a reviewer dedicated to full disclosure and experimentation, I entered (purely for research purposes, of course). Hopefully this review finds you willing to check out the Emerald City, and me the proud recipient of some luxurious Cubs viewing.

—Amy Lillard

WRIGLEYVILLE WINS
(Even when the Cubs don't)

As I write these words, our fearless Cubbies have been in what you might call a slump. But as any decent Northsider knows, that means exactly squat when it comes to game attendance or post-game partying. No matter the team record or the game score, Cubs fans know how to make a trip to Wrigley and around its friendly confines worth it. Welcome to Wrigleyville, where the bouncers start bouncing before noon, drinking with third-degree burns from sitting in the bleachers is encouraged by authority figures, and you can find low-key first-name-basis bars right next to clubs with paid dancers.

Whether you want to drown your sorrows on yet another losing season, or toast to the comeback of all comebacks, here are some key Cubs bars to hit during your trip to Wrigleyville.

The Cubby Bear: This bar is almost as famous as the ballpark it faces. It was ranked 7th best sports bar in America by Sports Illustrated this year, for good reason. Already monstrously huge, the Bear has recently finished some remodeling that promises to open up the bar even more. Since 1953 this bar has been keen on keeping your Wrigley beer buzz going, but with awfully better choices of liquor and a scenic view of the marquee right outside. This is also a perfect place to view the game in case of rain, cold, or simply a better view—the TVs are ginormous and plentiful.

Outside of Cubs games, the Cubby Bear offers a perfect size venue to see live shows of smaller bands and local favorites, such as Mike and Joe and Hairbanger's Ball. (1059 W. Addison Street, (773) 327-1662, www.cubbybear.com)

John Barleycorn's: The Wrigleyville location of the Lincoln Park historical site opened a few years ago, and quickly became a neighborhood favorite. Warm and spacious, Barleycorn's has been the necessary first spot for a day at Wrigley for years now—lunch and a warm-up drink here, watching the crowds gather, is a great first pitch. After the game or on any weekend night, the lines stretch down the block. The downstairs is an open, casual bar, and the upstairs features more space and lots of bump and grind to DJ-spun tunes. (3524 N. Clark, (773) 549-6000, www.johnbarleycorn.com)

Irish Oak: An authentic import from Ireland, this bar is consistently ranked by patrons among the top Irish bars in a city bursting with them. The fact that it is right down the street from Wrigley makes it a must-see. Every piece of wood and decoration in this bar was shipped directly from the old country and constructed under the watchful eyes of the Galway family Lawless. An eclectic and comfortable spot, the Oak serves good, cheap Irish specialties and imported drinks. On weekends, check out the back room for fun acoustic sets from local musicians. (3511 N. Clark, (773) 935-6669, www.irishoak.com)

Sports Corner: This is the quintessential sports bar – close to the park, filled with TVs, offering simple food, and always packed. Thriving in the neighborhood before gentrification, this spot was recently ranked the third favorite sports bar in Chicago by Tribune/Metromix readers. For multi-taskers (or those who can't bear to continue watching the Cubs bite it on the TVs in every line of site), there is Golden-Tee and linked up trivia machines at the bar. Cheap eats, lots of beer, and filled with Cubs fans – how much more Wrigleyville can you get? (956 W. Addison, (773) 929-1441, www.cubbybear.com/sportscorner)

Hi-Tops: These folks don't just serve beer and big screens to ease or celebrate the Cubs score—they like to dance the night away. Come to Hi-Tops for their vastness, their big screens and open second floor, their Connie's Pizza and special pub offerings like the "Elvis Has Left the Building, " a burger topped with guacamole and served with a Twinkie. Stay at Hi-Tops for massively pumping tunes and girls dancing on the bars. Maybe that's one reason their staff has been rated Chicago's most friendly for four consecutive years. (3551 N. Sheffield, (773) 348-0009, www.hi-topsusa.com/chicagomain.shtml)

—Amy Lillard

Gingerman Tavern
A great place to enjoy 'good times.'
$$$
3740 N. Clark St., Chicago 60613
(at Racine Ave.)
Phone (773) 549-2050

CATEGORY	Casual Neighborhood Pub, a stone-throw away from Wrigley Field, but definitely NOT a sports bar
HOURS	Mon–Fri: 3 PM–2 AM
	Sat: noon–3 AM
	Sun: noon–2 AM
GETTING THERE	Parking can be a nightmare if there is a Cub's game at Wrigley Field
PAYMENT	VISA MasterCard AMERICAN EXPRESS DISCOVER
POPULAR DRINKS	Beer is the most popular drink here, with over 50 bottled beers and 15 on tap. I tried the Heffeweizen and found it had a hickory taste to it. Not my favorite but there is plenty to choose from. My friend ordered a Peach Stoli and soda which was fantastic.
UNIQUE DRINKS	Beer. Over 50 different imported and domestic bottles listed on chalkboards directly behind the bar.
FOOD	Gingerman's does not serve food, but there are hot dog vendors on the street, a burrito house just steps away, and plenty of places to get a burger and fries.
SEATING	The front bar seats 24, tables seat 75, and the back bar (open on weekends) seats 15. The front room can get a little crowded, but overall there is plenty of room.
AMBIENCE/CLIENTELE	There is nothing pretentious about Gingerman's Tavern. The atmosphere is very welcoming, as are the bartenders and people who frequent this pub. There is plenty of natural light during the day, which floods in from the floor-to-ceiling windows that line the front of the bar, looking out onto the happenings of N. Clark Street, in the heart of Wrigleyville. The mood is upbeat and lighthearted. It's casual and eclectic, drawing in people from nearby venues—such as Wrigley Field, and concertgoers from the Metro and Annoyance—as well as locals who just want to kick back and enjoy a good beer. You're more likely to blend in—with a t-shirt and flip-flops, but people aren't here to judge.
EXTRAS/NOTES	There are a couple pool tables in the back bar and the 'hippest jukebox' in town. However, it's the staff and people who come to Gingerman's Tavern that really make this pub what it is: a great place to enjoy today.

—*Melanie Briggs*

"When I read about the evils of drinking, I gave up reading."

—Henny Youngman

Guthrie's

Bored? Guthrie's has board games!
Since 1933
$$

1300 W Addison St., Chicago 60613
(at Lakewood Ave.)
Phone (773) 477-2900

CATEGORY	Neighborhood Bar
HOURS	Mon–Fri: 4 PM–2 AM
	Sat: 4 PM–3 AM
	Sun: noon–2 AM
GETTING THERE	Street parking, tougher to park around the neighborhood during Cubs season. Cabs on Addison pass frequently.
PAYMENT	VISA MasterCard DISCOVER
	ATM is one block west at Southport Ave.
POPULAR DRINKS	Beer and a shot, with 38 brands of bottled beer to choose from, but be sure to check at the bar for specials.
UNIQUE DRINKS	Root Beer Barrel—Shot of Root Beer schnapps in a highball glass of pilsner beer—tastes just like a Root Beer float. Homemade Sangria in the summer - $5/glass.
FOOD	Bar/Munchie food. Very reasonably priced. Wings, pizza, white castle cheeseburgers—heated up in a toaster for you. Or you can ask for one of the delivery menus and order in. During Bears season, FREE CHILI on Sundays.
SEATING	Room for 50 in front, stools and tables around. Heated back porch holds about 25 (windows opened in summer). Good space for parties up to six people, anything over is dicey. Backyard barbecue and porch can be rented for parties, but no drinking outside (too many complaints from neighbors).
AMBIENCE/CLIENTELE	Casual, fun bar. Not a binge drinking bar, but more of a nursing your beer type of place. Regulars and neighborhood people. Some stragglers from pre/post Cub games and pre/post show at the Metro. Not college-ey.
EXTRAS/NOTES	Founded in 1933 by the Moretti family, Guthrie's has been family operated by different families ever since. The staple of Guthrie's are the various board games available to play. Just take one off the shelf near the bar and enjoy yourself over a game of Scrabble, Monopoly, amongst a myriad of classic and obscure board games, great for groups. The ceiling panels have been painted by local artists and friends of the owner. T-shirts available for $15. Sweatshirts are $20. Regular Euchre games on Sunday between customers. They sponsor plenty of softball, volleyball, and soccer teams throughout the year, so check at the bar if you want to join up. The bar was named after J.B. Guthrie, a Lakeview neighborhood developer from the 1880s.

—Jeffrey Goodman

Hi-Tops

Sports bar by day,
Girls Gone Wild by night.
$$$

3551 N. Sheffield Ave., Chicago 60657
(at Addison St.)
Phone (773) 348-0009
www.hi-topsusa.com

CATEGORY	Sports Bar/Club
HOURS	Sun: 11 AM–2 AM
	Mon–Fri: 5 PM–2 AM
	Sat: 11 AM–3 AM
GETTING THERE	There is street parking if you get there early enough; otherwise there is a pay lot right behind the 7-11 on the corner of Addison and Sheffield.
PAYMENT	VISA MasterCard
POPULAR DRINKS	Mai Tais are really strong, but tasty. Just make sure you get the bartender who charges you $6 for the drink instead of $8.
UNIQUE DRINKS	With almost 70 televisions, Hi-Tops is by far one of the best bars to watch sports in the Chicago area. But if sports isn't your thing, come back on Friday or Saturday night and watch Hi-Tops undergo a transformation into a hip dance club.
FOOD	Hi-Tops has a full-blown menu from pizza to a blackened tuna sandwich that is rated pretty high among regulars. The average price for a dinner entrée is between $8 and $15, depending on what you order and if it's Cubs season.
SEATING	The first floor has almost twenty bar tables with stools, and seating around the bar. The second floor has about the same number of bar tables with a couple of couches for the avid sports fans to lounge on all day.
AMBIENCE/CLIENTELE	For watching sports, you can come to Hi-Tops in shorts and a baseball cap; no one cares. Especially over the summer when everyone is in a laid-back mood, so is Hi-Tops. But when the lights get dim and the thongs come out, you can expect to see people sporting trendy threads to Hi-Tops: the dance club. The DJ spins urban and hip-hop tunes to match the young and casual personalities of the bar goers.
EXTRAS/NOTES	Bartenders here are great it seems like they are having just as much fun as you are; they dance around and even do shots with you! There are a few video games in the back and a pool table. Every Saturday night, Hi-Tops is known for it's scandalous thong contest during the dance party. There are also unique parties every so often, such as a pajama party and holiday promotions. There was also a Vegas trip giveaway one night, which could happen again soon!
OTHERS	• Look for Hi-Tops in Phoenix, Pittsburgh and coming soon in New York.

—Mindy Golub

John Barleycorn

(see page p. 41)
3524 N. Clark, Chicago 60657
Phone (773) 549-6000

Pick Me Up Café & Espresso Bar

Coffee, kitsch, and killer cheese fries!

$$

3408 N. Clark St., Chicago 60657
(at Roscoe St.)
Phone (773) 248-6613

CATEGORY	Upscale Coffeehouse and Gourmet Diner
HOURS	Mon–Thurs: 3 PM–3 AM
	Fri–Sun: 24/7
GETTING THERE	Neighborhood street parking is iffy but possible, as long as the Cubs aren't in town.
PAYMENT	VISA MasterCard AMERICAN EXPRESS DISCOVER
POPULAR DRINKS	Shakes are made with premium ice cream and fresh fruits. The cup of mocha is recommended for its chocolaty, velvety texture, and drizzled flower design, which floats delicately on a thick layer of froth.
FOOD	A big menu offering tasty vegan and "meat-friendly" upscale diner dishes. Highly touted: the Cheez Fries, which are covered in real cheddar and oven-baked. Other popular items include the Pesto Cream Linguini and the Brownie Sundae, served in a giant margarita glass.
SEATING	Two rooms seating up to 70 hungry patrons; the sunny patio seats 18 in the summertime.
AMBIENCE/CLIENTELE	The crowd is as diverse as they come- it's not unusual to see high school and college students, rowdy Cubs fans, business people, punks, yuppies, and perhaps the occasional coven of witches. The décor is eclectic, with corrugated aluminum ceilings, colorful hand-decorated tables and walls cluttered with photos, poetry, postcards and stickers.
EXTRAS/NOTES	This is a terrific place to people-watch. Goths, frat boys, punkers and the occasional rock star from a nearby concert venue all come to Pick Me Up. Hip-hop star Common and his lady friend Erika Badu have been spotted at this happening Lakeview-area café. Weekday visitors find mellow fellow diners bobbing to surf-punk on the jukebox; weekends turn Pick Me Up into a louder, dimmer hipster joint for the caffeine-inclined. Open 24 hours on the weekends- perfect for those with early morning omelette cravings.

—Gina M. DeBartolo

Tai's Lounge

The place that rocks after two o'clock.

$$

3611 N. Ashland Ave., Chicago 60613
(at Addison St.)
Phone (773) 348-8923 • Fax (773) 348-8926

CATEGORY	Late Night Dive
HOURS	Sun–Fri: 7 PM–4 AM
	Sat: 7 PM–5 AM
GETTING THERE	Street parking. Plenty of taxicabs around at night.
PAYMENT	VISA MasterCard DISCOVER
	$20 minimum to charge

POPULAR DRINKS	Beer is a safe bet
UNIQUE DRINKS	The late hours liquor license makes everything unique here in the wee hours.
FOOD	Pizza (starting at $9). Bag of chips (75 cents).
SEATING	Cozy. Seating is limited. Back room usually reserved for parties and DJ's on the weekend. You'll most likely be standing.
AMBIENCE/CLIENTELE	Mainly young people who are already three sheets to the wind, making their last saloon for some more pops before going home. Very casual, though you can get away with your best duds. Can and will get very smoky, crowded and loud.
EXTRAS/NOTES	a.k.a Tai's 'til Four. DJ on Friday between 12:30 AM and 3:30 AM, Saturdays between 1:30 AM and 4:30 AM. Pool Table, Golden Tee, Dart Board (in the back room). ATM machine. Starts to fill up after 1 AM, and will be crowded until closing time. A good place to come and hang out for a drink, but as the night progresses, the rowdier it will get inside Tai's (ie: loud drunks, random hook-ups, etc…). Available for parties, contact Blake for more info.

—*Jeffrey Goodman*

Uncommon Ground
Cozy coffee haunt and hub for live acoustic music.
$$
1214 W. Grace St., Chicago 60613
(at Clark St.)
Phone (773) 929-3680 • Fax (773) 929-0805
www.uncommonground.com

CATEGORY	Independent coffeehouse/café
HOURS	Fri–Sat: 9 AM–midnight. (They may stop serving food at 10:30 PM, but the coffeehouse stays open until 1-2 AM, depending on traffic.)
GETTING THERE	It's Wrigleyville, so good luck finding a "legal" parking space. Weekdays may offer a little hope, but weekends are nearly impossible. Buses and cabs are plentiful.
PAYMENT	VISA MasterCard DISCOVER
POPULAR DRINKS	"Famous" hot chocolate, lattes, a unique selection of top-shelf martinis, wine, beer, and coffee.
UNIQUE DRINKS	"Liquid Desserts"—specialty hot chocolate drinks flavored with liqueur, Pear Cassis Martini, Seasonal Cranberry Martini.
FOOD	High-quality comfort food. Standout dinner items include Pumpkin Ravioli, topped with blue cheese (available in the Fall and Winter), the Louisiana grilled chicken salad and the "Uncommon Macaroni and Cheese", prepared with aged cheddar and served with chutney. Healthy fare such as homemade granola with yogurt, turkey sausage and pancakes with fresh fruit is available for brunch.
SEATING	Seats about 100. Front of the café is for diners only; the back room is used for live performances.
AMBIENCE/CLIENTELE	Clientele—"Upscale casual" diners, professionals in their late twenties/early thirties who have outgrown

the bar scene, some students and artists. The decor—soft lighting, local art work on the walls, a fireplace—is casual and welcoming, ideal for a first date. However, at night the ambience certainly leans more in the direction of a gathering place than a spot for individuals to sit and read for a few hours. In other words, if you're coming for the evening, bring a friend or two and leave the books and laptop computers at home.

EXTRAS/NOTES Uncommon Ground is best known by many Chicago music buffs as the place where singer/songwriter Jeff Buckley performed a legendary acoustic show years before his untimely death in 1997 and it continues to be a premier spot for acoustic folk and open mic nights today; it's also unique for serving wine, beer and mixed drinks as well as coffee in the evening, as well as a rather pricy but delicious dinner menu. The café is smoke-free, a pleasant option for those who tend to avoid the bar scene, but still crave lively entertainment on a Saturday night. The entertainment is largely limited to acoustic rock and open-mic storytelling so those looking for more intense musical options may want to stick to the clubs. Uncommon Ground rents out a private dining room for parties, and has hosted a live tribute concert to Jeff Buckley since 1997.

—*Keidra Chaney*

ROSCOE VILLAGE

Beat Kitchen
Dishing up beats, bites and beers,
Chicago-style.
$$
2100 W. Belmont Ave., Chicago 60618
(at Hoyne St.)
Phone (773) 281-4444
www.beatkitchen.com

CATEGORY	Neighborhood bar, music venue
HOURS	Sun–Fri: 11:30 AM–2 AM
	Sat: 11 AM–3 AM
GETTING THERE	Neighborhood street parking is okay.
PAYMENT	VISA MasterCard AMERICAN EXPRESS DISCOVER
POPULAR DRINKS	They serve mixed drinks, but this here is a beer bar, yo. Guinness, Bass, Boddington's and several more are on tap. 20 bottled beers also available.
FOOD	This Beat's got eats. The Kitchen cranks out a sump-tuous Thai Pizza (a legend among locals), the drool-inducing Beat Salad, a bevy of towering sandwiches, and hearty sides such as jalapeño corn bread and bruschetta. Perhaps a wee bit pricier than other bars, but well worth it.
SEATING	The front bar room offers eight booths and several stools along the bar. Chairs and tables face the stage in the back room.
AMBIENCE/CLIENTELE	The crowd is a wildly diverse mix of rock n' rollers, neighborhood regulars, business people and shoppers

from nearby antique boutiques. Daytime visitors find a cheerful, sun-drenched bar sporting tin ceilings and a well-stocked jukebox; nighttime turns the Kitchen into a lively, smoky, dimly-lit den of booze, tunes and laid-back music lovers.

EXTRAS/NOTES For an intimate evening of live music with the likes of Junior Brown, Old 97's, Waco Brothers, Leon Russell and countless local favorites, there is no better place than the back room of Beat Kitchen. The place can fill up fast so get there early, enjoy a pint and have a chat with one of your fellow music fans at the bar.

—*Gina M. DeBartolo*

A TRIBUTE TO THE BREW 'N' VIEW
(or the Greatest Damned Theater ever)

If you often find yourself sitting in a movie theatre, clenching the arms of your chair in effort to stop yourself from screaming out to the actors on the screen, you've just been rescued from white-knuckle hell. This movie theatre will set you free. On the nights that the Vic Theatre isn't hosting a concert or special event, it turns into the almighty Brew 'N' View, one of the best places in Chicago to catch a flick. After three years in the works, the Victoria Theatre (The Vic) was opened in 1912 as a five-story Vaudeville house. Vaudeville was the most popular form of entertainment during the early 1900s and with good reason. During the shows of days past, the audience would often shout at the entertainers or even participate in the shows. The Vaudeville shows were always loud and never claimed to be intellectual. They were the most popular form of entertainment during the early 1900's and a great way for people to escape from their daily troubles. It's safe to say that if any ghosts from the Vic's Vaudeville days roam the halls here, they are quite content to remain for the boisterous nights at the Brew 'N' View.

The original marble staircases still remain, along with most of the elaborate artwork that opened the place. Aside from being quite beautiful, the ornate design of this theatre often serves as the perfect ironic backdrop to the mostly cult-classic and art house films that are shown here. Although there seems to be a fondness for the underground, mainstream movies are played as well. Actually, anything is played here. It's not unusual to catch an early evening viewing of the Grammys or a Chicago Bulls game (when they make the playoffs). The best part about it all is that you don't need to have an interest in what's on the screen to have a good time. Most of the entertainment comes from watching the drunk people watch the movie. The Crowd will often talk (or even dance) along with the actors on the screen. Even a Shakespearean monologue from Romeo and Juliet takes on an entire new meaning when being slurred by 100 or more inebriated people at the same time. My all time favorite is still when the entire audience counted how many times "Mitch" in Dazed and Confused tucked his hair behind his ears. It's customary to partake in the antics; and if you have a talent for memorizing dialogues in

their entirety, you'll be right at home. The above mentioned rowdiness is supported splendidly by the Brew 'N' View's economical prices. The Admission is a flat five bucks for everyone, every day of the week. The brews are less than two bucks and cocktails are cheap as well. If you come on a Tuesday, you can get an entire pitcher of Miller or Miller Lite for $2. There are three bars open while the movie is playing, so wherever you sit you'll be able to take advantage of the bargain basement prices. To soak up all that beer you drink, they recently began serving Pizza from Gino's East Pizzeria. As always, they also still have your standard yummy movie snacks.

You need to be at least 18 to cross the threshold, and they do card heavily here. A valid form of identification must be presented or you'll be told to take a hike. Don't bother trying to argue that you're only seeing Spongebob Squarepants either;

nobody under 18 is admitted. Those 21 and over who wish to drink will be free to let the fluids fly once marked with a wristband. Bags are checked as well, so don't get any ideas. Any outside beverages or food will be confiscated unless you want to eat it all before you go in. But you really don't need to go through the bother; their prices aren't much more than those at the convenience store down the street. Other than the ID and bag checking, almost anything goes and you will never be kicked out for being too loud in the theatre.

If you're on your way, public transportation is highly recommended. Aside from the obvious fact that you will most likely be really drunk and shouldn't be driving anyway, parking is a nightmare. There is one lot across the street, but it seems to be eternally full. Your best bet is to take either the Brown or Red line and get off at the Belmont stop. Walk west on Belmont and Sheffield is the first cross street, take a left and look for the Vic Theatre sign.

Oh, and if by chance you and this writer end up at the Brew 'N' View on the same night, please take this word of caution: Wear waterproof clothing. Walking up the steps to the stadium seating in this theatre with your second full pitcher of beer is trickier than it sounds. However, after the first three rows received their Miller Lite shower, a very friendly usher came out with his flashlight to successfully find my wallet wedged in between two very nice people's chairs. As always, another night at the Brew 'N' View proves itself entertaining. (3145 N. Sheffield, Chicago, 60657, (773) 472-0499, www.victheatre.com)

—*Alana Sitek*

Grizzly's Lodge
A taste of the North,
South of the border.
$$

3832 N. Lincoln Ave., Chicago 60613
(at W. Grace St.)
Phone (773) 281-5112
www.grizzlyslodge.com

CATEGORY	Mainly a sports bar, literally a Meat Market
HOURS	Sun–Fri: 11 AM–2 AM
	Sat: 11 AM–3 AM
GETTING THERE	Street parking, metered parking on Lincoln Ave.
PAYMENT	VISA MasterCard AMERICAN EXPRESS DISCOVER
	Also, ATM on premises
POPULAR DRINKS	Beer/Shot, 25 beers on draft
UNIQUE DRINKS	If you're there on a Sunday ask Leslie to mix you one of her devilishly good Bloody Marys
FOOD	Buffalo, Elk, Venison (Deer), Wild Boar, Alligator, Quail, Ostrich, and sometimes, Kangaroo (that's right!!! Kangaroo!!!). These exotic meats are available on the menu and a bit pricey (for the obvious reasons). Two soups always available (Soup du Jour and French Onion). Award-wining ribs. Also regular Sports bar fare: Burgers, Sandwiches, Salads… all reasonably priced. Monday thru Friday from 11 AM–3 PM is the $4.99 lunch special (entrée, side and soft drink).
SEATING	Bar seats twenty, plenty of space. Good for larger size parties. Private party room available—call to reserve, price will depend on number of people, food and drink desired, etc… Beer garden in rear and sidewalk dining area are open until 10 PM, 11 PM on weekends.
AMBIENCE/CLIENTELE	The interior of a North Woods rustic hunting lodge with many a bust of a Buck on the wall. Neighborhood people mostly. Very casual and friendly atmosphere.
EXTRAS/NOTES	NTN trivia game. Golden Tee. Cruising USA (driving video game), Jukebox. Bus trips to Bears games during the NFL season. Check at the bar for more details.

—*Jeffrey Goodman*

Mulligan's Public House
Darts & Jameson… who could ask for anything more?
$$

2000 W. Roscoe St., Chicago 60618
(at N. Damen Ave.)
Phone (773) 549-4225
www.sportssportssports.com

CATEGORY	Neighborhood Beer/Shot Bar
HOURS	Mon–Fri: 3 PM–2 AM
	Sat: noon–3 AM
	Sun: noon–2 AM
GETTING THERE	Street parking, metered on Roscoe. Can get hard to find a space at night.
PAYMENT	VISA MasterCard AMERICAN EXPRESS DISCOVER
	ATM on the outside of the building

POPULAR DRINKS	Eight beers on tap, fifteen brands of top-shelf Irish whiskey on ready for a shot pour.
UNIQUE DRINKS	Guinness at $3.50 for an Imperial pint (20 oz.) or Jameson Irish Whiskey at $3/shot. If you should happen to finish the last drop in the bottle of Jameson, you get the prize of signing the bottle and having it displayed alongside the myriad of Jameson bottles lining the ceiling mantle around the bar.
FOOD	Restaurant to open soon
SEATING	Medium-sized space with lots of stools and fixed counter-space. Bar seats about 20-25 people. Hoping to expand soon. The most impressive part is the lighted Dartboard area, featuring four cork-based Dart boards. Very professional for the true Dart enthusiast. Dart Leagues are on Monday, Tuesdays, and Thursday's. Inquire at the bar for more information about the leagues.
AMBIENCE/CLIENTELE	Casual bar. Jeans and t-shirt. Leans towards the sports bar aspect with fourteen TV's throughout the space (2 are big-screen projection). During football season (NFL), the TV's will show every game from around the country. Afternoons are usually occupied by local tradesmen for a late-afternoon, post-work cocktail, while the evenings cater to a younger, college or post-college crowd.
EXTRAS/NOTES	Golden Tee and jukebox are ready to eat your pocket change. Mulligan's Public House is one of the largest sellers of Jameson in the Midwest. Bob "Sweets" Nelson was a Mulligan's regular who passed away in 2002. He was a big Cub fan and could often be seen running the door from time to time. 'Sweets' was a fixture at Mulligan's for years and he remains a fixture in the form of a vintage Ale lamp hanging over the men's restroom in memoriam.

—Jeffrey Goodman

MoJoe's
Your daily fix of drips.
$$
2256 W. Roscoe St., Chicago 60618
(at Oakley Ave.)
Phone (773) 388-1236
www.mojoescafe.com

CATEGORY	Independent Coffeehouse
HOURS	Mon–Fri: 6:30 AM–10 PM
	Sat–Sun: 7:30 AM–10 PM
GETTING THERE	Easy street parking
PAYMENT	Cash only
POPULAR DRINKS	Traditional espresso drinks: espresso shot, latte, cappuccino, mocha, regular coffee. They have flavored syrups but it's good as is. The latte is the most popular. I recommend trying it iced. They also have chai tea lattes, Italian sodas, bottled juices, teas, and hot chocolate. All coffee is Intelegencia.
UNIQUE DRINKS	No unique drinks, really. Real Traditional. Real Simple. Real Good.
FOOD	Reasonably priced: bagels, croissants, croissant breakfast sandwiches, muffins, scones, and cookies.

They also have daily quiche specials—spinach/tomato basil, lorraine, and mushroom.

SEATING Six small indoor tables, a small red velvet couch, two outdoor, two-seater tables. Small and cozy, good for couples/friends.

AMBIENCE/CLIENTELE Set in a quiet neighborhood, this coffeehouse is a nice change of pace from those typically located in parking lots or on busy city streets. The soothing mint green interior is complimented by warm tones of salmon and peach. An eclectic assortment of 1950s-style, sparkling, vinyl-covered chairs, a red velvet couch, and a variety of small tables invite you to sit and relax—if only for a minute. Coffee cup chandeliers blend with an unusual collection of antique items and vintage posters. The bay window moonlights as a stage for live music performances and open mike nights. The music is mellow, the dress is casual, and the coffee is excellent. This is a neighborhood coffeehouse, so there are lots of regulars. Brain, a digital artist, has multimedia art showcased at MoJoe's. Jim, in the movie production industry, often stops by with his dog Tinkerbell. The barista's a very friendly and down-to-earth.

EXTRAS/NOTES This place hosts a small book collection, board games (Scrabble, chess, cards, etc.) and plenty of photography and fine art for sale, or simply for your viewing pleasure. In the windows, they advertise local venues: music, local comedy, theater, and indie films). A bulletin board lists places for rent, music and language lessons/tutors, cleaning services, and photography classes to name a few. Behind the counter there is a vault, now used to store supplies-this place used to be a bank. Every Tuesday: Jazz and Rockabilly (local artists) usually starts around 7:30 PM and open mike on Saturday nights starting around 7 PM.

—*Melanie Briggs*

Riverview Tavern

All sorts of room to eat, drink, and be merry.
$$
1958 W. Roscoe St., Chicago 60618
(at Damen Ave.)
Phone (773) 248-9523
www.southportlanes.com

CATEGORY Tavern. Bar/Grill
HOURS Sun–Fri: noon–2 AM
Sat: noon–3 AM
GETTING THERE Street parking mainly. Metered spaces on Roscoe.
PAYMENT VISA MasterCard AMERICAN EXPRESS DISCOVER
ATM on premises
POPULAR DRINKS Extensive selection of single malt scotch, $6.50 and up
FOOD Full menu. Plenty of reasonably priced burgers, sandwiches, salads, and traditional bar appetizers.
SEATING Restaurant area has ample space, tables and booths. Good for parties of six or more. Outdoor seating holds about 45 people. There is a private party room (w/pool table and jukebox) that can hold anywhere

from 30 to 100 people. Call ahead to check availability. The games room has tables, too. Along with a Golden Tee and Dome Hockey.

AMBIENCE/CLIENTELE Casual, although the bar has a bit more of an upscale feel to it… don't let it fool you. It's a younger person's hangout with the video games and televisions around the bar area. Mainly college kids, young urban professionals.

EXTRAS/NOTES Golden Tee and Dome Hockey in the games room. The Riverview Tavern was named after the famous River-view Amusement Park (opened in 1904 – closed in 1967) which was just down the street near Lane Tech High School, bordered by Western and Belmont Avenues and the Chicago River. The Riverview and its sibling establishments (Southport Lanes, Corner Pocket, Lucky Strike, Daily Bar & Grill) are all interchangeable with their mahogany finished bars and traditional grill fare. And as usual, the Riverview can cater to the big party with their private party room.

—*Jeffrey Goodman*

Su Van's Café & Bake Shop

Eat more sweets, please.
$$
3351 N. Lincoln Ave., Chicago 60657
(btwn. W. Roscoe St. and W. School St.)
Phone (773) 281-0120 • Fax (773) 281-3950

CATEGORY Independent Coffeehouse and Café.

HOURS Mon–Fri: 10 AM–7 PM
Sat: 8 AM–6 PM
Sun: 9 AM–3 PM

GETTING THERE Okay street and metered parking

PAYMENT VISA MasterCard AMERICAN EXPRESS DISCOVER

POPULAR DRINKS Regular Coffee

UNIQUE DRINKS Though not known for their special drinks, this place has tasty banana mango smoothies and orange juice smoothies.

FOOD This is a great place to grab a sandwich without breaking the bank. Focus here is on lunch food including a sandwich/soup combo. There are over 30 different sandwiches here! The BLT is not to be missed.

SEATING With fourteen non-smoking tables, this place can accommodate large groups or couples looking for a cozy nook.

AMBIENCE/CLIENTELE Born in an old belly dancing school by two friends, Susan and Vanessa (Su Van, get it?), this mellow Lakeview lunch and early dinner spot reminds you of your Favorite Aunt Frida, the one who decorated with kitschy cat sculptures and let you eat all the sweets you wanted. Don't bother baking for yourself. Instead, nibble country-kitchen goodness from their current space near the corner of Roscoe/Lincoln/ Paulina. They put a lot of gusto into over 30 sandwiches like the perfect BLT, featuring sun dried tomato mayo. Pick one with a fun name like Ghost of the Belly

Dancer. Salads, soups and chili round out the menu, as well as kiddie offerings like a peanut butter and banana sandwich, named the Elvis, of course.

—*Janet E. Sawyer*

The Village Tap
The staple of Roscoe Village food and drink.
$$$
2055 W. Roscoe St., Chicago 60618
(at Hoyne Ave.)
Phone (773) 883-0817

CATEGORY	Neighborhood Bar
HOURS	Mon–Thurs: 5 PM–2 AM
	Fri: noon–2 AM
	Sat: noon–3 AM
	Sun: noon–2 AM
GETTING THERE	Street parking mainly with meters on Roscoe. Can be tough to find a street space at night.
PAYMENT	
	Plus, an ATM in the bar.
POPULAR DRINKS	Mainly a beer and a shot bar.
UNIQUE DRINKS	27 Beers on tap.
FOOD	Full menu here. Sandwiches, burgers, burritos, salads and veggie fare (falafel, hummus), fish n'chips, ribs. Check the menu for Daily specials.
SEATING	Stools and chairs in the front. Bar seats about twenty, more stools and tables throughout the main area. There is a very spacious Beer Garden in the rear, which is covered by a retractable tent (for easy closure when it rains). It is not open year round, but can house large parties with its plethora of picnic tables lined up together.
AMBIENCE/CLIENTELE	A mix between neighborhood professionals and local artists. Very casual scene with a lively mood (but not too over the top).
EXTRAS/NOTES	Aaron, an eight-year veteran of the Village Tap, spun a good yarn about how the space at 2055 W. Roscoe has always been a bar in some way, shape or form. It was mainly an Irish/German hangout through Pre-prohibition. And it was a carnie (that is, carnival worker) hangout known as Freddy Feelgoods during the time of the Riverview Amusement Park days (the park closed in 1967). Today, the Best Beer Garden in Chicago (as voted by *Where Chicago Magazine* and *The Official Chicago Bar Guide*) is open until 11 PM on weekdays, midnight on weekends. Paintings by local artists on the exposed brick walls are for sale. Video games include Golden Tee and a Ms. Pac Man/Galaga. TVs throughout the bar, so it is a good place to catch the game and have a bite to eat. Located in the heart of Roscoe Village, this bar features a lively blend of the young urban and art professionals, where people can enjoy some good food and drink without all of the 'yahoo' of younger, college-aged beer-hoisting.

—*Jeffrey Goodman*

UPTOWN

Carol's Pub

*Southern hospitality and good music are
the mainstays of this Uptown classic.*
$

4569 Clark Street, Chicago 60640
(at Leland Ave.)
Phone (773) 334-2402

CATEGORY	Carol's Pub is one of Chicago's few venues for country and western music—and I mean the real stuff, Hank Williams (that's Hank Williams Senior) and the like, not the highly marketed "pop" crossover style that takes up too much airspace these days. This honky tonk is very much a dive bar, but that's part of its charm.
HOURS	Mon–Tues: 9 AM–2 AM Weds–Fri: 11 AM–4 AM Sat: 11 AM–5 AM Sun: 11 AM–4 AM
GETTING THERE	Street parking available. You can also take the Red Line to the Wilson El stop and head west. Turn right on Clark Street and go another block to Leland. It's about a 15 minute walk.
PAYMENT	Cash only
POPULAR DRINKS	Beer, beer, and did we say beer? Mugs of Miller Lite and Old Style are 2/$5 making this place popular with penny pinchers and students from Truman College.
FOOD	Hot sandwiches are served late into the evening and are surprisingly good. A cheeseburger, choice of fries or onion rings, and a mug of beer will only set you back $7 or so.
SEATING	A long bar with stools, tables with bar stools, and chairs are scattered throughout the pub. A good place to meet up with friends, but probably not good for large groups.
AMBIENCE/CLIENTELE	A laid back place where the beer is cheap and the cowboy hats plentiful. Solo drinkers are made to feel welcome, as there is always a friendly ear and a bit of conversation to be had. The décor is simple and homey with concert photos and a sketch of the Pillsbury Doughboy decorating the wall. On weekends the popular house band covers the standards. Darts and a pool table will keep you occupied, and Thursday night country karaoke is always worth the trip out. It's the one night of the week when college students, newly transplanted yuppies, and good ol' boys can hang out comfortably. Carol's has a house band featuring country music. On Thursdays there is Karaoke with few stellar performances, but lots of enthusiasm.
EXTRAS/NOTES	From World War II until about 1970, an estimated 3 million people moved to the Midwest from the Appalachians. A great many of these migrants found their way to Uptown, giving it its nickname of "Hillbilly Heaven." Many taverns in the neighborhood boasted "live hillbilly music" on the weekends. Today, Carol's Pub remains a testament to that era. The rough-looking biker guys checking IDs at the door are rather intimidating when you first meet them, but are actually quite friendly.

—J. Asala

Crew Bar and Grill

The best damn gay sports bar in Chicago, period.

$$

4804 N. Broadway St., Chicago 60640
(at Lawrence Ave.)
Phone (773) 784-CREW
www.worldsgreatestbar.com

CATEGORY Crew is one of the latest additions to Uptown. This very modern gay-themed sports bar and grill has a 92-inch TV screen, multiple monitors, and satellite and HDTV offering a range of sports programs and events. Not in the mood to watch the Cubs? Several of the screens also play music videos. Don't let your heterosexuality stop you from walking in the door; many Uptown locals refer to Crew as "a straight-friendly gay bar."

HOURS Mon–Thurs: 11:30 AM–midnight
Fri: 11:30 AM–2 AM
Sat: 9 AM–2 AM
Sun: 9 AM–midnight
Outdoor dining closes at midnight daily.

GETTING THERE Parking in Uptown is always a bit tight. Fortunately, Crew is right by the Lawrence Red Line El stop.

PAYMENT VISA MasterCard

POPULAR DRINKS It's a sports bar, and beer is what many people drink. With several dozen different beers on tap and in bottles, there is sure to be one you'll call your new favorite. The sangria is delicious, and if you ask nicely, the cute waiters will bring you extra fruit. The fully stocked bar was a welcome site, but the cocktail prices are a bit steep.

UNIQUE DRINKS Pitchers of beergaritas—a margarita and beer hybrid are available for $12.00

FOOD Full menu available 'til 10 PM; late night bar menu 'til closing. Above-average pub food goes beyond the usual fare to offer tasty treats like Pepper Parm Chicken Caesar Salad, the Very Veggie Wrap, and the provocatively named Threesome Grilled Cheese Sandwich. Decorate your half-pound "Double Fisted Burger" with your choice of premium toppings including sautéed garlic spinach, mushrooms, onion strings, caramelized onions, red peppers, jalapeños, tomatoes, sliced pickles, avocado, four types of cheese, and bacon. Sandwiches range from $6 to $8 and come with choice of side dish. A generous selection of appetizers and "sides to share" offers Macaroni and Cheese, Oven Baked Goat Cheese Marinara, and Overloaded Cheddar Bacon fries—the later a perfect finish to an evening of heavy drinking. On weekends there is a breakfast menu served from nine until noon but the jury is still out on if it will be a success or not.

SEATING There is a new sidewalk café with a half dozen or so tables and a nice view of the Green Mill and the Uptown Theatre. Inside, tall bar chairs surround even taller tables. There is also a bar running the length of Crew. Seating is tight, and it's a little difficult to navigate your way to the restrooms in back. It's also hard for the waiters to see all the tables and know when someone new has come in. Best for groups of friends—avoid taking your date here; it's so loud

you'll never be able to flirt appropriately.

AMBIENCE/CLIENTELE This is the kind of bar to either start or end your evening with. Beergaritas are cheap, so have a pitcher or two with your friends before moving on. Crew quickly fills up and is very, very, loud and chaotic for most of the evening. Stop by later for another drink before going to bed—their late-night bar menu is just the thing you need to put something other than alcohol in your stomach and prevent that hangover the next morning. Crew is a "friends" place. Don't bother coming alone, because everybody is already here with someone else.

EXTRAS/NOTES Every fourth Friday of the month is designated Frat Boy Friday and there is a "hot jock" contest with a not-so-shabby $300 prize. Bring your iPod along on the second Tuesday of the month and sign up with the DJ to subject everyone in the bar to your favorite tunes. Other regular events include "God Save the Queens," an ode to all things British with specials on English ale and cider. Wheelchair accessible. Hats and t-shirts are available with the Crew logo. There is a happy hour every Friday from 4 to 6 where appetizers are half off and regular drink specials throughout the month.

—J. Asala

The Green Mill
"Jazz and machine guns, the most historic bar in Chicago!"
Since 1907
$
4802 N. Broadway Ave., Chicago 60640
(at Lawrence Ave.)
Phone (773) 878-5552
www.greenmilljazz.com

CATEGORY Yes, it's a Jazz Club, but it's much, much more—read on!

HOURS Sun–Fri: noon–4 AM
Sat: noon–5 AM

GETTING THERE Street parking isn't so bad and there's a free lot at Lawrence and Magnolia after 6 PM. The Green Mill steps away from the Lawrence El stop too.

PAYMENT AMERICAN EXPRESS

POPULAR DRINKS Schlitz beer. There I said it.

DRINKS Plenty of beer and standard cocktails.

SEATING Ample stools along the huge L-shaped bar, booths and tables. Seats about 110

AMBIENCE/CLIENTELE The Green Mill is the type of place you want to bring friends when they visit from out of town on the weekends, but hang out at with the locals during the week. One of the most famous bars in Chicago, The Green Mill was a regular hang out for gangster Al Capone after one of his henchman, "Machinegun" Jack McGurn, bought a 25% share in the tavern. McGurn is alleged to have been one of the gunmen in the St. Valentine's Day Massacre. There's a corner booth that Capone and his men would sit at that gave them a view of both the east and south doors.

Also, little known to many patrons, there's a trap door behind the bar that leads to a cellar where a tunnel was used to run liquor up to the bar during prohibition. Today the Green Mill still has the same romantic charm that it possessed from the 20's right up through the 40's when it was a regular for all sorts of big name entertainers. But despite its sort of hoity-toity past, the atmosphere is anything but. A person can come in for a post-dinner cocktail with a first date, or use it as cool place to relax with some friends. It's not uncommon to see the occasional tuxedo-clad patron elbow to elbow with a flannel-wearing bus driver. But this probably isn't the place for loud drunks or for your softball team to meet after games. If you live in the city, chances are you've been there. If you don't, what are you waiting for? And if you're visiting, you have to stop by. It's a must for music lovers.

EXTRAS/NOTES Established in 1907, The Green Mill is one of the most famous jazz clubs in Chicago, if not the country. The Green Mill is, in fact, the oldest, continuously running jazz club in the United States. Al Jolsen performed here in the 1910's and was followed with a veritable who's-who of A-list stars like Billy Holiday, Tommy Dorsey, Sophie Tucker, Bix Deiderbecke, Jack Teagarden, and Benny Goodman. Still a staple in the Chicago jazz scene, the Green Mill hosts regular acts on different nights of the week, and has hosted a Sunday night poetry slam since 1986. It will also play host to local stars and traveling jazz legends who feel inclined to pop in uannounced. The Mighty Blue Kings, a swing band which has gained national prominence, used to play here on Tuesday nights. This writer remembers the days when a seat was easy to find, but it didn't take long for the word to spread and the line went out the door and around the corner. Inside, at the turn in the L-shape of the bar, the bar bubbles out to make room for a baby grand piano upon which sits a photograph of Al Capone. Also, it just might be the most filmed tavern interior in the city of Chicago, appearing in such movies as, "High Fidelity" (2000) starring John Cusak, "Prelude to a Kiss" (1992) with Meg Ryan and Alec Baldwin, "Thief" (1981) featuring James Caan, "A Family Thing" (1997) with Robert Duvall, and of course "The Untouchables" with Sean Connery, Kevin Kostner, and Andy Garcia, with Robert DeNiro starring as Al Capone.

—*Mike Fertig*

"Always do sober what you said you'd do drunk.
That will teach you to keep your mouth shut."

—*Ernest Hemingway*

LINCOLN SQUARE

Bad Dog Tavern

Attitude and style more Lincoln Park than Square.
$

4535 N. Lincoln Ave., Chicago 60625
(at W. Wilson Ave.)
Phone (773) 334-4040

CATEGORY	Trendy Tavern
HOURS	Mon: 4 PM–2 AM
	Tues–Fri: 11 AM–2 AM
	Sat: 11 AM–3 PM
	Sun: 11 AM–2 AM
GETTING THERE	Next door is a pay lot that is inexpensive, but occasionally full on the weekend evenings. Street parking is very difficult. Bad Dog is about four blocks from the Western Brown line stop.
PAYMENT	VISA MasterCard AMERICAN EXPRESS DISCOVER
POPULAR DRINKS	Ciders are a favorite for regulars. European imports pay respect to the area's history. There's a small wine list and a normal selection of mixed drinks.
FOOD	Dressed-up bar food, but in a good way.
DRINKS	Beer, Wine, Cocktails, Martini's.
SEATING	Plenty of room inside and out. One of Bad Dog's biggest draws is its well-designed patio. It is a great place to people watch in warmer weather. Inside the seating is ample, but upfront window seats are prime spots for both dining and drinking. Bad Dog has a loungey feel that separates it from most other Lincoln Square bars.
AMBIENCE/CLIENTELE	Bad Dog has a homey, "come as you are" kind of vibe. But if you want to dress up for dinner, you won't feel out of place.
EXTRAS/NOTES	Bad Dog has a varied music schedule—Mondays and Tuesdays feature Live Jazz or Irish music—Friday is often DJBV Music night and DJ's spin on weekends.

—Brent Kado

The Book Cellar

Independent bookstore/coffeehouse with small-town character.
$$

4738 N. Lincoln Ave., Chicago 60625
(at W. Lawrence Ave.)
Phone (773) 293-2665
www.bookcellarinc.com

CATEGORY	Coffeehouse/Bookstore
HOURS	Sun: noon–6 PM
	Mon: 10 AM–10 PM
	Tues: noon–6 PM
	Weds–Fri: 10 AM–10 PM
GETTING THERE	Lots of parking options, including two nearby parking lots. Close to Western Brown line stop.
PAYMENT	VISA MasterCard AMERICAN EXPRESS
POPULAR DRINKS	Hot chocolate, or coffee and espresso from Torrefazione

UNIQUE DRINKS	Modest wine list from $25-37 a bottle, $4-6 a glass
FOOD	Turkey, roast beef, and veggie sandwiches, cheese plate with olives, salads, soups. All under $10.00.
SEATING	Roughly ten small tables.
AMBIENCE/CLIENTELE	This Lincoln Square gem has the familiar feel of a college-town bookstore, and combines two elements of a great time: great books and great wine. The atmosphere is quiet, but welcoming to those interested in talking lit. over a bottle of Cabernet.
EXTRAS/NOTES	The Book Cellar features weekly literary events, readings, workshops, and a book club.

—*Keidra Chaney*

Café Selmarie

*Leading people-watching spot
in Lincoln Square featuring
lovely provisions.*

$$

4729 North Lincoln Ave., Chicago 60625
(at Leland Ave.)
Phone (773) 989-5595
www.cafeselmarie.com

CATEGORY	The scene here is a potpourri of different kinds of Chicagoians much like the neighborhood itself. It lies somewhere between local joint and upscale coffee houses.
HOURS	Mon: 11 AM–3 PM
	Tues–Thurs: 8 AM–10 PM
	Fri–Sat: 8 AM–11 PM
	Sun: 10 AM–10 PM
	(Sunday brunch from 10 AM to 3 PM)
GETTING THERE	Not the easiest. Some metered street parking is possible, but not likely especially on the weekends.
PAYMENT	VISA MasterCard AMERICAN EXPRESS DISCOVER
POPULAR DRINKS	Wine, Lattes, and Café Au Laits are the drinks of choice here. A full-service espresso bar and Intelligentsia coffee make any caffeinated drink choice of the utmost quality.
UNIQUE DRINKS	A small list of European beers give Café Selmarie a connection to the neighborhood's ethnic past.
FOOD	Café Selmarie is top spot for food on the northwest side. While it may be tempting to skip the main courses and go straight to their famous dessert treats, meals here are well worth a taste. Executive Chef Christopher Stoye has created an admirable menu. With changing dinner specials, a healthy beer/wine list and attentive service, this café sets up an atmosphere for memorable cuisine in an upscale, casual sort of way. But don't gorge on items like Radiatore Pasta or Grilled Eggplant and Cous-Cous because deserts is a must. The café's desert menu is mouth watering and all made-from-scratch. The mainly European delights are mesmerizing to the mouth. Top choices include Stolen (a German treat appropriate considering Lincoln Square's history), carrot cake and a bevy of pies, cookies and muffins. Café Selmarie is known for a brunch that continues to

	impress week after week.
SEATING	Seating is usually not a problem, but on busy winter weekend nights you may have to wait for a table. You can grab an espresso and sit at the bar stools that line the café windows as you wait. During warmer months outdoor seating is plentiful on the Square. You can dine while watching patrons of other cafes nibble on inferior desserts, old time Eastern Europeans study the action from the park benches, or maybe even some jazz during the summer music series. Despite all the outdoor room, Café Selmarie is best suited for couples and small groups.
AMBIENCE/CLIENTELE	Since the Café offers a dash of something for everyone, you will find all kinds here. Young artsy couples, Boho professors, yuppie parties, and of course long time resident Europeans. Dress varies from business casual to hipster couture. Conversation is always lively at the café as dinners wait on meals and watch steady streams of people come in for Lattes and Scones.
EXTRAS/NOTES	Very nice art work on the walls from local creative-types. Check out the café's Wine nights and other special events like book signings.

—Brent Kado

The Grafton

Irish pub charm with an urban feel.

$

4530 N. Lincoln Ave., Chicago 60625
(at W. Sunnyside Ave.)
Phone (773) 271-9000

CATEGORY	Irish Pub
HOURS	Mon–Fri: 5 PM–2 AM
	Sat: 11 AM–3 AM
	Sun: 10 AM–2 AM
GETTING THERE	Take a cab or catch the El. Street parking available in sparse Lincoln Square.
PAYMENT	VISA MasterCard AMERICAN EXPRESS DISCOVER
POPULAR DRINKS	Guinness, Harp
FOOD	Regular bar food, but an especially good steak sandwich.
SEATING	Wooden booths and stools in the front, a few long tables in the back, with a narrow, uncomfortable stool area.
AMBIENCE/CLIENTELE	Everyone is welcome here, but the Lincoln Square crowd (later 20s, early 30s) takes charge of The Grafton. This is definitely the cheery ol' place a group of friends can go to, sit down, and catch up on the week's happenings, conjure up quick-rich schemes, or just drink a nicely poured Guinness and enjoy the black and white pictures, wood finish, and the students from the Old Town School of Folk Music jam on an Irish jig song. There's also an open-mic night for the really adventurous.

—Sy Nguyen

Old Town School of Folk Music

Not just for hippies anymore!
Since 1957
$$

4544 Lincoln Ave., Chicago 60625
(between Wilson Ave. and Sunnyside Ave.)
Phone (773) 728-6000
www.oldtownschool.org

CATEGORY	Live entertainment/folk music center.
HOURS	Mon–Thurs: 10 AM–10 PM
	Fri: 10 AM–6 PM
	Sat–Sun: 10 AM–5 PM
GETTING THERE	Easy street and metered parking nearby
PAYMENT	VISA MasterCard AMERICAN EXPRESS
POPULAR DRINKS	Coffees, plus a full selection of traditional and microbrewed beers from $2-4
FOOD	Mediterranean dish with hummus, stuffed grape leaves and falafel. Spinach pie.
SEATING	Not much in the way of seating when there's a show. There are a couple of tables and chairs available in the front lobby during class hours.
AMBIENCE/CLIENTELE	Music students of all ages, with a fair share of folksy, granola types.
EXTRAS/NOTES	The renowned Old Town School of Folk Music, founded in 1957 during the height of the genre's popularity, moved to the spacious former digs of a public library in 1998. The school offers classes in a variety of instruments, songwriting, dance and yoga, and sponsors local and national concerts and community performances in folk and world music. The café serves more as a pit stop for students and concertgoers than a destination. Still, the food – pastries and some salads – is surprisingly good, and the beer selection impressive.
OTHER ONES	• Lincoln Park: 909 W. Armitage Ave., 60625, (773) 728-6000

—Keidra Chaney

Perfect Cup

Perfectly cute coffee in, yes,
Perfect Cups.
$$

4700 Damen Ave, Chicago 60605
(at Leland Ave.)
Phone (773) 989-4177

CATEGORY	Independent Coffeehouse
HOURS	Mon–Fri: 6:30 AM–9 PM
	Sat: 7:30 AM–9 PM
	Sun: 7:30 AM–8 PM
GETTING THERE	Street parking and metered spots
PAYMENT	Cash Only.
POPULAR DRINKS	Nice smooth cuppa regular ol' joe, lattes, also cafe umbria brand coffee.
UNIQUE DRINKS	Mighty Leaf brand of teas, not many locations in the city carry this brand, Ann's Special (named for the owner): coffee, chocolate cream and espresso.
FOOD	Small menu features quick breakfast items (bagels,

muffins, scones, croissants) small assortment of standard sweets (brownies and cookies), pannini sandwiches (turkey, ham, roast beef, veggie), and Little Miss Muffins.

SEATING Airy, high ceilings, big storefront windows make this place seem larger than it really is, but the eight tables and couches make this the perfect cozy place for couples.

AMBIENCE/CLIENTELE With chintzy but not uncomfortable black plastic chairs, worn, comfy loveseats and couches, and work from local artists and photographers for sale on muted toned walls, this cute corner spot feels like a friend's living room. Jazz in the background and inexpensive wi-fi access add to the sit-and-stay-a-spell vibe. An assortment of snacks like gum and diet bars, standard breakfast sweets and paninni sandwiches draws gal pals, long term relationship couples and laptop-working singles from the quiet neighborhood near the Damen Brown Line El stop. Anyone passing on the Damen Avenue thoroughfare to Bucktown/Wicker Park might never make it to the hipster 'hoods. This place is so darn cute. No sleepovers allowed on the crash-at-my-place style couches, though.

EXTRAS/NOTES Work of local artists and photographers for sale, also handmade greeting cards. Plus, cheap wi-fi access.

—*Janet E. Sawyer*

ANDERSONVILLE/RAVENSWOOD

Beans and Bagels
Punker coffeehouse with neighborhood appeal.
$

1812 W. Montrose Ave., Chicago 60613
(at Ravenswood Ave.)
Phone (773) 769-2000
www.beansandbagels.com

CATEGORY Neighborhood Eatery and Coffeehouse

HOURS Mon–Fri: 6:30 AM–8 PM
Sat–Sun: 7 AM–4 PM

GETTING THERE Plenty of street parking, though you may need to walk a block or two.

PAYMENT Cash only

POPULAR DRINKS Specialty Coffees

UNIQUE DRINKS Yogurt smoothies

FOOD Sandwiches, including the Turkey Reuben, the Ferdinand (hummus, tomato, spinach on a pizza bialy), the Korntucky (tuna, cheddar and mustard on Polish rye). Also, great falafels.

SEATING Seating for about fifteen.

AMBIENCE/CLIENTELE Countercultural, student coffeehouse vibe, that's equally popular with "suits" and stay-at-home parents with their kids.

EXTRAS/NOTES This neighborhood coffee hangout is popular with morning commuters. The friendly, familiar servers have a punky, indie vibe. Work from local artists adorns the walls, and is usually for sale. Check the bulletin board for news on local music, art and

community events.

OTHER ONES • Northwest/Rockwell: 2601 W. Leland Ave., Chicago 60625, (773) 649-0015

—Keidra Chaney

Brownstone Tavern & Grill

A friendly neighborhood bar where the game is always on.
$$
3937 Lincoln Ave., Chicago 60613
(at Irving Park)
Phone (773) 528-3700 • Fax (773) 528-3705
www.brownstonetavern.com

CATEGORY	Brownstone is wholeheartedly a Big 12 and University of Texas sports bar!
HOURS	Mon–Thurs: 5 PM–2 AM
	Fri: 11 AM–2 AM
	Sat: 11 AM–3 AM
	Sun: 11 AM–2 AM
GETTING THERE	Pay lot (City lot on the corner of Damen)
PAYMENT	VISA MasterCard AMERICAN EXPRESS DISCOVER
POPULAR DRINKS	Traditional Tavern: Beer (draught/bottle, domestic and imported) Traditional white wines and a variety of reds
UNIQUE DRINKS	Beer- Bell's Seasonal (Summer: Oberweis) or Blue Moon draught, Duvel Belgian Ale (bottle), Wine: 2001 La Linda Malbec (Argentinean-Red), Full bar: 16 draught beers, 37 bottle beers, 14 different wines
FOOD	Full Menu- Appetizers, Salads, Soups, Sandwiches, and some Entrees (lamb, salmon, or tuna). Not too pricy. Traditional American with some Mexican-American dishes (quesadilla, fish tacos, chicken tortilla soup). Kitchen open until midnight.
SEATING	Seats 88–100 indoor, 30 outdoor.
AMBIENCE/CLIENTELE	Brownstone Tavern was designed in the classic imagery of the 'Brownstone' period of Chicago's architectural history. It's a flashback, with antique bronze fixtures, a large, Victorian-style mahogany bar, stained-glass chandeliers, and tufted, black, leather seating. Photos of Chicago's famous Brownstone homes adorn the walls. Despite the old fashioned décor, this is- first and foremost- a sports bar, equipped with five new flat-screen televisions, a jukebox, dance floor, and a new sound system. The dress is casual: t-shirts, jeans, flip-flops. The mood is light, though the energy gets pretty intense when the game is on. Brownstone is a great place to enjoy a cold beer and catch up with friends, family, and current sporting events.
EXTRAS/NOTES	With an outdoor patio, Big 12 games on the screen, and live music at 8 PM every Sunday, this may just become your new favorite hang.
OTHER ONES	• Part of the Four Corners Tavern Group: Schoolyard Tavern & Grill: 3258 N. Southport Ave., Chicago 60657, (773) 528-8226; Gaslight Bar and Grille: 2426 N. Racine Ave., Chicago 60657, (773) 929-7759; Sidebar: 221 N. La Salle St., Chicago 60601, (312) 739-3900

—Melanie Briggs

*D-I-Y OR B-U-Y (JUST NOT D-U-I): A Guide To Your Fake I.D.**

D-I-Y

With today's printers, home laminating, and Photoshop it's pretty easy to make an I.D. at home. Take a look around the web and you'll find tons of guides on everything you'll need from I.D. templates to how to laminate at home. If you're going to do this, make sure you do pick the right state—some are tremendously hard to fake, others are notoriously easy (thanks, New Jersey!). A few pointers: In the wake of the recent growth of identity theft, a lot of laws about fake I.D.s have changed, so be sure to use your own name on your I.D. rather than a made up one—or Homeland Security might come knocking. Also, make sure you proofread your work. Seriously, I know someone who misspelled the word "license" on his homemade fake.

B-U-Y

If you're less than computer savvy or more than a little lazy, you can shell out anywhere between forty and a hundred twenty bucks for a fake I.D. Scanable fakes are almost always more expensive than those that don't, but are usually worth the extra cash. If you don't know where to get one, ask your older brother/sister or a friend (hey, we're not going to do *all* the work for you). The first rule of buying a fake: Never give all of your money up front. It may seem like common sense, but many otherwise desperate minors have made this mistake.

Above all remember: If you choose to make or purchase the fake I.D.—not that we would advise you to—do so with the knowledge that it goes as quickly as it comes. It can be useful if used with caution, but one grumpy bouncer can ruin the pseudo-21-year-old high in a snap. And they always know it's fake. It's a bouncer's judgment call every time.

If you already lost your I.D. to a bouncer or are too broke to buy one, don't worry, you may be underage, but you're not down and out. We have two tips that can get you by.

The Dinner Trick: This one only works where food is served, but it works almost all of the time. Just arrive at your chosen venue early (way early—before 8 PM) and order dinner. Don't bother ordering drinks until after you've eaten, by then the drinking crowd should have entered and you can sidle up to the bar unnoticed. If it looks like they're going to try to kick you out before the festivities begin, you can always hide in the bathroom.

Dress Up, Dress Down, and Just Act Cool: You always want to look like you belong where you're going. So if you're going to Funky Buddha or Sopo (p. 12 and p. 87), make sure you dress to the nines. And if you're going to a dive, you aren't going to impress anyone with your sequined dress or Armani shirt. By the way, never ever try the 'do you know who I am!?!?' trick. This one never works. Ever.

*This list is purely for entertainment value. We would never, ever, *ever* recommend making, buying, or using a fake ID.
—Louis Pine

Café 28

Vacation south of the border,
without ever leaving the city.

$$$

1800 W. Irving Park Rd., Chicago 60613
(at N. Ravenswood Ave.)
Phone (773) 528-2883 • Fax (773) 528-2887
www.cafe28.org

CATEGORY	Latin-American restaurant and bar
HOURS	Mon: 5:30 PM–9 PM
	Tues–Thurs: 5:30 PM–10 PM
	Sat: 9 AM–2 PM; 5:30 PM–10:30 PM
	Sun: 9 AM–2 AM; 5:30 PM–9 PM
GETTING THERE	Valet (Friday-Saturday nights only)
PAYMENT	VISA MasterCard AMERICAN EXPRESS DISCOVER
POPULAR DRINKS	Mojitos and Margaritas- like the cuisine, they are authentic and tasty. Also, a full bar with bottled beer and an extensive wine list (Italian, Spanish, S. American, French, Australian).
UNIQUE DRINKS	Try a mojito—traditional Cuban cooler: made with light rum, mint leaves, lime juice, sugar, and soda water.
FOOD	Cuban and Mexican cuisine. Full dinner menu- appetizers, soup and salad, entrees, and dessert. They also have brunch on the weekends. Prices are inexpensive to moderate. Try the Baked Goat Cheese or Empanadas to start. Bistec a La Cubana and Pistachio Crusted Chicken are nice choices for dinner.
SEATING	There is a small front bar, with six stools, two-seater pub tables line the walls in front of the windows, with a couple lower cocktail tables towards the back. The main dining area seats about 100. The patio area has seating for 30.
AMBIENCE/CLIENTELE	Samba and salsa rhythms- barely audible over the sound of lively conversation- allure you into this friendly, family-owned restaurant bar. Café 28 is one of the best-kept secrets for Cuban and Mexican cuisine—not to mention: Mojitos and Margaritas. It's a great place to watch the day turn into night. Inside, it is a stark contrast to the hustle and bustle seen through the storefront windows overlooking Irving Park Rd. The rich warm colors of the décor, complimented by the slow, rhythmic pace of the ceiling fans, create a setting far removed from the city that surrounds this establishment. Add to that, a refreshing Mojito or Margarita and you'll be lost in the moment. Although many people don't know about this place, it is always bustling. Sunday brunches are no exception; you can wash down that hangover with a refreshing Bloody Mary and a plate of traditional huevos rancheros while you enjoy the live acoustic Brazilian grooves- from afar, if necessary. Breakfast, lunch, or dinner- this lively corner restaurant bar welcomes you to relax, have a drink, and escape the city for a while.
EXTRAS/NOTES	A three-piece band plays Brazilian grooves in the back dining room during Sunday brunch (11 AM–2 PM).

—Melanie Briggs

Entervision's Cosmic Café

Coffeeshop-cum-community meeting place
in Ravenswood.

$

1944 W. Montrose Ave., Chicago 60613
(at Winchester Ave.)
Phone (773) 728-2233
www.cosmicafechicago.com

CATEGORY	Neighborhood coffeehouse and eatery
HOURS	Mon–Thurs: 6:30 AM–10 PM
	Fri: 6:30 AM–11 PM
	Sat–Sun: 8 AM–9 PM
GETTING THERE	Street and metered parking nearby.
PAYMENT	Cash only
POPULAR DRINKS	Standard coffeehouse fare, including non-caffeinated drinks such as Naked fruit juices and Goose Island Root Beer.
UNIQUE DRINKS	BYOB in the evening. Drinks are available in three sizes, named for the owner's three children: Elijah, Nana and Baby David.
FOOD	Try the New York-style deli sandwiches including "Blazin' Buffalo Chicken" and Sun-Dried Tomato ham.
SEATING	Seating for about 35. Plenty of room for a small group meeting.
AMBIENCE/CLIENTELE	Arty but unpretentious. Perfect for families.
EXTRAS/NOTES	Come for the food, stay for the fun! Cosmicafe plays host to a number of music/community events each week. Jazz musicians entertains the crowd on Sunday mornings. The "Kelly Girls" knitting group meets on Wednesday nights, and Wi-fi is available (for $3 an hour) for those who would prefer to socialize virtually.

—*Keidra Chaney*

The Hidden Cove

Whisk yourself away to the tropical world of Karaoke.
$$

5338 N. Lincoln Ave., Chicago 60625
(at W. Berwyn Ave.)
Phone (773) 275-6711

CATEGORY	Karaoke Bar
HOURS	Sun–Fri: 11 AM–4 AM
	Sat: 11 AM–5 AM
GETTING THERE	There is a free lot in the rear of the building but spaces are limited. Street parking can be hit or miss.
PAYMENT	VISA MasterCard
POPULAR DRINKS	Have Jessica make you a Mai-Tai ($5), it's very tasty.
UNIQUE DRINKS	$4.50 'oilcans' of Fosters and Labatt's.
FOOD	Grill food and bar snacks.
SEATING	Mainly bar stools and tables (10-12 tables, depending on the arrangement), seats at the bar as well. Medium sized place, but you won't feel packed like a sardine, there's enough space to get from the bar, to your seat, to the bathroom without spilling on someone. Good for groups of four or more.
AMBIENCE/CLIENTELE	Dress code is very casual, but watch that you don't

wear a wife-beater tee-shirt or colored bandanna (this is not a joke). The clientele comes from the gamut of Chicago's socio-economic strata, all looking for a good time to drink, have a smoke, and belt out a few tunes. Great for the younger crowd, the middle-aged, and the young at heart (old folks).

EXTRAS/NOTES Golden Tee and World Class Bowling video games. The Hidden Cove has a very diverse and very large selection of Karaoke tunes. Bar is available for private parties, call and ask for Bonnie for more info. Looks like a dive but has the obligatory Christmas lights and a bit of a tropical/Hawaiian motif interspersed throughout the space.

—*Jeffrey Goodman*

Hopleaf Bar
Hop on in…God I'm burned out!
$$$
5148 N. Clark St., Chicago 60640
(at Foster Ave.)
Phone (773) 334-9851

CATEGORY	Trendy bar turning restaurant.
HOURS	Mon–Fri: 3 PM–2 AM
	Sat: noon–3 AM
	Sun: noon–2 AM
GETTING THERE	Street parking can be difficult.
PAYMENT	Cash only
POPULAR DRINKS	Large selection of Belgian beers. Over 200 beers here.
UNIQUE DRINKS	Belgian beers.
FOOD	New, expanded kitchen with Belgian bar fare. Sandwiches, smoked duck. Little pricey.
SEATING	Cramped, but new expansion offers good seating.
AMBIENCE/CLIENTELE	A little taste of Belgium in Andersonville. The newly expanded kitchen offers new treats to what was already a decent bar. A lot of old beer posters from the 1920's decorate the walls and the clientele is varied. Trendy…alternative…yuppie…this place draws them all. It strikes me as the kind of place where intellectuals might go to let loose and unwind. This is not a place for hardcore drinkers. It almost feels as though you have to mind your manners.
EXTRAS/NOTES	A lot of patrons sit around reading various newspapers. It's almost like a coffee house.

—*Brian Diebold*

FIELD TRIP
Living It Up in Madison

I was sitting in one of Lakeview's fine eating establishments one afternoon when I spotted one of those free alternative weeklies we young Chicago hipsters so love to read. One of them had the caption, "What's brewing in Chicago's Coffee Culture?" I laughed out loud. Coffee culture? Chicago? Where? The existence of an

independent coffeehouse culture here was news to me, since I was mostly aware of the, oh, two million coffee chains that seem to dot every other city block in Metro Chicago. But then, I'm probably a bit spoiled having returned to Chicago after spending three years in the Coffee Mecca of the Midwest (Madison, WI to the unenlightened). Though I've managed to finally find my way around Chicago's independent coffeehouse scene, there's something about Madison's devotion to its local coffeehouses that just can't be matched.

Madison is a college town, so it should come as no surprise that most of its denizens are addicted to caffeine. On State Street, Madison's answer to the Magnificent Mile, you can find about seven coffeehouses—and only one of them is a Starbucks. In Madison, coffee culture is taken so seriously that the mere act of consuming a cup of joe is elevated to a significant statement of social and political responsibility. You call yourself a Neo-Marxist/activist type? Then don't even think about drinking a cup of coffee in Madison if it's not fair trade (I mean it!). And you must be certain that our bird friends aren't being displaced by your thoughtless consumption. Make sure your coffee beans are shade grown, too. Don't want your coffee brewed by The Man—or men at all? Grab yourself a mocha over at A Room of One's Own, a feminist coffeehouse and bookstore—they're quite good! Either way, you get my point. Madison has a major coffee culture. In fact, Madison's devotion to coffee even rivals Seattle—the city by which all coffee consumption in the Western Hemisphere is measured. Here are a just few of Madison's most notable haunts:

Ancora is the city's premier coffee roaster, their flagship store and was once a popular hangout for pop/rock band Garbage when they recorded their CD in the Mad City. (3/4 of the band hails from Madison). Ancora cafés are stylish and upscale, and the large variety of coffee blends available is uniformly excellent. One popular drink is the White Zombie, a coffee drink made with lightly roasted espresso beans that create an unusual nutty taste—and packs a mighty wallop of caffeine. (112 King St.; (608) 255-0285. Various locations at www.ancora-coffee.com)

Fair Trade Coffee House, a newer addition to the downtown Madison coffee scene, lives up to its name, featuring local roasts and coffee selections from fair trade roasters Equal Exchange, in addition to scones, bagels and the usual coffeehouse fare. (418 State St.; (608) 268-0477

Michaelangelo's Coffeehouse is located next the Capitol and is the coffeehouse in the area that most resembles Friends' Central Perk. Spacious and sunny with lots of plush sofas and soup bowl-sized coffee cups. Michaelanglo's tends to attracts a slightly older crowd than its contemporaries. (114 State St., (608) 251-5299)

Located on Madison's beloved "Willy Street," **Mother Fools Coffeehouse** is a center for progressive art, music, and culture. The pastries are vegan, the coffee is organic, and fair trade and the music is eclectic—folk, jazz, klezmer/hard-rock fusion. Steak munching Rush Limbaugh fans will likely not find their soul mate here. (1101 Williamson St.; (608) 259-1301 www.motherfools.com)

A Room of One's Own is a feminist bookstore and coffeehouse that has served Madison's women's community for nearly three decades. They also serve a truly mind-blowing mocha. (307 West Johnson St., (608) 257-7888

Steep & Brew is a coffee chain with the soul of an independent; the 544 State Street location routinely features student art, music and open-mic. (544 State St. (608) 256-2902)

Victor Allen's is another Madison-based chain and coffee roaster, very popular with longtime Madison residents (check the website for a list of locations, www.victorallens.com). And, while not a coffeehouse, **Opus** (116 King St., (608) 441-6787), by far the swankiest lounge in Madison, is highly recommended with a diverse array of wines, champagnes and cocktails and an eye-popping tapas-style menu.

—Keidra Chaney

Kopi, A Traveler's Café

Funky, vegetarian-friendly café/store for the bohemian set.
$$
5317 N. Clark St., Chicago 60640
(at Summerdale Ave.)
Phone (773) 989-5674

CATEGORY	Independent coffeehouse/travel store
HOURS	Mon–Thurs: 8 AM–11 PM
	Fri: 8 AM–midnight
	Sat: 9 AM–midnight
	Sun: 10 AM–11 PM
GETTING THERE	Parking is less than plentiful in this popular neighborhood.
PAYMENT	VISA MasterCard DISCOVER
POPULAR DRINKS	Lattes, fruit smoothies, Oregon Chai
UNIQUE DRINKS	Mexican Latte (especially delicious), White Chocolate Mocha
FOOD	Meals for the veggie-inclined. Veggie burgers, Tempeh "chicken" sandwiches, meat free French Onion soup, etc. Sandwiches accompanied by (rather dry) tortilla chips. For those who prefer their sandwich fillings with faces, Tuna melts are available. Wonderful bakery items, delicious cheesecake.
SEATING	The café seats about 40-50 people. The store in the back of the café is a bit cozy, not exactly ideal for potential browsers. Prime seating on an elevated platform in the window… shoes off please, you'll be sitting on the floor.
AMBIENCE/CLIENTELE	Tables near the front window are accompanied by plush, jumbo pillows. More traditional seating can be found in the back, where shelves are lined with *Lonely Planet* travel guides and exotic knick-knacks, all available for sale. College rock pipes in from the walls, which are covered with tapestries, clocks and artwork. Clientele includes art students sporting pixie haircuts and black-rimmed "geek glasses", stylishly disheveled boho's and young professional couples with small children.
EXTRAS/NOTES	Living up to its billing as a "traveler's café", Kopi features artwork, jewelry and curios with an international theme. Travel books are also available for sale.

—Keidra Chaney

PRE-PARTYING, CHICAGO STYLE

By no means are we advocating them, but drinking games are one of the best ways to start the kind of truly memorable night that you will never remember. They're cheaper than even the lowest of dives and a great way to rally the troops before you all jump out of the trenches and (god-willing) into someone's bed. They're also extraordinarily juvenile and should not be attempted by anyone who expects to be taken seriously. For those would-be presidential types, remember, nearly all of your friends have camera phones, so, caveat boozer. The basic rules of movie drinking games are simple, any time a particular predetermined event occurs everyone drinks (that's a drink, not a sip, and please, not a chug—no one wants to drag you home).

We've come up with a few standard rules for one of our favorite Chicago movies The Blues Brothers. Of course, the rules may be modified to suit the fortitude of your liver.

Drink every time there is a dance number.

Drink every time there is a car chase.

Drink every time there is a car crash resulting from said car chase.

Drink every time anyone onscreen drinks.

Drink every time Jake and Elwood recruit a new band member.

Drink every time the Mystery Woman appears.

Drink for every stinkin' Illinois Nazi that comes on screen.

Drink for every blues celebrity cameo. (If only one member of the party can recognize the cameo than the rest of the party drinks double.)

Finish everything you have once you hear "Jail House Rock". You are now on your very wobbly way to a great night out.

—Louis Pine & the Glove Box Guides Editors

"I am going to St. Petersburg, Florida tomorrow. Let the worthy citizens of Chicago get their liquor the best they can. I'm sick of the job—it's a thankless one and full of grief. I've been spending the best days of my life as a public benefactor."

—Al Capone

NORTHWEST SIDE

Cleos

"Don't let the halo over their logo fool you."

$

1935 W. Chicago Ave., Chicago 60622
(at N. Damen Ave.)
Phone (312) 243-5600
www.cleoschicago.com

CATEGORY	Artsy Lounge.
HOURS	Mon–Fri: 5 PM–2 AM
	Sat: 5 PM–3 AM
	Sun: 11 AM–2 AM
GETTING THERE	Street parking is *okay* at times, but tricky at others. If you're familiar with the lay of the land, go ahead and drive, you'll be okay. If not, be prepared to hunt for the "secret parking spots," but once you find them, you're golden for the next time and the time after that and the time after that!
PAYMENT	VISA MasterCard AMERICAN EXPRESS DISCOVER
POPULAR DRINKS	Beer, of course!
FOOD	For a bar, the food at Cleo's is great. Besides the weeknight food specials, they have a full menu complete with appetizers and salads, burgers and sandwiches, entreés, and a handful of unique pizzas made to order. Pizza choices include the three-cheese veggie, portabella mushroom, margarita, pico-de-gallo, chicken or shrimp pesto, buffalo chicken, and BBQ chicken. The prices are very reasonable.
DRINKS	Beer and standard cocktails.
SEATING	The long, snaky bar seats plenty, or there's table seating or booth seating. It's a large place, so there's usually a place to find a spot during the week if you get their early enough. Otherwise, stand by, something usually opens up.
AMBIENCE/CLIENTELE	A majority of Cleos patrons are regulars from the neighborhood, but the jukebox and sort of retro/loungey atmosphere attracts others as well. It's a nice place to just hang out with friends. It is a popular hangout for an artsy crowd at times, as the walls feature numerous pieces of art created by young local artists, many of whom are no doubt patrons. On Friday and Saturday nights, Cleos features a DJ. Though you might see a handful of people dancing after having a few cocktails, this is by no means a dance party. Usually it just features some good music and a great mingling opportunity. It's one of those places that a person might stumble into and fall in love with, or simply miss altogether. But the food is great and the atmosphere is more than pleasant. It's a nice place to sit and enjoy some dinner after work without feeling over crowded. One of the nicer things about the bar is that in the warmer months the front French doors open to the street, giving the bar some fresh air. If you're lucky enough to score one of the tables in the window, you might find yourself parked there all night enjoying the show outside. The people are great. Most patrons show up with friends and keep to themselves, but everyone is always friendly if you're looking for an

ear to bend. There is zero pretension present, which is nice.

EXTRAS/NOTES While there is no specific "happy hour," there's a different food special every day. Specials range from ten-cent wings to $2.99 homemade pizzas or fish and chips, each Monday through Thursday night you can find food for a bargain. Plus on Saturday nights there's a complimentary buffet from 11 PM-1 AM—perfect for the late-night munchies. There are daily beer-of-the-month specials as well for $2.50. Cleos features a Golden Tee Machine, red felt pool table, and one of the best juke boxes in the city.

—*Mike Fertig*

Club Lucky

"Everyone gets lucky with the killer martini."
Since 1938
$
1824 W. Wabansia Ave., Chicago 60622
(at N. Honore St.)
Phone (773) 227-2300 • Fax (773) 227-2236
www.clubluckychicago.com

CATEGORY	Classic Chicago Restaurant Lounge with famous martinis
HOURS	Kitchen:
	Mon–Thurs: 11:30 AM–11 PM
	Fri: 11:30 AM–midnight
	Sat: 5 PM–midnight
	Sun: 4 PM–10 PM
	Cocktail Lounge:
	Mon–Thurs: 11:30 AM–"late night"
	Fri: 11:30 AM–2 AM
	Sat: 11:30 AM–3 AM
GETTING THERE	Valet, street parking can be challenging.
PAYMENT	VISA MasterCard AMERICAN EXPRESS DISCOVER
POPULAR DRINKS	Any kind of Martini
UNIQUE DRINKS	The "Killer Martini" was voted the best martini in Chicago and yes it's true—they use hand-stuffed blue cheese olives.
FOOD	The menu is Italian and everything is delicious. The average dinner entrée can run from $15-$25. But it's worth every cent.
DRINKS	Beer, Wine, and Cocktails
SEATING	Combined, both the restaurant and cocktail lounge seat about 200 people. The lounge has bar stools and booths, while the restaurant combines booths with table seating in a large, "open-space" atmosphere.
AMBIENCE/CLIENTELE	This is another one of Chicago's unique restaurant/bars that attracts patrons from all walks of life. The cocktail lounge is an exact replica of the lounge that was here when the bar opened in 1938. Before that this corner location was a hardware store, which served as a front for the speakeasy located downstairs. But more recently, the owners have gone to great lengths to restore the building to its original look. People of all ages come here to eat, and they might be wearing suits, cocktail dresses, or ripped jeans and a t-shirt. Though you won't see much of

the latter, as Club Lucky has a sort of distinguished feel to it that just makes a person want to look presentable. This is a great place to bring a family for dinner, whether that means a party of four or a birthday party of twenty-four. But at the same time, it's the perfect place to bring a date. Be warned, however, the restaurant gets loud. The supper club type atmosphere creates a continuous din of conversation that requires a confident voice when engaging in conversation. The waitstaff is very efficient, and adding to the atmosphere, is their long aprons and matching uniforms. They also have what they call The Club Room—a room available for private parties where you can arrange for a family style meal or open bar packages if you so desire.

EXTRAS/NOTES Club Lucky has a pretty storied history behind it that makes its allure that much stronger. The building was built in the 1920's and was originally a hardware store. When prohibition was put into effect, the whole building was remodeled, adding a rear entrance through the hardware store that led to the speakeasy in the basement. Around 1934, after the end of prohibition, the hardware store was converted into a Polish bar and banquet hall. The hall included a stage where live acts would perform, naturally. This was when the name Club Lucky was born. The banquet hall remained in operation until the 1970's when the hall closed, but the bar remained open until the late 1980s. In the 1990s the new owners rehabbed the building back to its original design of 1934, which includes the barrel ceiling, the long Chicago bar, glass block storefront, antique martini shaker collection, and the black enamel cooler. The old banquet hall was converted into the main dining room and still has the original tin ceiling, shadow box glass block windows, tile flooring, and original bar which is now used as a salad and dessert station by servers. Club Lucky has also been the polling place during elections for the 35th precinct of Chicago since 1940. It still functions in this capacity today, using The Club Room for this purpose.

—Mike Fertig

Davenport's Piano Bar and Cabaret

Auntie Em! We're not in Kansas… it feels like New York City!

$$$

1383 N. Milwaukee Ave., Chicago 60622
(between Wolcott Ave. and N. Paulina St.)
Phone (773) 278-1830
www.davenportspianobar.com

CATEGORY Piano Bar

HOURS Mon: 7 PM–midnight
Weds/Thurs: 7 PM–midnight
Fri/Sat: 7 PM–2 AM
Sun: 7 PM–11 PM

GETTING THERE Parking is a nightmare, valet on weekends, best

bet—hail a cab!

PAYMENT	VISA MasterCard AMERICAN EXPRESS Discover
POPULAR DRINKS	Great Martini List (all with musical names)
UNIQUE DRINKS	Beer is barely served here, taps are sacrificed for bottles. Most patrons take it up or on the rocks.
SEATING	Velvety banquet tables flanked with metal tables and chairs, all based around the piano. Bar stools at the bar.
AMBIENCE/CLIENTELE	There aren't a lot of true piano bars in Chicago. They have recently been taken over by dueling tourists in the Mag Mile area, but here in Bucktown, Davenport's is the real thing. It's a place to drink heavily, listen whole-heartedly, and sometimes even sing along. No matter your walk of life, everyone here, from singing staff to regulars, will make you feel at home. There's bound to be a diverse clientele, maybe an occasional cross-dresser, but this is definitely not a gay bar. It is a lovefest for all, and no one cares if you don't know the songs, just make sure you quiet down every once and awhile to respect the performers. Check out the back room for a more structured show schedule.
EXTRAS/NOTES	Live music every night: music theatre, rock, and jazz standards. Cabaret in the back room is primarily jazz. You can usually purchase CD's, but check out the groovy multi-colored bar!

—*Piper Parker*

Goldstar

Oozing with character and history,
a true old school Chicago bar.
$$
1755 West Division St., Chicago 60622
(between N. Woods St. and N. Hermitage Ave.)
Phone (773) 227-8700

CATEGORY	Historic Bar
HOURS	Mon–Fri: 4 PM–2 AM
	Sat: 3 PM–3 AM
	Sun: 3 PM–2 AM
GETTING THERE	Metered street parking
PAYMENT	Cash only
POPULAR DRINKS	Pretty much a beer and shot place
FOOD	No food here, but they do have free popcorn
SEATING	Bar stools in front and beat up couches and lawn chairs in the back
AMBIENCE/CLIENTELE	One of the few mainstays that seem to hang tough and rough between the trendy Sushi Bars and clubs. Walking into Gold Star may not make you say wow, but spend a night there…and you'll see why it's been around as long as it has. The long bar is stacked with bar stools on the west side of the bar. Local artists occasionally hang their works here and nine times out of ten, they make good conversation pieces. The bar itself supports a modest selection of beers on tap like Old Style, Point and Bud. Beer prices are far from the five-dollar bottles a few doors down (average two dollars a beer—maybe a little more for an import). The old jukebox supports a wide

variety of music and it always seems to be playing. Down at the end of the bar – is a tattered pool table that definitely gets a workout. There is no shortage of pierced and tattooed types roaming around the bar. To say the crowd is "laid back" is an understatement. If you're looking for multiple T. screens and sports—this is not the place for you. If you're looking for a place where you can chill and enjoy an inexpensive beer, this is it.

EXTRAS/NOTES Some people say Goldstar is haunted and others say there was a brothel above the bar back in the day.

—Grant Christman

Handlebar

"Not your average beer peddlers."
$$
2311 W. North Ave. Chicago 60647
(at N. Oakley Ave.)
Phone (773) 384-9546 • Fax (773) 384-3320
www.handlebarchicago.com

CATEGORY	Hipster Joint.
HOURS	Mon–Weds: 4 PM–midnight
	Thurs–Fri: 4 PM–2 AM
	Sat: 10 AM–2 AM
	Sun: 10 AM–midnight
GETTING THERE	Street parking only. Spots are a bit scarce, but not impossible. Naturally, there's plenty of bike parking.
PAYMENT	VISA MasterCard
POPULAR DRINKS	Beer! The bar is known for its great beer selection thanks to the fact the owner/proprietor of the bar used to work as a brewer at a local microbrewery. Check out the regional microbrew favorites Bell's and Alpha King on tap.
UNIQUE DRINKS	On the cheap side, you can get a $2 can of Schlitz, or can throw down over $10 for a tall bottle (750ml) of the potent Belgian ale, Delerium Tremens.
FOOD	Full menu of upscale vegetarian and seafood dishes for not much more than your average pub grub. Average entrees are $10 or less. Definitely not just for strict vegans, the entrees are good enough to please both veggie and meat eaters.
SEATING	Handlebar is quite small and cozy...but the place expands in the summer thanks to a small beer garden in the back
AMBIENCE/CLIENTELE	A mostly hipster/neighborhood type crowd, but not overtly trendy or pretentious by any means. Overall, a very casual and laid back atmosphere. As the name suggests, the bar has a "bicycle" theme, complete with bar stools made out of bike seats and plenty of bikes, bicycle parts and bicycle pictures that adorn the room throughout.
EXTRAS/NOTES	While the bar's owners and managers are huge bicycle advocates and they welcome local cyclists with open arms (bike messengers get free fries on Monday), you certainly won't feel out of place if you walk in without a helmet and bike shorts. You really just have to appreciate good beer and/or good food to enjoy this place.

—Brad Knutson

FROZEN OR ON THE ROCKS?
Sure Bets for the Margarita Enthusiast

The Margarita is everywhere in Chicago. It's true: options abound in the city if you are looking to spice up your night (or day!) with this classic chilled drink that seems to be everyone's favorite. With our summer months that cater to bar/restaurant sidewalk seating, beer gardens, and hidden back patio dining, it's no wonder that this beverage is ever popular, and currently chic for that matter. Even in winter months, Chicagoans have been seen on the scene ditching their coffee and Baileys, opting for a margarita, in hopes it will inspire a little warmth.

Whether you find yourself drinking outdoors in August, or amidst a Chicago blizzard in January (undoubtedly dreaming of summer's past and future), here are a few margarita notables...

Las Piñatas
Folks, this is as authentic as it gets. When you walk in and spot the mural walls and the sombrero props...you know you are in a margarita haven. Old Town locals are regular clientele, and amongst the popular Wells/North strip, you won't find this gem crowded very often (except for Cinco de Mayo, of course...expect a line out the door). The atmosphere is unpredictable; sometimes very mellow, sometimes very rowdy—depending on how many drinks the crowd has downed. The service/staff is great, and the food here is above average. Take advantage of the free chips and salsa... margaritas served here are as strong as they get. Standard flavors are available; either frozen or on the rocks, you will find yourself smiling (and perhaps a bit chatty) as you float out the door at the end of the evening. *(1552 N. Wells, (312) 664-9277, Mon-Thurs: 11 AM-midnight, Fri/Sat: 11 AM-1 AM, Sun: noon-midnight)*

El Jardin
A highlight to the Wrigleyville/Lakeview neighborhood! El Jardin is a nice change of pace from the endless pubs that cater to the sports loving community. You will find this restaurant/bar crowded on game days, though, especially since outdoor seating is offered. Traditional drink/food menu, reasonably priced. The atmosphere here is warm and friendly, and the crowd is pretty diverse. The outdoor patio is perfect for relaxing and people watching, as it faces Clark St. If you do indulge in a few margaritas, take a cab home or walk it off; there's no such thing as a weak pour of tequila at this spot. *(3334 N. Clark, (773) 528-6775, Mon-Thurs: 11:30 AM-11 PM, Fri/Sat: 11 AM-midnight, Sun: 11 AM-11:30 PM)*

Coobah
This saucy restaurant/lounge on the popular Southport Strip has become quite the trendy spot for both food and drink. The frozen margaritas here are worth splitting a pitcher or two with a date or friends, and be on the lookout for weekly margarita specials. Lakeview locals and Roscoe Villagers frequent Coobah, and are often seen dining/drinking both indoors and out. The vibe here is ultra hip, and you are lucky to grab a seat without a wait on the weekend. Food is expensive, but splitting an appetizer or two with that pitcher of your fave frozen drink makes for an attractive option. Another perk? Coobah is open late night, baby. *(3423 N.*

Southport Ave., (773) 528-2220, www.coobah.com, Sun-Fri: 5 PM-2 AM, Sat: 5 PM-3 AM)

Northside Bar and Grille

You'd never guess by the looks of it, but Northside Bar and Grille serves a pretty tasty margarita. This fun Wicker Park hangout is known for it's great American grub and cozy patio, perfect for throwing back a few beers. However, on a mid-July day last summer, I discovered that the margaritas here rival some of the best I've had in the city. Try the peach or original margarita on the rocks, and it won't disappoint. The atmosphere here is ultra casual and fun, but the service is so-so. No worries, it won't deter from your good time. Food and drinks are reasonably priced. This is the perfect place to get caught in the middle of a summer rainstorm; I did, and spent my afternoon with my good friend from New York…and my margarita(s), of course. (1635 N. Damen, (773) 384-3555, Sun-Fri: 11 AM-2 AM, Sat: 11 AM-3 AM)

Twisted Lizard

Lincoln Parkers and DePaul Students are especially fond of this neighborhood favorite. Most popular in summer months, the prime outdoor seating at busy Sheffield and Armitage is usually packed with twenty-somethings, sipping and slipping away on a frozen drink or two (or three). Go for the original or flavored margarita pitcher on the rocks; this gives you more bang for your buck, vs. the frozen option. Be sure to also check out the impressive tequila selection, with over 20 different brands to choose from. Prices are reasonable, and the food menu is good for sharing; split the combo appetizer platter and drink pitcher with your friend or date, and you're all set for under $30. In cooler months, chill out in this bar's garden level dining area, and look forward to the next 75-degree day… (1964 N. Sheffield, (773) 929-1414, Mon-Thurs: 4 PM-11 PM, Fri-Sun: 11:30 AM-midnight, www.thetwistedlizard.com)

Cesar's

This Lakeview restaurant/bar claims to be the "Home of the Killer Margarita", and I honestly can't argue that statement. Drinks here are large and in charge, and will cost you, too. If you're looking for a buzz, you've come to the right place. A variety of flavors are available; I like the frozen raspberry. Tip: The location on Broadway is better than that on Clark. Outdoor seating is available, along with two levels, which makes this restaurant more spacious and a better choice for group outings. The neighborhood atmosphere in this neck of the woods is better, too—your only view from the Clark location is the gigantic parking garage next to Marshall's, Linens and Things, and DSW. Not really a good conversation starter (although you will have your fair share of interesting pedestrians stroll by). Vibe at both locations is casual with a diverse crowd; a wide span of ages. Food here is average and slightly overpriced, but city dwellers come here mainly for the giant drinks, and aren't too concerned with the quality of their quesadilla. (3166 N. Clark, (773) 248-2835, Mon-Thurs: 11 AM-11 PM, Fri/Sat: 11 AM-1 AM, Sun: noon-8 PM; 2924 N. Broadway, (773) 296-9097, Mon-Thurs: noon-10 PM, Fri/Sat: noon-11 PM, www.killermargaritas.com)

—Kristy Stachelski

The Hideout

In the middle of town and the middle of nowhere.

$$

1354 W. Wabansia Ave., Chicago 60622
(at Elston Ave.)
Phone (773) 227-4433
www.hideoutchicago.com

CATEGORY	Hole in the Wall. Waaay off the beaten path.
HOURS	Mon: 7 PM–2 AM
	Tues–Fri: 4 PM–2 AM
	Sat: 7 PM–3 AM
GETTING THERE	Plenty of free parking around the neighborhood. Taxicabs tend to be sporadic around this area.
PAYMENT	Cash Only
POPULAR DRINKS	Solid beer and a shot kind of place.
UNIQUE DRINKS	Good premium beers on draft (Goose Island, Summit, etc.)
FOOD	Chips, peanuts, popcorn all for just 50 cents a bag.
SEATING	Cozy up front (tables, bar stools) with more tables and booths in the more spacious rear. The rear of the bar has a stage for musical acts, DJs, etc… Good for groups or more, even more with the back room.
AMBIENCE/CLIENTELE	Very cool scene, very casual, a good cross section of Chicago's north side patrons. Bartenders have their choice of music to play, and it's most likely something you won't normally hear on the radio, so that's good. No jukebox to hog tracks on. Very much a jeans and t-shirt place, but you can come as you are (in costume, in tuxedo, etc.). Naugahyde rules the seats and barstools, so don't wear your hot pants, otherwise your skin will stick to the stool. You'll feel good knowing that there is a bar tucked away from the Trixie-land of sports bars, faux Irish pubs, and cheesy discos.
EXTRAS/NOTES	The Hideout cab be hard to find so, look for the sign as you drive southbound on Elston. It will lead you to the bar. Big Joe, a veteran bouncer, will most likely be the one at the door checking your ID. He is a big, intimidating looking man, but has the heart of a kitten. He'll even spin you a yarn about the golden days of bouncing at Dingbats with Mr. T. Jim Hinchsliff (one of the owners) is there to welcome patrons with a smile and a handshake. Front Porch Blues with Devil in a Woodpile every Tuesday night at 9:30 PM. The Hideout is available for private parties, call and ask for Katie. Various Chicago musicians (and those passing through) hang out here, so don't be surprised if you see them, and leave them alone!!! The building looks like a crack house on the outside with an Old Style sign, but through the door resides a friendly and respectable dynamic pulse that is well contained between the double high studs and cheap siding. The inside is a lot cleaner, too. Remember, there is plenty of live music every week and there is some form of entertainment. ALL THE TIME!!! Be sure to pick up a calendar at the bar for upcoming musical acts and events!!! Also be sure to check out their website at www.hideoutchicago.com for any other inquiries or interests that need satisfying.

—Jeffrey Goodman

Inner Town Pub

Cheap booze and free pool.
Did I mention FREE POOL?
$$

1935 West Thomas St., Chicago 60622
(near Damen Ave.)
Phone (773) 235-9795

CATEGORY	Dive
HOURS	Mon-Fri: 'til 2 AM
	Sat: 'til 3 AM
GETTING THERE	Street parking only, some streets you will need a zone permit. Cabs will pass by frequently on Damen Ave.
PAYMENT	Cash only, but ATM on premises.
POPULAR DRINKS	Whatever is cheapest. Usually beer. Typical beer and shot type of place.
UNIQUE DRINKS	Guinness $3.50 on tap. Poured properly and at the right temperature.
FOOD	Limited bar snacks (peanuts).
SEATING	Barstools and tables for seating. Good for groups of four and couples. Not very spacious, can get crowded.
AMBIENCE/CLIENTELE	Non-pretentious, hip, artistic crowd. T-shirt and jeans, very casual. Diverse music on the jukebox ranging from punk to funk to country. The music is loud enough to hear the lyrics, but not so loud that you can't carry on a conversation. It's a dive, so it's not necessarily the cleanest of places, so try not to wear your Sunday best. It can and will get smoky in there, so smoke 'em if you got 'em.
EXTRAS/NOTES	Live music every Sunday and Thursday. Free Pool (every night, all night). Golden Tee and World Class Bowling video games. Lots of tapestries and pictures of Elvis Presley (which probably explains owner Mike Gromley's pompadour-ed hair). Also notice the collage of candy bar wrappers and presidential campaign bumper stickers in the form of an American Flag... a patriotic touch to a space that seems like its Christmas inside all year round. Stain glass windowpanes are a nice touch as well. Made Stuff Mag's Top 20 List of Dive bars in the U.S. in January 2003 issue.

—*Jeffrey Goodman*

Jinx

Pussycat, pussycat, whoa, oh-oh-oh
$$

1928 W. Division St., Chicago 60622
(at N. Winchester Ave.)
Phone (773) 645-3667

CATEGORY	Independent Coffeehouse.
HOURS	Tues–Fri: 11 AM–8 PM
	Sat/Sun: 10 AM–6 PM (8 PM during the summer)
GETTING THERE	Street parking or take the Blue Line to Division.
PAYMENT	Cash only.
POPULAR DRINKS	Coffee
UNIQUE DRINKS	Try the root beer float, for old times sake, or dive into a peanut butter shake for a new spin on a classic.
FOOD	Features standard café fare, including line of bagel sandwiches

SEATING	With six tables, five booths, and one couch this coffee shop is both good for couples and groups.
AMBIENCE/CLIENTELE	With the red, black and yellow paint reminiscent of the German national flag, this gritty, urban, loft-like space with the stale overhang of lingering cigarette smoke might actually fit in Berlin. Food is standard café fare, including bagel sandwiches and breakfast munchies. Satisfy the kid in you with a root beer float or a peanut butter shake. Between the latest electronica jams and the healthy offerings of flyers and free alternative newspapers in the front and at the coffee bar, this is a good place to catch up on what's hip. Just pretend like you don't know what's going on and staff will help you find out what's hip and happening when they're not busy. Or, you really may not know what's going on, and that's okay, too.
EXTRAS/NOTES	This place has traded in the now-hip smoothies for classic milk shakes, don't miss out.

—Janet E. Sawyer

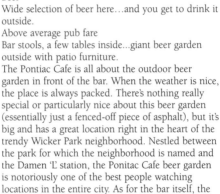

Pontiac Café
"Park your ass outside."
$$$
1531 N. Damen Ave., Chicago 60647
(at Milwaukee Ave.)
Phone (773) 252-7767

CATEGORY	Beer Garden
HOURS	Sun-Fri: 11:30 AM-2 AM
	Sat: 11:30 AM-3 AM
GETTING THERE	Street parking only...not recommended
PAYMENT	VISA MasterCard
POPULAR DRINKS	Beer
UNIQUE DRINKS	Wide selection of beer here…and you get to drink it outside.
FOOD	Above average pub fare
SEATING	Bar stools, a few tables inside...giant beer garden outside with patio furniture.
AMBIENCE/CLIENTELE	The Pontiac Cafe is all about the outdoor beer garden in front of the bar. When the weather is nice, the place is always packed. There's nothing really special or particularly nice about this beer garden (essentially just a fenced-off piece of asphalt), but it's big and has a great location right in the heart of the trendy Wicker Park neighborhood. Nestled between the park for which the neighborhood is named and the Damen 'L' station, the Ponitac Cafe beer garden is notoriously one of the best people watching locations in the entire city. As for the bar itself, the reason why there a giant slab of asphalt in the front is because the Pontiac is actually a converted old gas station. The main part of the bar is housed in the garage area of the old service station, which is evident from the large overhead door still in use at the front. The high ceiling, exposed brick and paint-ed asphalt floor on the inside gives the bar a lot of character, but the real charm of the Pontiac will always be that large beer garden. The clientele of the

bar consists almost entirely of local yuppies from Wicker Park and neighboring Bucktown.

EXTRAS/NOTES Fridays have recently become a very popular night at Pontiac thanks to the local phenomenon, "Live Band Karaoke." Instead of singing along with pre-recorded music like regular karaoke, bar patrons get to go on stage and sing with a live backing band. Like any karaoke or amateur night, there can still be many cringe-worthy moments, but overall, the live version sounds better and is a lot more fun for everyone.

—Brad Knutson

Sweet Thang

"Better than any french kiss you've ever had!"

$$

1921 W. North Ave., Chicago 60622
(at N. Winchester Ave.)
Phone (773) 772-4166 • Fax (773) 772-4269
www.sweetthangcakes.com

CATEGORY Upscale European Pastry Shop/Coffeehouse.

HOURS Mon-Sat: 7 AM-10 PM
Sun: 8 AM–8 PM

GETTING THERE You'll have to search for street parking if you want to enjoy Sweet Thang, because there is no lot. Parking is always challenging along North Ave. so bring along good luck and great timing. If you get really desperate, the restaurant Piece is nearby, and they do offer valet. Luckily, Sweet Thang is in within walking distance of the Damen stop on the Blue Line. You can also take the #56 Milwaukee, #72 North or #50 Damen buses. And cabs are plentiful.

PAYMENT VISA MasterCard
Charge only on orders for over $20. So if you're just grabbing espresso and a croissant, you better have cash.

POPULAR DRINKS Decent Italian coffees, espresso and cappuccinos—they're the perfect complement to your European experience. But very few venture to Sweet Thang just for the drinks.

UNIQUE DRINKS A coffee shop where coffee plays second fiddle? Yep, that's what you'll find at Sweet Thang where croissants, quiche, cakes, and 'oh those mousse tarts' take the leading role. But, if you're ever to order straight espresso shots, this is the place—it's authentic European brew.

FOOD What's served here shouldn't really be classified as food: it's closer to ambrosia. One bite of the flaky, buttery croissant and you'll think you're dining atop the Eiffel Tower. The croissants come in a variety of flavors including ham and cheese, turkey and Swiss, chocolate and almond, which all usually get snatched up quicker than they can be created. And Sweet Thang has managed to transform quiche into a light and airy, but entirely filling meal, available in varieties such as spinach and Portobello mushroom. Paninis have that straight-from-the-

Italian-market taste—fresh baked French bread, loaded with fresh cheeses, meats and veggies. Served cold or grilled, per your request. But, if there's one thing you have to sample here, it's the fresh mousse tarts. Hard to describe, but even harder to resist, they're small tarts with fruit fillings, and the creamiest, lightest mousse. The tiramisu, white chocolate raspberry (with peanut butter crust) is to die for. And, the double chocolate is nothing to snuff at.

SEATING

Small and cozy. A mildly dilapidated old-world café that just oozes charm. Here you'll find a chaise lounge covered in rich red velvet, heart-shaped chairs and café tables—all calling your name. It seats about twenty, so it's best to visit in small groups or all on your own. And believe me, you'll want to find a seat: one look at the pastries and there's no way you'll make it home before indulging.

AMBIENCE/CLIENTELE

Casual café that's bright and airy, perfect for long relaxed weekend afternoons. At night, the romance, mystique and ambience get turned up a few notches. The peeling paint doesn't distract from the experience, it stays true to what Sweet Thang is—a charming café focused on delicious pastries. You'll see a little bit of everyone here. Located in Wicker Park, you'll get the typical yuppies, artists and everything in between. But people come far and wide to sample from these treats. So anything goes.

EXTRAS/NOTES

Sweet Thang is Bernard Runo's gift to the city. It's one of the few places you can shell out a few bucks and get an awe-inspiring French pastry made from the highest-quality, freshest ingredients. Sweet Thang's wholesale business is the dirty little secret of some of the city's most prestigious hotels and restaurants, including the Peninsula, Park Hyatt and The Pump Room. Many of their desserts are supplied from Sweet Thang. If what you crave is a fancy pastry, no need to go to an expensive hotel, just stop by this French oasis in the heart of Wicker Park. Bernard Russo is usually around. Owner and Head Pastry Chef, Sweet Thang is infused with much of his Russo's personality, which is friendly, relaxed and accepting. And he's always eager to explain his products. There are also a handful of outgoing waiters and waitresses mainly from France, who are eager to make your visit great.

—*Katie Murray*

"Decaffeinated coffee is kind of like kissing your sister."

—*Bob Irwin*

UKRAINIAN VILLAGE

Atomix
Blast off to coffee heaven, excelsior!
$$
1957 W. Chicago Ave., Chicago 60622
(at Damen Ave.)
Phone (312) 666-2649

CATEGORY	Independent Coffeehouse
HOURS	Mon-Fri: 6:45 AM-10 PM
	Sat/Sun: 9 AM-10 PM
GETTING THERE	Street parking or take the 66 to Damen
PAYMENT	VISA MasterCard
POPULAR DRINKS	Good, uncommonly strong coffee or a nice frothy café au lait
UNIQUE DRNKS	Mocha drinks with syrup with fun names like Mr. Turtle (mocha with caramel syrup), Funnygirl (syrup-flavored latte) and Ophelia (cappuccino w/nut-flavored syrup)
FOOD	Panini sandwiches and bakery stuff (zucchini bread, cookies, rice crispie bars, muffins, scones) baked right on the premises, mostly vegetarian and vegan food, including veggie chili
SEATING	With four booths and eight tables, this place is cozy, not cramped.
AMBIENCE/CLIENTELE	As the name suggests, the coffee will blast you off to space with some of the strongest java-bean brew in the city. Rightfully so, with nary a national chain in sight as the anchor coffee shop in the Ukrainian Village neighborhood. Head to the smoking booths in the back to talk shop with local creative writers, filmmakers, musicians and other starving and not-so-starving artists. You won't smell smoke at the tables up front, thanks to decent enough ventilation. Munch on a fresh vegan/vegetarian menu including grilled paninni sandwiches and vegetarian chili. Wash it down with the popular, kooky-named mocha drinks flavored with syrup like Mr. Turtle (mocha w/caramel syrup) or an unusual brand of root beer or cola. Forget what your mama told you about boys with tattoos. The arm-inked cuties here bake awesome zucchini bread and other pastries, heated and even buttered upon request.
EXTRAS/NOTES	A photo booth and toy vending machine; wi-fi access.

—*Janet E. Sawyer*

"I have taken more out of alcohol than alcohol has taken out of me."

—*Winston Churchill*

Club Foot
"Hipster Heaven."
$$
1824 W. Augusta Blvd., Chicago 60622
(btwn. N. Damen Ave. and N. Ashland Ave.)
Phone (773) 489-0379

CATEGORY	Hipster Joint.
HOURS	Sun-Fri: 8 PM-2 AM
	Sat: 8 PM-3 AM
GETTING THERE	Street parking on Augusta—can be difficult to find a spot at times.
PAYMENT	Cash only
POPULAR DRINKS	Bottles of Pabst Blue Ribbon.
UNIQUE DRINKS	In this neighborhood, prices this low are always unique.
SEATING	Bar stools and tables.
AMBIENCE/CLIENTELE	Club Foot looks like a bar placed inside a former comic book store. All sorts of toys, inflatables, rock memorabilia, and other collectables adorn the walls from floor to ceiling. Adding to the fun are a pinball machine and Tetris arcade machine in the front and a pool table in the back. Local DJs spin rock, new wave and other hipster-friendly jams almost every night. Speaking of which, this is a total hipster joint. Suffice it to say, you'll find lots of guys with messy hair and ironic t-shirts and girls sporting thrift store chic.
EXTRAS/NOTES	If you're over age 30 and/or don't consider yourself a "hipster," you may feel a bit out of place here on a Fri/Sat. night, however, the staff is anything but pretentious and during the week the bar has more of a corner neighborhood/dive bar kind of feel with a broader range of clientele.

—*Brad Knutson*

Lava Lounge
"Neighborhood pub that rocks like a club."
$$
859 N. Damen Ave., Chicago 60622
(at W. Iowa St.)
Phone (773) 772-3355

CATEGORY	Hipster Joint/DJ Bar.
HOURS	Sun-Fri: 7 PM-2 AM
	Sat: 7 PM-3 AM
GETTING THERE	Street parking only, but a taxi or public transit is recommended.
PAYMENT	VISA MasterCard AMERICAN EXPRESS
POPULAR DRINKS	$2 PBR on Friday and Saturday.
UNIQUE DRINKS	Above average selection of imports and micro's both on tap and in bottles.
SEATING	Lava has the classic Chicago bar configuration of "long and narrow," but it is neatly divided into two sections. The front room is big and spacious with a long bar, DJ booth and monster speaker system. However, the back room is rather cozy with low ceilings, a few tables, an intimate lounge room, a pool table and a pinball machine in the back corner.
AMBIENCE/CLIENTELE	Lava certainly lives up to its "lounge" moniker—lots

of red mood lighting, stark decor and a very laid back atmosphere. However, with live DJs nightly who spin a wide variety of hip-hop, electronic music, and indie-rock, one might also consider this a "club." In reality, Lava is probably neither—it's really just an uber-hip neighborhood pub that plays great music. It's an ideal destination for those who like DJ music, but don't want to put up with the hassle of going out to the expensive clubs. There's certainly no dress code here (real or implied) and you won't see too many people sipping on martinis as beer seems to be the beverage of choice. Plus, there's never a cover to get in, which is a huge selling point on the weekends. Highly recommended for people with eclectic music tastes who prefer local pubs to big clubs.

EXTRAS/NOTES The Lava Lounge (or is it just Lava now?) was recently taken over by the people behind Logan Square's Small Bar. Overall, they've kept the general aesthetic of the bar almost the same, though there are a few subtle differences. The most notable change is that they've torn out the extra seating in the front room, so that now there is just the bar, some stools and a nice wide-open space for conversing and impromptu dancing. On the walls, they've emphasized the bar's DJ culture with framed posters from the world of hip-hop and electronic music. Finally, it seems like they've streamlined their marketing efforts with more flyers in the bar promoting upcoming DJ nights and a new, more visible sign outside with a brand-new logo.

—*Brad Knutson*

GET THE SCOOP ON EVERYDAY POETRY READINGS!

To hear some of the hottest young performance poets in town read (or to read with some of the hottest young poets) you don't have to go to college campuses and snooty bookstores. Some of the liveliest performers in the city appear at your local bars, lounges, and cafes and they often do it for little more than the chance of winning a prize that will just barely pay for a bus pass. It's about love of the spoken word here. And if you want to perform there are no cliques, favorites, or "gotta know somebody"s to get in. All you have to do is walk up to the host or bartender and put your name on the list. So make the rounds and check out some of the best shows out there.

SUNDAY
Funky Buddha Lounge
Who hasn't heard of "Supa Soul Sundays" at the Funky Buddha? The Buddha features live Poetry and Jazz hosted by Mike Fulla Flava. Doors open at 8 PM and admission is free. Full bar, top shelf liquors too! *(728 W. Grand, (312) 666-1695, www.funkybuddha.com)*

MONDAY
Weeds
Every Monday night at 9 PM "Poetry Night" is hosted by Gregario Gomez and admission is free. Full bar. *(1555 N. Dayton, (312) 943-7815)*

TUESDAY
Phyllis' Musical Inn
Open mic hosted by Bert Heyman. Poetry, rap, story and song, whatever you have to say—you can say it here. Every Tuesday night at 9 PM. Free. Budget-friendly beer prices. *(1800 W. Division, (773) 486-9862, www.phyllismusicalinn.com)*

WEDNESDAY
Joy-Blue
Local poet and author Lisa Hemminger presents: "Yammer Zone: A night of Poetry, Open Mike, and Entropy," every Wednesday night at 9 PM on the corner of Southport and Irving. Admission is free. Full bar in 1st room, beer specials. *(1401-03 W. Irving Park, (773) 477- 3330, www.joublue.com)*

Café Penelope
Stop by for a night of rhyming, reading and spoken word every Wednesday night at 7 PM. "The Free Speech Network" is hosted by Elemental. $5 full bar, breakfast, lunch, dinner. *(230 S. Ashland (three blocks from the United Center), (312) 243-3600, www.cityinsights.com)*

THURSDAY
Coffee Expressions
Spoken Word hosted by Mathias the Marvelous. Excellent coffee, super friendly owner and patrons, and admission is free. *(100 W. Oak St., (312) 297-1515)*

FRIDAY
Coffee Chicago
John Starrs hosts Open Mike Poetry starting at 7:30 PM every Friday. $2 for open mike participants, $3 for all others. Coffee, pastries, teas. *(5626 N. Broadway, (773) 784-1305)*

Gio's Sports Bar
Poets, comedians and musicians gather together to strut their stuff for you. If you want to perform, show up around 7-7:30ish to register. If you just want to watch, be there at 8 PM sharp. First and third Friday of every month. Open Run. Great beer specials! *(4857 N. Damen, (773) 334-0345, www.giosbarandgrill.com)*

SATURDAY
Swift Mansion Some Like it Black Coffee Club
Every Saturday night from 10 PM to 1 AM, Kelli Rich presents the open mic night, "Some Like It Black." Poets, musicians and singers. The suggested donation is $10, but it's free for participants. *(4500 S. Michigan Ave., (773) 374-2660)*

—*Michelle Burton*

"I'd rather have a bottle in front of me,
than a frontal lobotomy."
—Tom Waits

Rainbo Club

Rockin' the night away in a beer induced frenzy.
$$

1150 N. Damen Ave., Chicago 60622
(at W. Division St.)
Phone (773) 489-5999

CATEGORY	Low-Key, Dark, Slacker Bar
HOURS	Sun-Fri: 4 PM-2 AM
	Sat: 4 PM-3 AM
GETTING THERE	Street Parking
PAYMENT	Cash only
POPULAR DRINKS	Beer and shots
UNIQUE DRINKS	Prices like this are pretty darn unique
SEATING	Bar stools and booths along the walls. Plenty of standing room on those busy weekend nights.
AMBIENCE/CLIENTELE	This unique neighborhood bar still manages to keep its rough, rocker, slacker edge during a time when everything's' "gone yuppie." Walking in the dimly lit bar will bring you back to a time when this area, along with Wicker Park, was a haven for artists, musicians, writers and bohemians. The oval shaped bar supports a small selection of tap beer that will never make your wallet cry. As you make your way through the smoke-filled room, you'll find booths lining the north wall. The band blaring from the speakers may very well be the "next big thing," so remember that tune and note the name. Don't forget to grab a couple of your friends and pile in the retro photo booth for some black and white pocket photos—aaahh memories! On a good night, the thick smoke might bother some—but the genuine ambience will make you forget about it.
EXTRAS/NOTES	Check out the west wall inside the bar. Various "scenes" are on display in a glass case mixing myths, seasons and activities with action figures. Think the abominable snowman and scuba divers against a blue light.

—Grant Christman

LOGAN SQUARE

Quencher's

"Quench your thirst for beer variety."
$$

2401 N. Western Ave., Chicago 60647
(at Fullerton Ave.)
Phone (773) 276-9730
www.quenchers.com

CATEGORY	Neighborhood bar
HOURS	Sun-Fri: 11 AM-2 AM
	Sat: 11 AM-3 AM
GETTING THERE	Metered street parking is a bit limited, but not impossible to find.
PAYMENT	VISA MasterCard AMERICAN EXPRESS
POPULAR DRINKS	You can always get the "beer of the week," for a special low price. The featured beer on our visit was $3.50 bottles of Anchor Steam and Liberty Ale.

UNIQUE	Wide variety of domestic and imports...18 beers on tap, 200 varieties of bottled beer.
FOOD	Cheap pub snacks...sandwiches, personal pizzas, wings, hot dogs, brats and best of all, tater tots! Also, free self-service popcorn is available.
SEATING	Very spacious two rooms. Lots of stools, tables and even a couple of beat up couches.
AMBIENCE/CLIENTELE	Despite having a very upscale selection of beer, the atmosphere of Quencher's is very casual. Refreshingly unpretentious. Unlike most Chicago bars, Quencher's is rather bright and spacious. For this review, we were able to get a seat right away on the couch late on a Saturday night. Easy to feel right at home here. The clientele is a mix of locals both young and old.
EXTRAS/NOTES	Overall, a great place to go for a casual night out with a big group of people. Grab a cheap domestic pitcher for the entire table, or sample something new from their expansive, world-class beer selection. Don't forget to grab a free basket of popcorn and get some extra quarters for the tabletop Ms. Pac-Man machine.

—Brad Knutson

Underbar
There's no need to fear...UNDERBAR is here!
$$$
3243 N. Western Ave., Chicago 60618
(at Belmont Ave.)
Phone (773) 404-9363

CATEGORY	Low-key bar
HOURS	Sun–Fri: 4 PM–4 AM
	Sat: 4 PM–5 AM
GETTING THERE	Street parking mainly, although you can park under the overpass if there is space. The American United taxi stand is at the corner of Western and Belmont, so a taxi should be close by.
PAYMENT	VISA MasterCard AMERICAN EXPRESS DISCOVER
	All require minimum $20 charge. ATM also available.
POPULAR DRINKS	Pabst Blue Ribbon, just $2.50 every day.
UNIQUE DRINKS	Draft beer changes seasonally. A good mix between the mass-produced, imports, and microbrews on tap.
FOOD	Potato chips for a buck a bag.
SEATING	Small and cozy. Bar seats around twenty people. Stools and tables against the wall.
AMBIENCE/CLIENTELE	Industry people (those who work at other bars in the area) tend to frequent this nestled watering hole. Local barflies and the occasional bohemian will pop in from time to time. But because the bar is open until 5AM on Saturdays, you'll probably get some younger, hard-core drinkers entering the bar for their last drink of the night. A casual classic joint, simple and clean with a modern sound blaring over the speakers. If you're that worried about how you look, you are more than welcome to check yourself out in one of the many mirrors against the wall, opposite the bar.
EXTRAS/NOTES	The Cook County Circuit Court is across the street from the bar on Western, so it's very convenient if you want a drink after bailing out a friend from

jail… or celebrate your court victory with a shot and a beer. One of Metromix.com's top "new bars" of 2004, this bar caters to the late night drinking crowd with its late night liquor license (a license coveted by many bar owners in the city, few have them). Formerly *Paul and Joe's*, Underbar is a nice little out of the way place to get a quiet drink…that is, until the other bars close and the overflow piles in. It's just down the street from the Viaduct Theatre, so it's good for that post-show cocktail you're looking for.

—*Jeffrey Goodman*

Whirlaway Lounge

Cozy… feels like drinking beers in your best bud's basement
$$
3224 W. Fullerton Ave., Chicago 60647
(at Kedzie Ave.)
Phone (773) 276-6809

CATEGORY	Neighborhood, hole-in-the-wall, tiny sports bar that hasn't been molested by redecoration since the early '80s
HOURS	Sun-Mon: 3 PM-midnight
	Tues-Thurs: 3 PM-2 AM
GETTING THERE	Street parking, no permit required
PAYMENT	VISA MasterCard AMERICAN EXPRESS DISCOVER
POPULAR DRINKS	Probably most popular would be a gin and tonic or rum and coke but mostly beer is what flows from clinking bottle to bottle
UNIQUE DRINKS	This place is far better known for its comfortable atmosphere than for its frou-frou drinks.
FOOD	Just bar snacks, tasty bar snacks.
SEATING	It seats about 25 with standing room for a dozen more. There is a loveseat toward the front of the room and a couple of small tables.
AMBIENCE/CLIENTELE	On any given day you can find a construction worker, some indie rock kids, and a newly married yuppie couple all sitting at the bar. It doesn't look like much from the outside. Its distinction from other bars is that you won't find hipster kids, muscles with tattoos, or flirtatious ex-sorority girls behind the bar. Just looking around the bar everyone is having a good time and not too cool for his or her own good. What helps the vibe is that people don't come here to be seen. All around the room is chatter and laughs under the blue collar/semi-modern jukebox hits. Picks range from Elton John to Tom Petty to Ryan Adams to Fugazi. The randomness of the jukebox is a good reflection of the clientele in the bar—which seats about 25 and there is standing room for about a dozen more. Most people are regulars I take it. But, it's not the kind of vibe where if you're new you feel unwelcome.
EXTRAS/NOTES	99% of the time you can expect to see a sweet little Latina lady with glasses named Maria. You can rarely find her without a smile on and it rubs off. Maria even made my girlfriend a cake to celebrate her 21st birthday, and first time in the bar. Then she played

Happy Birthday on the jukebox, passing around cake to our friends and other strangers we soon met. In addition to Maria, there is a pool table in there and even though there is one table it is usually easy to get turns in. I've never had a problem bringing friends in there and counting on a spot at the table. On the downside, it doesn't have enough room on either side of it for a cue stick when you're making a shot unless you poked someone sitting at the bar in the back and the other side is a wall.

—*Brent Fuscaldo*

CHICAGO'S BOWLING ALLEYS
if you really just want to bowl!

Chicago is well known for a lot of things – bars, blues and one of the most beautiful skylines in the country. But, bowling alleys? It might not be the first thing that comes to mind when you think of Chicago, but this small round-up of bowling alleys from the laid back to the over-the-top, just might change your mind.

Waveland Bowl
Located on Chicago's North Side, not too far from trendy Roscoe Village, this historic alley has been open since 1959. WB features 40 lanes and some of the best prices in the city (anywhere from $1.50 a game to $6). There's something for everyone at WB. Adults can select from a list of over 200 cocktails from the lounge and a variety of different food choices from the kitchen. Gyros, tamales, egg rolls, hot dogs, Italian sausage, pizza, whatever you're in the mood for WB has it and it's all made to order. Be sure to stop by for Cosmic Bowling. All ages. *3700 N. Western Ave., Chicago 60618, (773) 472-5900* (www.wavelandbowl.com)

Fireside Bowl
Fireside Bowl has been through the ringer—open 60 years and counting, this infamous bowling alley has been the subject of "closing rumors" for years—but it never closes. This Logan Square hang, was more of a punk-rock music venue (sprinkled with a little bowling action) for a good 10 years, but with recent renovations and updates, FB has decided to get back to the basics once and for all—bowling. Pros and novices alike can enjoy a comfortable 16 lanes with "occasional" rock shows. Pool tables are also available as well as a decent list of beers ranging from PBR and Miller to Guinness and Harp. All ages. *2648 W. Fullerton Ave., Chicago 60647, (773) 486-2700* (www.firesidebowl.com)

Southport Lanes
Located in Chicago's West Lakeview neighborhood, Southport Lanes is a great place for casual bowling without all the bells and whistles of a larger bowling alley. This local hangout for the thirty-something set has only four lanes, but it's one of only 10

bowling alleys in the country that still has human pin-setters! SP is a bit pricey for it's size, ($20-30 per hour), but its well worth it to take a trip back in time. Oh, and there's lots of extras too— pool tables, golden tee and SP serves up some of the best pub grub in the city featuring menu items like: black bean BBQ burgers and buffalo chicken sandwiches and they also offer a large selection of bottled and draft beers. If you can, check out Southport Lanes during the week—weekends are super packed. *3325 N. Southport, (773) 472-6600 (www.southportlanes.com)*

Diversey River Bowl

Lights, cameras, action! Seriously, they really do have cameras here—if you're waiting for one of the 36 lanes at this Logan Square alley, be prepared to say "cheese." Things can get hectic here, so they have to have a system to track you down. Colorful light shows and smoke machines, a variety of arcade games like air hockey and full swing golf, and a huge selection of bottled beer, beers on tap and cocktails, attract couples, singles and families from Lincoln Park to Rogers Park. Prices range from $19 per hour, per lane during the week to $32 on weekends. Sundays are $26 per hour, per lane. Hungry? DRB has a full dessert bar, pastries, and a wide variety of appetizers, platters and trays as well as main dishes like chicken, pastas and pizza. *2211 W. Diversey Pkwy., Chicago 60647, (773) 227-5800 (www.drbowl.com)*
—Michelle Burton

BUCKTOWN

Beachwood Inn
Nestled a bit off Wood...
but nowhere near the Beach.
$$
1415 N. Wood St., Chicago 60622
(at Beach St.)

CATEGORY	Low key dive bar
HOURS	Sun-Fri: 4 PM–2 AM
	Sat: 4 PM–3 AM
GETTING THERE	Street parking mostly... harder to find a space at night. Cabs pass nearby on Milwaukee Ave.
PAYMENT	Cash only. There is an ATM across Milwaukee Ave. in the 7/11 or the Walgreens.
POPULAR DRINKS	Beer/Shot
UNIQUE DRINKS	Check the chalkboard behind the bar for a great deal.
FOOD	Pretzels/Nuts/Chips just 75 cents a bag.
SEATING	Bar seats about fifteen, seven booths/tables around. Small and cozy.
AMBIENCE/CLIENTELE	Clientele consists of the usual neighborhood regulars mixed in with the artsy, bohemian crowd with a sprinkle of the nascent yuppiedom of the gentrified Wicker Park/Bucktown area. Dark and small, a bit

rustic with a dusty, checkerboard linoleum floor. Old school chotchkes line the wall behind the bar. Music and movie posters line the walls. No draft beers available. Beer by the bottle, kept cool in a deep, wood laden refrigerator.

EXTRAS/NOTES Tons of machines to dump your quarters into: coin-operated pool table, *Simpsons* pinball machine, and a jukebox. Also, cigarettes and t-shirts ($15) for sale behind the bar. Remember, you can smoke but, no cigars or clove cigarettes are allowed.

—*Jeffrey Goodman*

Cans

As dark and full-bodied as a can of Guinness.
$$$
1640 N. Damen Ave., Chicago 60647
(near North Ave. and Milwaukee Ave.)
Phone (773) 227-2277
www.cansbar.com

CATEGORY	Meat Market, Trendy Joint.
HOURS	Mon-Fri: 4 PM-2 AM
	Sat: 10 AM-3 AM
	Sun: 10 AM-2 AM
GETTING THERE	Metered street parking on Damen, $9 valet for the bullet-biters. Nightmare parking on weekends.
PAYMENT	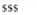
POPULAR DRINKS	Beer served in—cans, duh, 34 to choose from. $1 cans of Bud are a hit. Red Bull & vodkas do brisk business too.
UNIQUE DRINKS	Beer seems to be standard here, though bartender Tymm mixes a magical Bloody Mary.
FOOD	Menu boasts popular items in generous portions: heaping platters of nachos, sandwiches that include fries and wings alleged to be the "best in the city."
SEATING	High tables, cozy booths, bar seating and back room with plush bench sofas and low ottoman-style seats.
AMBIENCE/CLIENTELE	Frat boys in khakis and beautiful beer-swilling Britneys, all set to an '80s rock soundtrack.
EXTRAS/NOTES	If you're looking for a neighborhood dive, you won't find it within the lush mahoganied walls of Cans. Choose from 34 different canned suds, as well as nine draft and several bottled favorites. Three fully stocked bars also serve mixed drinks and mostly domestic wines. While you drink your brew watch '80s movies on the back room or listen to the DJs spin funk, hip-hop, soul, and, of course, '80s cheese.
OTHER ONES	• Four: 1551 W. Division, Chicago 60622, (773) 235-9100
	• Bird's Nest: 2500 N. Southport, Chicago 60614, (773) 472-1502

—*Gina M. DeBartolo*

Filter

Highly caffeinated hipster
hot spot.
$$
1585 N. Milwaukee Ave., Chicago 60622
(at Damen Ave.)
Phone (773) 227-4850

CATEGORY	Hipster Coffeehouse/Lounge.
HOURS	Mon–Fri: 7 AM–midnight
	Sat: 8 AM–midnight
	Sun: 8 AM–11 PM
GETTING THERE	Some metered street parking. Street parking. It is possible to find parking during the week, though it's always hectic. Don't even bother on the weekends.
PAYMENT	Cash only.
POPULAR DRINKS	Coffee
FOOD	Boasting a rather large menu for a coffeehouse, Filter serves a wide-variety of sandwiches, entrees, breakfast items, and snacks. While you can get a chicken or turkey sandwich, the majority of the menu seems to cater to vegetarians. As you'd expect from a coffeehouse, there's nothing over $10 on the menu. However, if you're just looking for a cheap sandwich and cup o' Joe for under $5, this isn't the place to go.
SEATING	Large, spacious, bright and cozy, Filter is great for both small groups and individuals looking to read or study. For groups, there are vintage couches, love seats and chairs (complete with requisite coffee tables) that suck you in and make you feel right at home. For individuals, there are numerous small tables and chairs set up throughout the lounge. Adding to the ambience are thrift store lamps, exposed brick walls, rotating artwork and giant store-front windows on both ends of the room that give Filter as much natural light as you'll see in any coffeehouse.
AMBIENCE/CLIENTELE	So, how is it possible to have street-front windows on opposite ends of a lounge? Well, Filter is located in a classic old building that is literally sandwiched between two extremely busy streets at the apex of a three-way intersection. In addition to providing ample amounts of sunlight for reading, this unique building structure also makes it an unbeatable people watching spot. Besides being a heavy traffic area, Filter's location at the corners of Damen, North, and Milwaukee also puts it at the heart of two of Chicago's hottest neighborhoods, Wicker Park and Bucktown. Needless to say, Filter is almost always busy day and night. However, it isn't just its prime location that keeps the place packed. Filter is a great coffee house with a huge lounge that's great for meeting up with friends and ideal for studying, reading or catching up on work on the laptop. Speaking of which, Filter definitely lives up to the "hot-spot" moniker applied to businesses with wireless Internet access. No matter when I visit this place, I almost always see at least a half-dozen people peering over the top of their bright LCD screens. The clientele at Filter is very representative of the neighborhood: lots of local hipsters, artists and students. During the day, the lounge is fairly

quiet and laid back, with a decent selection of hipster-friendly music playing in the background. You could almost comfortably fall asleep on one of the couches if they let you. However, at night, it gets a lot more crowded and sometimes it can be downright loud if there are a lot of groups hanging out. Nonethe- less, even then it's still a great place to study or read alone, just don't forget to pack your headphones.

EXTRAS/NOTES Wireless Internet access is available.

—*Brad Knutso*

The Note

Late night hangout fills up when everywhere else shuts down.
$$
1565 N. Milwaukee Ave., Chicago 60622
(at Damen Ave.)
Phone (773) 489-0011 • Fax (773) 4489-4457
www.thenotechicago.com

CATEGORY	Late night hangout.
HOURS	Tues: 10 PM–4 AM
	Wed–Fri: 8 PM–4 AM
	Sat: 8 PM–5 AM
	Sun: 10 PM–4 AM
GETTING THERE	Nightmare street parking.
PAYMENT	VISA MasterCard AMERICAN EXPRESS DISCOVER
POPULAR DRINKS	Everything is popular when you can get it 'til 4 AM.
SEATING	About 450 capacity with two bars and scattered high tops. Lots of room but does get very crowded after 2 AM.
AMBIENCE/CLIENTELE	One word sums of the crowd at The Note; Eclectic. With rock bands playing early in the night followed by hip-hop DJs to close the night, The Note breeds diversity. It is a very dimly lit, almost grungy type of environment that is a good place to find yourself sitting next to a guy with a mohawk on one side and a dreadlocked Rasta on the other. Very laid back nonetheless and easy place to just be your self and throw a few back.
EXTRAS/NOTES	Pool Tables. The Note is housed in Chicago's historic Flat Iron Building. Samba nights on Thursdays and Open Mic Night on Tuesdays (Hip Hop).

—*Spiro A. Polomarkakis*

"If you ever reach total enlightenment while drinking beer,
I bet it makes beer shoot out your nose."

— *Jack Handey, Deep Thoughts*

Rodan

Eclectic solutions for eclectic tastes.
$$
1530 N. Milwaukee Ave.,
Chicago 60622
(at W. North Ave.)
Phone (773) 276-7036

CATEGORY	Hipster/Industry Bar.
HOURS	Mon-Thurs: 6 PM-2 AM
	Fri: 5 PM-2 AM
	Sat: 5 PM-3 AM
	Sun: 10 AM-3 PM and 5 PM-2 AM
GETTING THERE	Nightmare street parking with valet available on weekends only
PAYMENT	VISA MasterCard AMERICAN EXPRESS DISCOVER
POPULAR DRINKS	I recommend the Blue Moon (Belgian White Ale), served with a wedge of orange. Ice cold and very light and refreshing. Full bar, a variety of international wines, sake, and champagne.
UNIQUE DRINK	Bubbletini: mango, coconut, pineapple and black tapioca pearls.
FOOD	Argentinean and Southeast Asian Fusion. Full menu-appetizers, entrees, desserts. Brunch (Sunday only), Dinner, Late-Night (Full menu offered until 11 PM, appetizer menu until 1:30 AM daily, exception of Sunday, when kitchen closes at midnight). Smoking Restricted to the bar during dining hour. It's reasonably priced and very unusual: Rodan pizza- roasted asparagus, shallots, ginger, garlic, avocado, and Chihuahua cheese, Adobo Cornish hen in tamarind-honey-garlic sauce, and Ginger-soy grilled Pacific swordfish to name a few.
SEATING	Seating for 75, booths, bar stools (at the bar), tables, and lounge (sofa) seating.
AMBIENCE/CLIENTELE	The dynamic décor of this swank lounge is both calming and invigorating. Pub tables and deep-blue ultra suede banquettes fill the front, where the modest-sized full bar is bathed in soft blue light. A few large booths line the left side, with a number of low, gray sofa seats arranged on the right, in the rear of the bar. The large projection screen on the back wall displays graphic designs that morph from one abstract pattern into another. Occasionally, they show movies. The crowd at Rodan is stylish and diverse, much like the music. DJ's, VJ's, and live performances are frequent and it's not uncommon to hear techno, indie rock, jazz, and lounge music over the course of one evening. The dress is casual, but this is definitely a place to 'see and be seen'. Whatever your palette, this place is sure to please. So, grab a friend—or a date—and come experience the fusion: great drinks, unique dishes, and an eclectic variety of audio and visual entertainment.
EXTRAS/NOTES	Live jazz on Thursdays. Also regular VJ and audio/visual shows featuring alternative rock, funk, soul, r&b, jazz, techno, industrial, and electronica. Be sure to visit the bathrooms; it's a most unique experience.

—*Melanie Briggs*

Salud

Late night hangout fills up when everywhere else shuts down.
$$$$

1471 N. Milwaukee Ave, Chicago 60622
(at Damen Ave.)
Phone (773) 235-5577
www.saludtequilalounge.com

CATEGORY	Tequila Lounge
HOURS	Sun-Fri: 5 PM-2 AM
	Sat: 5 PM-2:30 AM
GETTING THERE	Nightmare street parking and valet for $9
PAYMENT	VISA MasterCard AMERICAN EXPRESS DISCOVER
POPULAR DRINKS	Margaritas and Tequila Flights (a sampling of various tequilas).
UNIQUE DRINKS	Seventy-five choices of 100% pure Agave tequila.
FOOD	Full, and somewhat pricey, menu of Latin influenced food.
SEATING	Salud has two bars, both decent sized. Booths, tables and a few hi-tops scattered. The back room is a good place for a group or private party.
AMBIENCE/CLIENTELE	A polished crowd holds down Salud for the most part. You can expect to hear Latin infused electronic music while you are debating between over 75 choices of 100 percent pure agave tequilas. Very nice decor makes you feel far from Chicago, especially in the winter.
EXTRAS/NOTES	Really, just a great place to take your best girl or gal and try some classy tequila.

—Spiro A. Polomarkakis

Subterranean

Not as underground as you think.
$$$

2011 W. North Ave., Chicago 60622
(at Damen Ave.)
Phone (773) 278-6600

CATEGORY	Lounge/live music
HOURS	Mon-Fri: 6 PM-2 AM
	Sat: 7 PM-3 AM
	Sun: 8 PM-2 AM
GETTING THERE	Street parking is very difficult.
PAYMENT	VISA MasterCard AMERICAN EXPRESS DISCOVER
POPULAR DRINKS	Beer
FOOD	Sandwiches and munchies, not too expensive.
SEATING	Two floors, lots of space, good for groups. Couches and hi-tops
AMBIENCE/CLIENTELE	Upstairs in the "Cabaret Room" you can hear live music while downstairs you can listen to DJ's spin hip-hop, funk, reggae, jazz, and electronic. There is a very ethnically diverse crowd here that ranges from 20 somethings to 40 somethings. Very laid back environment with a lot of locals.
EXTRAS/NOTES	Good place to meet up with a group and have a few drinks to start off the night. After 11 PM it can get really crowded on the weekends though.

—Spiro A. Polomarkakis

IRVING PARK/PORTAGE PARK

Abbey Pub

*Good food, good drinks,
great live music.*

$

3420 W. Grace St., Chicago 60618
(at Elston Ave.)
Phone (773) 478-4408
www.abbeypub.com

CATEGORY	Irish Pub/Musical Venue
HOURS	Mon–Fri: 11 AM–2 AM
	Sat: 11 AM–3 AM
GETTING THERE	Street parking, no permit needed, can get a little dicey to find a spot at night, you might have to do a little walking from your car to the pub. Taxicabs are sporadic.
PAYMENT	VISA MasterCard AMERICAN EXPRESS DISCOVER
	Plus an ATM on premise.
POPULAR DRINKS	Guinness on tap for $4
UNIQUE DRINKS	Away from the hustle and bustle of Lincoln Park, Lakeview, and Downtown… seems out of the way, but worth going to.
FOOD	Kitchen open until midnight. Irish Fare and comfort food. Fish and Chips ($10), Shepherd's Pie ($9), Lamb Shank ($13) round out the Irish fare. Burgers, sandwiches, and salads also available. Good for weekend breakfast, too.
SEATING	The bar is divided into two parts, both of which are large. On one side is the pub (you'll see a little sign on the door that says "PUB" if you get confused) which contains seating at the bar and plenty of booths and tables. There is also a back room available for private parties (for 20 to 200 people). Very good for groups of 4 or more. Can get crowded at night and weekends when there is a musical act performing in the Musical space. This leads me to the other side of the bar, the stage area. The main floor is pretty much standing room only with a bar in back and is the best seat in the house to watch your favorite indie act perform on stage. If this is not your style, you can retire upstairs to the loft where, again, there are plenty of seats and tables surrounding the main floor and stage area. The bathroom, which is one of the cleanest I've seen for any bar in the city, is on the lower level. Coat check, which looks like a hole in the wall, is on the upper level. Small bars on both levels.
AMBIENCE/CLIENTELE	Very casual. Beer drinking and cigarette smoking are mandatory (more or less). Come as you are. It's a true music lovers crowd, bohemians, regular joes, and the occasional old-schooler trying to regain youth clash together in synchronization. It's a very intimate musical venue and some of the best acts in indie-rock, jazz, blues, and funk come through to play on stage.
EXTRAS/NOTES	Golden Tee in the pub area. The music/stage area is a great place to see a show. Sure it may be a little out of the way, but the venue is easily one of the best kept secrets about Chicago (or maybe after this

review it won't be). Anyway, the Abbey Pub provides everything. Great music, good drink, good food at a fair price, plenty of room, and good times for all. With Caramel Apple Pie and a Chocolate Tiramisu ($5) offered year round, why not?

—*Jeffery Goodman*

Windy City Inn
Where everybody knows your name.
$$
2257 W. Irving Park Rd., Chicago 60618
(at Oakley Ave.)
Phone (773) 588-7088

CATEGORY	Neighborhood Pub/ Dive
HOURS	Mon–Fri: 11 AM–2 AM
	Sat: 11 AM–3 AM
	Sun: 11 AM–2 AM
GETTING THERE	Street parking is easily found.
PAYMENT	VISA MasterCard
POPULAR DRINKS	Shot and a beer joint.
UNIQUE DRINKS	Standard drinks, mixed strong and cheap.
FOOD	Bar snacks. Pizza, chicken tenders, etc. Reasonably priced.
SEATING	Small and cozy, but back room seating actually makes it feel larger. Party space available.
AMBIENCE/CLIENTELE	The Windy City Inn has become my Cheers. It's the type of place where everybody knows your name. At first, regulars might scorn outsiders but once you go in a few times you become part of the family. I'm not sure if this is a good thing. It's a very casual environment where neighborhood folk gather and tell their stories. Be careful though. Once you are in you are really in and this is the type of place where everyone talks about everyone else. I would recommend this place to the hardcore drinker who is in the mood for that small, intimate dive bar affair. Just get to know the regulars and everything will be fine.
EXTRAS/NOTES	Video poker games, pool table and darts.

—*Brian Diebold*

WEST SIDE

GREEKTOWN

Artopolis
The heart of Greektown.
$$$
306 S. Halsted Street, Chicago 60661
(between Van Buren St. and Jackson Blvd.)
Phone (312) 559-9000 • Fax (312) 902-9955
www.artopolischicago.com

CATEGORY	European Café.
HOURS	Mon–Thurs: 9 AM–midnight Fri–Sat: 11 AM–midnight Sun: 10 AM–11 PM
GETTING THERE	Street parking, but it can be difficult to find parking on Halsted, try one of the side streets. Also pay lot on Halsted within one block.
PAYMENT	VISA MasterCard AMERICAN EXPRESS
POPULAR DRINKS	The ice frappe with ice cream added!
UNIQUE	Ice frappe (a mocha coffee smoothie concoction) and Greek coffee.
FOOD	There is a full menu that ranges from pizzas cooked in a wood-burning oven to traditional Greek dishes like Yuvetsaki (braised beef mixed with orzo pasta, red wine tomato sauce and greek cheeses). If you have already eaten dinner, stop in for coffee and sample a sweet from their in-house bakery's delectable selection. The Loukoumades (fried dough drizzled with honey, cinnamon and walnuts) are sinful, but heavenly.
SEATING	Seating is spread over the first floor and a lofted second floor.
AMBIENCE/CLIENTELE	If what you are looking for is a contrived Greek vibe (i.e. waiters setting cheese aflame and yelling, "Opa") this is not the place to go. Here you will experience the warmth of the Mediterranean temperament—the host will shake your hand (or give you a hug!), learn your name and be sure that you feel like a VIP—whether you are a student or a stockbroker. The crowd is a mix of ethnic bohemians, due in part to its proximity to the university and its Greek roots, and urban yuppies who have helped pave the gentrification of the surrounding area once known as 'skid row.'
EXTRAS/NOTES	Artopolis is more than just a café, inside there is a bakery counter/marketplace where you can buy homemade cookies by the dozen, fresh baked bread, imported olive oils/vinegars, homemade candies/chocolates, olives, honey or Greek wine and spirits. Additionally, there are small gift items and cards available for purchase.
OTHER ONES	None, but the same family owns Pegasus, which is a Greek restaurant down the block with an amazing rooftop deck.

—Catherine De Orio

Barrel Café/Vareladiko

*It's all Greek to you, but that includes
good drinks and dancing all night.*

$$

820 W. Jackson Blvd., Chicago 60607
(at Halsted St.)
Phone (312) 559-9012

CATEGORY	Restaurant Bar with live music.
HOURS	Daily: 11 AM–2 AM
GETTING THERE	Street parking; pretty hard to find a spot, but there's a pay lot around the corner.
PAYMENT	
POPULAR DRINKS	Greek Wine.
UNIQUE DRINKS	Greek wine!
FOOD	11-4 PM buffet style lunch with American/Greek cuisine. 4 PM-2 AM full menu.
SEATING	161 capacity, bar stools, tables, booths. Large enough for parties, stage, dancing.
AMBIENCE/CLIENTELE	Large front windows, wood bar, very clean, no cover, dim lights, very casual, but you wouldn't want to wear flip-flops and a t-shirt. Big circular bar.
EXTRAS/NOTES	Live Greek music Wednesday through Friday and DJs on Saturday.

—*Spiro A. Polomarkakis*

Byzantium

*Late-night Greek Town club with live Greek
music and a very diverse crowd.*

$$$

232 S. Halsted St., Chicago 60607
(at Jackson Blvd.)
Phone (312) 454-1227

CATEGORY	Greek/International Club
HOURS	Daily: 6 PM–4 AM
GETTING THERE	Street parking not so easy. Pay lot across the street.
PAYMENT	
POPULAR DRINKS	Mixed drinks are made stiff and are reasonably priced.
FOOD	Full menu not too pricey.
SEATING	Capacity from about 200 with a big bar and tables in the main room. Decent amount of room but gets crowded after 2 AM.
AMBIENCE/CLIENTELE	Very diverse crowd with a lot of Greeks and Eastern Europeans. Very casual with a welcoming attitude. When there is live music expect a pretty rowdy scene with people dancing everywhere and the occasional shot glass smashed on the floor or against the wall. Good place to go late night or after a nice meal in Greektown.
EXTRAS/NOTES	Live music on special nights: DJs, Greek bands, and Serbian music. Expect a very smoky environment.

—*Spiro A. Polomarkaki*

Dugan's Drinking Emporium

After a nice Greek dinner head over to Dugan's to indulge on a Guinness for dessert.

$$$

128 S. Halsted St., Chicago 60661
(at Madison St.)
Phone (312) 421-7191
www.dugansonhalsted.com

CATEGORY	Irish Pub/Sports Bar
HOURS	Mon–Fri: 2 PM–4 AM
	Sat: 2 PM–5 AM
	Sun: 11 AM–4 AM
GETTING THERE	Street parking and valet at neighboring restaurants.
PAYMENT	VISA MasterCard AMERICAN EXPRESS DISCOVER
POPULAR DRINKS	Any of the many beers on tap.
UNIQUE DRINKS	The Blue Dugan: Blue Curacao, Malibu, lemonade,
FOOD	Free pizza on Friday or you can order from surrounding Greek restaurants.
SEATING	Bar stools, tables, good meeting place, private party room.
AMBIENCE/CLIENTELE	A bar for locals, cops, revlers and a meeting place for friends ready to go out on the town. Very casual atmosphere.
EXTRAS/NOTES	Pool tables, pop-a-shot, ATM. The building used to be used as a brothel back in the day.

—*Spiro A. Polomarkakis*

Nine Muses

Opa!

$$$

315 S. Halsted, Chicago 60607
(at Jackson Blvd.)
Phone (312) 902-9922

CATEGORY	Swank Greek Lounge
HOURS	Mon–Fri: 11 AM–2 AM
	Sat: noon–3 AM
GETTING THERE	Metered street parking, also valet
PAYMENT	VISA MasterCard AMERICAN EXPRESS DISCOVER
POPULAR DRINKS	The gin and tonic.
UNIQUE DRINKS	Be careful to ask the bartender to go easy on the ice, otherwise all your drinks will be as rocky the Maine coast.
FOOD	There is a menu of pricey items, including baklava and that cheese Greeks like to light on fire.
SEATING	Nine Muses is laid out like a U with bar stools surrounding the U and wings of tables off to the side. Wannabe Athenians sit window side wearing sunglasses over their eyebrows, smoking languidly, gazing at the street scene.
AMBIENCE/CLIENTELE	The evening of this visit, a glass-encased laptop served as DJ, supplying an endless supply of thumping Europop.
EXTRAS/NOTES	Again, be forewarned if you don't like your cocktails too icey, be sure to ask for no ice.

—*Josh Cox*

SOUTH SIDE

HYDE PARK/KENWOOD

Jimmy's Woodlawn Tap
A friendly neighborhood bar just when you need it most.
$$
1172 E. 55th St., Chicago 60615
(at Woodlawn Ave.)
Phone (773) 643-5516

CATEGORY	Woodlawn Tap is the quintessential neighborhood bar
HOURS	Mon–Fri: 10:30 AM–2 AM
	Sat: 10:30 AM–3 AM
	Sun: 11 AM–2 AM
GETTING THERE	Metered and street spaces are available, but parking can be difficult during business hours or on weekend nights.
PAYMENT	Cash only
POPULAR DRINKS	Woodlawn Tap offers a variety of draft and bottled beers.
UNIQUE DRINKS	Woodland tap has a fully stocked bar, so you can get just about anything, but almost everyone here drinks beer.
FOOD	Your liver would be happy to know that Woodlawn Tap offers basic bar food and snacks. Although you won't find the menu to be a dieter's delight, there's certainly enough on the menu to curb your munchies without lightening your wallet. French fries, burgers, polish, and grilled cheese are what you can expect to find. Most menu items fall between $2-3.
SEATING	Woodlawn Tap has three rooms that all have tables with chairs and a bar.
AMBIENCE/CLIENTELE	Woodlawn Tap is a dimly lit, dark-wooded, dress-down neighborhood bar that does not need to rely on slick sales gimmicks to fill the bar. Upon entering Woodlawn Tap you will see antique and retro, but apparently still functional, cash registers behind the main bar. Above the middle cash register is the seal of the University of Chicago, but this bar is not a silly campus hangout. Woodlawn Tap is a classic Hyde Park neighborhood bar where people of all ages with all sorts of backgrounds will gather and have at least one thing in common – their quest for cold beer in a casual atmosphere. Sitting side-by-side on bar stools are more than just students and professors. There are also local people (professional and blue collar) who go there to grab an unfussy drink, get away from their wife, shoot the breeze with a buddy, check the score of the game, or any other number of alcohol-seeking human needs.
EXTRAS/NOTES	Sunday is live music day at Woodlawn Tap. In the back room there is a small bandstand where from 4 PM–8 PM on Sunday there is live blues. Live jazz is after 9 PM on Sunday.

—*Nicole Allen*

Seven Ten

Seven Ten: Beyond Basic Bowling
$$
1055 E. 55th Street, Chicago 60615
(at Ellis Ave.)
Phone (773) 347-2695
www.sparetimechicago.com

CATEGORY	Offering three distinct entertainment zones, Seven Ten is a combination bar. Under one roof you will find a cosmopolitan bowling alley, a pool table room, and a college-type pub.
HOURS	Tues–Thurs: 11:30 AM–1 AM Fri/Sat: 11:30 AM–2 AM Sun/Mon: 11:30 AM–midnight
GETTING THERE	There is street parking surrounding Seven Ten, but finding a space can be difficult at peak times. There is a University of Chicago pay lot within the same dwelling as Seven Ten. Parking is $1 per hour for the first four hours. .
PAYMENT	VISA MasterCard AMERICAN EXPRESS DISCOVER
POPULAR DRINKS	Although much more cosmopolitan than your grand-father's bowling alley, Seven Ten is still one-third bowling alley. This makes beer the most prevailing drink. Although Seven Ten is frequented by local Chicagoans, its proximity to the University of Chicago also makes it somewhat of a college bar. This college influence also makes beer a common drink. Wine is also a safe bet.
UNIQUE DRINKS	Seven Ten offers a standard variety of alcoholic concoctions: beer, wine, and cocktails.
FOOD	Seven Ten offers a full menu that will accommodate nearly anyone's taste or budget. There are your typical pub appetizers (e.g., chicken fingers) and your more collegiate appetizers (e.g., hummus plate). They offer impressively fresh dinner salads that step well beyond the realm of iceberg lettuce and entrees that range from $9.95 to $15.95. Burgers, sandwiches, small pizzas, dessert, and even weekly specials are available.
SEATING	Seven Ten is generally divided into three large 'zones.' The bar zone has a pub atmosphere where people can sit on stools at a fairly expansive bar - or at tables and booths if they plan to focus more seriously on a meal. Sports are likely to be showing on the two televisions that hang above each side of the bar. The pool hall zone has several pool tables for serious or not so serious matches. The bowling alley zone has eight lanes available for play as well as tables for you to enjoy food and drink.
AMBIENCE/CLIENTELE	Formerly known as Lucky Strike, Seven Ten is a dress-down hangout with a true cross-section of folk. There are your local residents and U. of C. employees who come for food and drink, but are more likely to be found in the pool zone when it's time for enter-tainment. There are college students, post-docs, and professors who also come for food and drink, so don't be surprised if you catch someone proofreading a term paper while snacking on fries. Music selection is up for grabs – whoever feeds the modern jukebox is in control. If you make the time to take it all in, a

visit to Seven Ten can also provide you with a pictorial history of Hyde Park. There are photographs of established neighborhood buildings that date back as far as 1913.

EXTRAS/NOTES Pool tables are first come, first served at $12 per hour. If you're determined to play on a weekend make sure to get there early. Bowling lanes can be reserved and cost $16.00 per hour. Shoe rentals are $2. You must have a credit card in order to bowl or play pool. Are you affiliated with the University of Chicago? If so then make sure to carry your campus identification and you may be able to take advantage of U. of C. drink and food specials. Planning a party or get together? Seven Ten can close off part of the bowling section so that you can have a private bowling party. They also offer party planning assistance and a variety of catering packages.

—Nicole Allen

STILL THIRSTY?

O Our glossary hits the nail on the head of all those elusive drinks and terms you kinda sorta know about but maybe need to know for sure before placing that order. Consult here to order a drink like a pro or a native.

agua fresca (Mexican)—(also *agua natural*) flavorful drink that's not quite juice, not quite soda. Popular flavors include *horchata (sweet rice milk with cinnamon), tamarindo (tamarind), jamaica (hibiscus flower), limón (lemon), piña (pineapple)*.

ale—heavy thick beer made with a top-fermenting yeast and available in a range of varieties including brown ale and pale ale.

americano (Italian)—a shot or two of espresso poured over a glass of hot water, (basically watered-down coffee, which is what Italians think we drink here).

apple martini—vodka and Apple Pucker, served *up* in a cocktail glass. *Trés chic.*

Arnold Palmer—iced tea and lemonade, mixed.

atole (Mexican)—thick malt drink made of corn meal and sometimes cinnamon.

barista (Italian)—your best friend in the morning—the guy or girl behind the espresso counter, the unofficial coffeehouse bartender.

batido (South American)—see *licuado*.

bee pollen—what bees eat. Chock full of protein, used as a nutritional supplement for humans, it is thought to stabilize the metabolism and mellow out allergies to proteins.

bier (German)—any way you slice it, it's just German for beer.

black eye—house coffee with a double shot of espresso.

Bloody Mary—a strictly pre-dinner hour cocktail of tomato juice, vodka, lemon juice, Worcestershire and Tabasco sauce, stirred and garnished with celery or other stalky vegetable.

bo ba nai cha (Taiwanese)—iced tea or coffee drinks with sweetened condensed milk and chewy little marble-sized tapioca balls (*boba* or pearls).

boilermaker—The ultimate in American intuition. A mixture of inexpensive beer and bourbon. Best consumed by dropping a shot of bourbon into your glass of beer and drinking quickly (a.k.a. the depth charge).

café—Spanish and French for coffee.

café au lait (French)—coffee served with warm milk.

café con leche (Spanish)—see *café au lait*.

café de olla (Mexican)—Mexican coffee, right from the pot, hot and spiced with cinnamon.

café den nong (Vietnamese)—French-Vietnamese style coffee with sweetened condensed milk.

caffé—Italian for coffee.

call drink—a cocktail ordered with the liquor brand of choice. Always "call" the brand first (e.g., a vodka tonic would still be a Stoli tonic).

canela (Mexican)—a favorite! Mexican cinnamon tea made with real cinnamon sticks.

Cape Codder—(a.k.a. Cape Cod) a cold and sour cocktail of vodka, cranberry juice and lime, served in a highball.

cappuccino (Italian) — the quintessential espresso drink. A perfect balance of espresso, steamed milk, and milk foam.

Chado (Japanese)—the traditional Japanese tea ceremony often translated to mean "Way of Tea."

chai (Indian)—a tasty special tea from India, usually served with milk and very popular in the U.S.

chaser—a non-alcoholic drink (often water or soda) ordered on the side to cut the taste of a *strong* drink.

chianti (Italian)—a sweetened Italian wine often served in a decorative jug and a favorite of *Silence of the Lamb*'s Hannibal Lector. Jugs recycled make for good candle holders.

Chuchifrito (Brazillian)—Happy Hour!

cider—juice made by pressing fruit, usually apples, and available in alcoholic varieties.

collins glass—the tallest cocktail glass (14 oz.); used for soft drinks, Bloody Mary's, and Tom Collins, of course!

cosmopolitan—(a.k.a. cosmo) besides its current rival, the apple martini, one of today's most popular drinks. Vodka, triple sec, and cranberry juice, up, with a wedge of lime.

crema (Italian) —the thick medium brown coating that tops a good shot of espresso.

cremosa (Italian)—a milky iced blended without the coffee and *with* the syrup flavorings of your choice.

Cuba Libre—a mixture of cola, rum, and lime, served over ice. Allegedly invented by Teddy Roosevelt's Rough Riders in Cuba at the turn of the 20th century.

cupping—process of tasting coffee employed by coffee professionals to determine which crops of beans to buy

demitasse (French)—small delicate half-size coffee cup mainly used for Turkish coffee or espresso, today's often come with intricate artful designs and delicate handles.

desert dry—martini sans vermouth. A theatrical bartender will wave the bottle of vermouth over the glass just for show.

Dirty Shirley (aka Shirley Temple Black)—Another embarrassing drink to order, this is essentially a Shirley Temple with a kick. Soda (7 Up or Sprite), grenadine, and vodka, with a cherry on top, all served in a highball.

dopio (Italian)—two shots of espresso (double).

double—drink with two shots of espresso; also a cocktail that's double the norm and priced accordingly.

dry—opposite of wet. How to order your cappuccino if you want less milk and more foam; how to order your martini if you don't want to taste the vermouth.

eau-de-vie (French)—(plural, *eaux-de-vie*)literally "water of life" and a stone fruit brandy popular with Europeans. The best are made from plums or sweet or sour cherries.

espresso (Italian)—a shot of concentrated coffee made by forcing hot water through finely ground, tightly pressed beans, and the basis of all Italian coffee drinks. An occasional indulgence for some, a religion for others, a well-made *demitasse* of espresso should be topped with *crema*.

espresso Cubano (Cuban)—(a.k.a. *café Cubano*) espresso brewed with raw sugar. *¡Qué dulce!*

40—slang for a 40-ounce bottle of malt liquor (Mickey's and Colt being the most popular brands).

frappé — a blended mix of frozen fruits; variations include mixing alcohol with shaved ice or going non-alcoholic and making a iced blended style coffee drink.

French press—a glass pot with metal plunger, used to brew coffee and (more recently) tea by isolating the ground beans or leaves at the bottom of the pot once it has steeped in boiling water, and *voilá*, the perfect cup!

gingko biloba (Chinese)—herbal supplement shown to improve circulation, increasing everything from memory to sex drive.

ginseng (Asian/North American)—a tonic herb extracted from the root of the ginseng plant, very popular in Asian countries and now world-wide to enhance overall health.

guanabana (Latin American)—delicious tropical fruit used in *licuados* in many Latin American countries.

gulab jamun (Indian)—small cake-like fried milk balls drenched in rose-infused syrup and one of the more popular Indian deserts with Westerners.

halo-halo (Filipino)—milk, shaved ice, mixed tropical fruits, tropical ice cream, *leche flan*, and crisp puffed rice-very popular!

hefeweizen—type of wheat beer where the yeast is not filtered out. Often served with a slice of lemon or orange.

high tea—traditional British afternoon tea service, complete with tea sandwiches and sweets.

highball—the most widely used cocktail glass (8 oz).

hookah—an ancient water pipe from the Middle East used for smoking prepared tobacco, usually passed around and shared by a group of people.

horchata (Mexican)—a mix of water, cold rice, and cinnamon to create a sweet beverage from heaven. One of the best *aguas frescas* this side of *Méjico*!

iced blended—a nice mix of coffee, milk, sweetner, and ice brought to a frothy fruition in a high powered blender similar to the frappé. The most popular flavors include mocha and vanilla. The original Ice Blended was trademarked by The Coffee Bean & Tea Leaf in 1988.

Irish coffee—sweetened coffee spiked with Irish whiskey and topped off with whipped cream.

Italian syrup—Flavorings mixed in with ice and club soda to make great Italian soda, also used to flavor coffee drinks. Torani and Monin are popular brands.

Jack 'n' Coke—Jack Daniels and Coca-Cola over rocks in a highball.

jamaica (Mexican) — remember those *aguas frescas* we told you about? This is another great one, made from hibiscus flower.

joe—as in "cup of joe," a slang term for coffee developed during WW2.

kamikaze—vodka, triple sec, and lime chilled and served in a shot glass.

karaoke (Japanese)—dress up, get drunk, and sing-a-long with your favorite (and not so favorite) tunes to a room full of strangers.

keg—a Frat boy's favorite word, referring to a large metal container of beer tapped at the top and capable of upwards of 100 cups.

kombucha—a fermented tea made with yeast culture and also a popular health drink.

lager (German)—style of beer usually aged for about month to two months, and golden in color; your basic European brew.

lassi (Indian)—a yogurt drink served salted or flavored with mango. Banana, or even rose.

last call—what the bartender yells at the end of the night and your last chance to order a drink. Period.

latte (Italian)—(also, caffé latte) espresso drink filled with steamed milk and a touch of foam on top—milky, but not so milky you can't taste the coffee anymore.

leche flan—more milk added to regular flan to create a creamier experience (see *flan*).

licuado (Mexican)—(also *batido*) fruit juice blended with ice, milk and sometimes honey. Essentially a smoothie or frappé.

Long Island iced tea—a cocktail made with so many kinds of liquor you don't taste any of them! Actually, vodka, gin, light rum, tequila, triple sec, sweet-and-sour mix, and cola served over rocks in a collins glass.

macchiato (Italian)—literally, Italian for "mark" or "stained." In coffee terms, espresso stained by a dallop of steamed milk foam on top.

mai tai—a sweet cocktail with rum, crème de almond, triple sec, pineapple, sweet-and-sour mix, and topped with more rum, evoking tropical breezes and better days.

malt—(also, malted milk) a classic soda fountain drink made by mixing ice cream and flavoring with malted milk powder and milk.

mamey (Central American)—a native fruit of Central America that looks like the spawn of a papaya and a football; an acquired taste due to its chalky quality.

margarita—an icy cold sweet drink from Mexico served with white or gold tequila, triple sec, and lime juice, on the rocks or blended. Salt on the rim of the glass is up to you.

martini—gin with a splash of vermouth, chilled, stirred and served up with an olive. Variations substitute vodka for gin or a pearl onion or lemon twist for the olive, but true martini drinkers will tell you that's those aren't real martinis.

merienda (Filipino)—late afternoon snack of pastries, cakes, and candies, similar to afternoon tea.

michelada (Mexican)—beer with lime juice and salt over ice.

microbrew—a handcrafted beer produced by a small brewery.

milkshake—a creamy blend of ice cream, milk and flavorings ranging from coffee to Oreo to the king of all milkshakes, The Elvis Shake (with peanut butter and banana).

misted—cocktail served over crushed ice.

mocha—(also, café mocha) essentially a latte with chocolate added and served with whipped cream (only if you say, "pretty please").

mochi (Japanese)—small confections made from a rice base. Usually filled with red bean paste, they are chewy sweet treats that prove the best things in life do come in small packages.

mojito (Cuban)—refreshing rum drink filled with muddled mint leaves, lime juice, and sugar.

muddled—bar technique whereby some ingredients are ground in the glass (see *mojito*).

neat—booze straight outta the bottle, nothing added—for those who like the taste of their liquor.

New York egg cream—(also, egg cream) a soda fountain beverage originated in Brooklyn in the late 1800s that tastes a lot like a melted chocolate ice cream soda. No, it doesn't have a single drop of egg in it!

on-tap—beer from a keg which you won't see from your side of the bar; usually cheaper than bottled water.

phosphate—frothy old-skool soda fountain drink.

pillow—cocktail with cream. Order your drink with "a pillow" if you'd like it creamy.

pilsner—style of beer originating from Plzen in the Czech Republic. A lot like lager, but with a more distinct flavor of hops.

piscorita (Latin American)—Latin margaritas with Peruvian *eau-de-vie* in place of tequila.

pot bing soo (Korean)—a Korean shaved ice dessert extravaganza with red beans and fruit.

protein powder—a common smoothie supplement for folks who want to stay "in the Zone."

psyllim husk—a soluble fiber supplement. Add it to your juice and go go go.

raspado (Mexican)—popular slush of shaved ice and artificial fruit flavors.

rau má (Vietnamese)—pennyworth leaves drink.

red eye—house coffee with a single shot of espresso.

rickey—syrup-sweetened soda water served at classic fountains, usually flavored with cherry or lime or both.

ristretto (Italian)—the mother of all espresso drinks. With less water (almost half) but the same amount of coffee as your average espresso, this super-concentrated liquid will definitely keep you up.

rocks—(also, on the rocks) ice, and what your order your liquor with to water it down a bit.

sake (Japanese)—centuries-old fermented rice drink similar to a crisp white wine. Drink hot or cold.

sangría (Spanish)—popular concoction of red wine over ice with floating fruit and a bit of bubbly.

scones (Scottish)—Scottish biscuit-like desserts made of butter, flour, and fruit cooked or baked on a griddle.

screaming—code word for "add vodka" to any drink.

Sex on the Beach—a cold sweet cocktail with vodka, peach schnapps, and filled with cranberry and orange juice. Possibly the most embarrassing drink you could order in a real bar.

shaved ice—a Hawaiian snow cone with many juice and different flavorings ranging from fruit to tea flavors, even condensed milk!

shot—1.5 oz. of the potent liquid in a drink (e.g., espresso, bourbon); also a small glass size.

Singapore sling—a cold sweet layered drink of grenadine, gin, club soda, and sweet-and-sour, topped with cherry brandy.

single—one shot of espresso.

smoothie—a thick mixture of fruits, juice, ice (and sometimes yogurt or milk) together in a blender and boom, you've got a smoothie!

snakebite—A cocktail mixed with beer, hard cider, and currant. Popular with with young Brits.

soju (Korean)—a popular Korean distilled liquor usually served by the bottle and shaved by a table, strong but good.

spirulina—a rich amino acid popular for its protein qualities.

stout—the darkest beer known to man, sweet or dry, the style has been popularized by the Guinness brand, a meal in and of itself.

straight-up—see *neat*.

tall—drink served in a large glass.

tamarindo (Mexican)—a tropical Mexican juice drink (*agua fresca*) made from tropical tamarind fruits.

tapas (Spanish)—small Spanish appetizers. Order several with some *sangría* and you've got a garlic filled meal.

tapioca pearl drink—see *bo ba nai cha*.

tea sandwich—fancy sandwiches served during high tea.

tequila sunrise—tequila, orange juice, and grenadine served in a highball glass. Watch the grenadine fall to the bottom of the glass, then rise.

Thai iced coffee/tea—iced tea/coffee filled to the top with sweetened condensed milk for a double punch of caffeine and sugar.

toddy—coffee cold brewed (an overnight process which completely removes the bitterness), served cold over ice or hot.

Tom Collins—Essentially a variation of a Gin Sour. Gin, soda, and sweet and sour served usually served over ice. Expect tons of variations of the Collins, where gin is replaced by a favorite liquor and "Tom" is replaced by an appropriate nomenclature.

top-shelf—the expensive brand spirits, so called because they've kept on display on the bars top shelf.

ube (Filipino)—a ginger-like root used in sweets. Its purple coloring and spicy/sweet flavor are unique to Filipino desserts.

up—a drink that's chilled over ice than strained into a glass, beautifully ice free; how you want your martini.

vampiro (Central American)—literally, Spanish for vampire. A popular smoothie made with pineapple, orange, carrot, melon, papaya, apple, and celery.

Vietnamese coffee - see *café den nong*.

vuelve a la vida (Central American)—*licuado* with strawberry, banana, melon, and papaya.

well - a collection of low-end liquors kept easily on-hand by the bartender.

well drink—cocktail made with alcohol from the well (what you get if you don't *call* your brand).

wet—how to order your cappuccino if you want more milk than foam; how to order your martini if you want the taste of vermouth.

wheat grass—a juice made from nutritious wheat sprouts, creating concentrated forms of vegetable properties. Packs a punch!

white Russian—Sweet cocktail with mixed vodka, kahlua, and cream served over ice. A favorite of "Big Lebowski Fans." Not actually of Russian origin.

yerba maté (South American)—an herbal drink long used by the Guarani Indians in the forests of Paraguay for its medicinal qualities—most definitely an acquired taste!

zombie—though there are about as many variations on the Zombies as numbers in Paris' Sidekick, they are all centered around mixing several rums, liqueurs, and juice. The effect of these astonishingly potent concoctions is tremendous. Hence the name.

Nicole Allen is a Chicago-based therapist and freelance writer.

J. Asala is the editor of Compass Rose Cultural Crossroads, a not-for-profit publishing company in Chicago. You can visit her on the Web at: www.compassrose.org

Melanie Briggs is a freelance writer and graduate of Arizona State who has covered a lot of territory in the U.S. and abroad. Aside from scoping out the local bars, she enjoys hiking, travel writing, and promoting environmental conservation.

Sarah Brown - A Wisconsinite by birth, a Chicagoan by choice, living in North Center. Former waitress/barista/salesperson/project analyst, currently an editorial assistant at a nonprofit in the 'burbs.

Michelle Burton is a native Chicagoan and freelance writer with a love for grubby dives and old school neighborhood taverns.

Jennifer Carsen (www.jennifercarsen.com) is a freelance writer living in the Chicago area. Her areas of expertise are food (and drink!), law, health, and fitness.

Keidra Chaney is a Chicago born and raised freelance writer and editor for independent and alternative media. Her work has appeared in BlackVoices.com (formerly Africana.com), Bitch: Feminist Response to Pop Culture, Clamor Magazine and Friction Magazine.

Ever since the great web design crash of 2000, **Grant Christman** has been a professional drinker and dive bar junkie where there's always an old timer waiting to wallow or reminisce with him.

Weaned on a juice bottle most of his life, **Josh Cox** has only recently experienced the pleasure of adding vodka to the concoction.

Gina M. DeBartolo, writer, filmmaker and former Wrigleyville bartender, has dwelled, swilled and stumbled in Buena Park, Boy's Town, Ukrainian Village and Logan Square. She now pulls pints in Manchester, England, but her preferred beverage is the absinthe minded martini. She can be contacted at: rucksackwriter@yahoo.com.

Catherine De Orio is a reformed attorney turned caterer and food journalist. Her knowledge of drinking establishments was garnered through many nights spent drowning her sorrows over choosing a career in the law. When not visiting Chicago bars and restaurants, she can be found doing the same around the world.

Danielle Deutsch is a freelance writer, living, drinking and eating in Chicago!

Brian Diebold has spent a lot of years drunk in Chicago bars, writing for a local paper, "Barfly". He tends to get bitchy when he is not drinking. We prefer him to stay in the bars.

Mike Fertig is a product of Coe College in Cedar Rapids, Iowa and has worked for several years now as a children's book editor. Living in

Chicago, Mike has his own humor column at www.negativewaves.com and is also making waves in the blogging world with his scatterbrained blog entitled, *Because the World Is Round* (www.mike.wordpress.com). There is no question that Mike is quite thirsty and has been known to attempt to quench it at many of the establishments found within these pages.

Brent J. Fuscaldo - favorite drink: Cuba Libre; writes music reviews for local zine *The Crutch* (thecrutch.net), currently in the MFA Poetry program at Columbia College, volunteered for the Americorps program, from the east coast, left his car behind in North Carolina and is now riding trains and his bike, dodging the big buildings of Chicago.

Currently residing in Chicago, IL but originally from Nashville, Tennessee, **Nicole Galbreath** is a freelance writer with a Bachelor's in Business Administration from Tennessee State University.

Mindy Golub is a 24 year-old communications professional by day, and an avid "get up and dance to music" chick by night. A Cubs fan year-round, she also enjoys chocolate, laughing hysterically, and staying out until dawn. Her personal pastime is shopping, especially for girly-girl shoes, vintage purses and various pink lipsticks.

Jeffrey Goodman has lived in five different neighborhoods of Chicago (East Ukrainian Village, West Lakeview, Wrigleyville, Old Town & Roscoe Village) since first moving there 1999. Writing reviews for Thirsty? Chicago has kept his mind and fingers fresh for his one true love, screenwriting.

Michelle Hempel is a writer and English teacher who lives, works, eats and drinks in Chicago. Someday she hopes to publish a bestseller that will bring her worldwide fame and popularity. In the meantime, she considers eating and drinking her way through the Windy City to be an honor and privilege.

After the publishing of his first novel, the experimental "And Yet It Moves", **Brent Kado** has written for many on-line Zines, Blogs and local Alternative Presses. Kado currently divides his time between Ph.D. studies, work at a bookstore and reporting for Chicago's top website for Avant/Pop news, FlowFeel.com.".

Billy Kenefick has been a downtown Chicago native until he was whisked away to Los Angeles for his college education. Since graduating, he has returned to his home to try and write enough to feed himself and to slake his thirst. He is usually out and about in Lincoln Park or wherever drinks are less than $5. You never know where you will find him; but if you see a really good looking guy at a bar surrounded by beautiful women, Billy is probably standing next to you looking at the beautiful women.

Brad Knutson is a freelance writer and managing editor of the local music blog, RadioFreeChicago.org. He is a frequent bar-goer who enjoys a good microbrew or a stiff Manhattan. Knutson developed a vast knowledge of Chicago nightlife quickly after moving to the city when he was hired as a marketing representative for a local beer

distributor. His current favorite watering holes in the city include: The Empty Bottle, Handle Bar, Lava Lounge, The Matchbox and Sonotheque.

Amy Lillard has lived, worked, and played in Chicago for over 5 years. She has a day job, which pays for the living, working and playing. For fun and passion, she writes and occasionally gets attention for it. She is a freelance business writer, online commentator, and an aspiring novelist. She also has extremely useful friends, one of whom designed her website, amylillard.com.

Katie Murray has been a drinking connoisseur since the early age of three, when every morning she'd demand a perfectly blended cocktail of apple juice and o.j. In the years since, she's sampled quite a range of wine, beer and martinis. And she still likes her o.j.— but now she likes it mixed into a screwdriver. She even occasionally drinks at work, where she writes copy at an advertising agency. She loves baking, biking, and the city of Chicago. Although, she'd give all that up to spend a few years writing for *Thirsty? London*.

Courtney Nealis is a jewelry designer in Chicago and loves to eat and drink. Buy some of her jewelry at www.purpledesigns.biz or buy her a drink if you see her out!

Sy Nguyen, 28, hails from Beaverton, Oregon. He's lived in Chicago since 1998 where he's worked and frequented in the many watering holes offered in this great town. He lives with his dog, Incredible Emmitt in the Lincoln Square part of town. When he's not writing bar reviews or working in the financial services industry, he's either drinking in bars or thinking of quick get rich scams to get himself ironically out of financial services.

Piper Parker is a serious fan of fun bars & pubs and she's happy to share her favorites with the rest of the Thirsty world!

Louis Pine wanders the West. You know, like Caine in *Fung Fu*.

Spiro Polomarkakis is a freelance writer who has worked the restaurant and bar scene in Chicago for many years. He is a published travel writer and aspiring novelist. And yes, he is a borderline alcoholic who can drink with the best of them! Spiro believes Chicago is the best city in the world to discover your inner drunkard and have fun while doing so.

Chaz Reetz-Laiolo lives in California with his daughter, Isa. He has taught at the Art Institute of Chicago, and has a story forthcoming in Fourteen Hills Review.

Janet E. Sawyer is a Chicago native who eats, drinks, lives, laughs and tries really hard to love as a Windy City writer. She doesn't own a cat or an iPod, but thinks both are really cool. She wishes on a star for an affordable condo in a diverse neighborhood full of nifty bars and restaurants to discover.

Alana Sitek Waiting for a nervous breakdown while living the life of "OFFICE SPACE". Writing is her only connection to the world of cool. Is that your Stapler? Is your name on it?

Kristy Stachelski is a Chicagoland native that almost moved to Manhattan, but ultimately couldn't stand the thought of leaving the Windy City behind. 2.5 years ago, she broke free from the chains of Suburbia, and has found sanity in city life ever since. She enjoys avid writing in her free time…along with dining and drinking at new and old favorite urban spots.

Mark Vickery has been a freelance writer in Chicago for nearly ten years, and has been drinking in bars almost twice as long. There has never been a time he can recall when he did not foster strong opinions about what and where to drink

Kellee Warren resides in Chicago. She is the proud mother of a 5-year-old black pug named Bo.

Ian Weiss hails from New York and moved to Chicago following his four years at NYU. He enjoys drinking, drinking, and yes…eating. He currently works in Market Research and enjoys his ritual happy hours in the Lakeview area.

Marcy Wrzesinski writes, eats and resides in Chicago.

"First-time visitors can feel like natives with the handy Glove Box Guides."

-Bon Appétit

"Angelenos with dwindling dining out dollars, do not despair… Hungry? Los Angeles has hit the shelves."

-Westways Magazine

"Thank the folks at Glove Box Guides for providing an honest and often entertaining means of attaining a well-priced meal…"

-GroovyStylie.com

"Rather than focusing on fine dining, the strength of this series is its inside knowledge or unassuming neighborhood sandwich shops, ethnic gems, and hidden treasures where two can have excellent meals for $25 or under."

-Passport

"A Zagat Guide for Gen-X…"

-Los Angeles Times

"What we most enjoy are the idiosyncratic little essays scattered through the book on such subjects as the Grand Central Market, LA's best hot dogs, and nostalgic memories of restaurants that no longer exist (helpfully labeled "R.I.P.")."

-New Times

"An eating guide for Tinseltown's not yet rich and famous."

-Publishers Weekly

"A guide to the eateries in Los Angeles for the ever-so-hip but not-so-flush crowd."

-Nocturne.com

Check out our other Glove Box Guides!

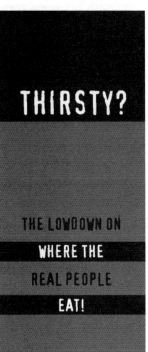

Available at a bookstore near you, or to the trade from
SCB Distributors at (800) 729-6423.

TAXI CABS

Wise up, wino. Driving Drunk is never safe,
and hailing a cab in Chicago is easier than
you might think. Hail one down the street—
or give them a call. To make it even easier,
here are the numbers. Bring this list along,
and drink to your heart's content.

Ace Cab (773) 381-8000

American United Cab (773) 248-7600

Checker Taxi (312) 243-2537

Sun Taxi (773) 736-3399

Yellow Cab Company (312) 829-4222